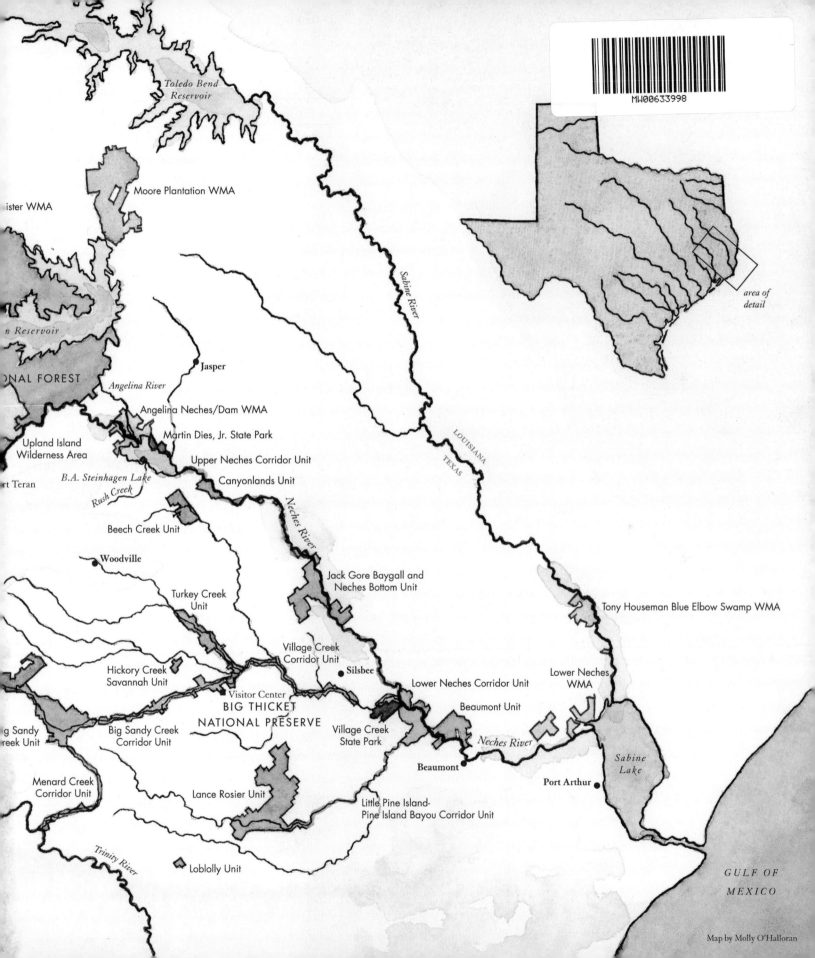

Toledo Bend
Reservoir

Moore Plantation WMA

...ister WMA

...n Reservoir

...NAL FOREST

Jasper

Angelina River

Angelina Neches/Dam WMA

Martin Dies, Jr. State Park

Upland Island
Wilderness Area

Upper Neches Corridor Unit

...rt Teran

B.A. Steinhagen Lake

Canyonlands Unit

Rush Creek

Beech Creek Unit

Neches River

Woodville

Jack Gore Baygall and
Neches Bottom Unit

Turkey Creek
Unit

Tony Houseman Blue Elbow Swamp WMA

Village Creek
Corridor Unit

Hickory Creek
Savannah Unit

Silsbee

Lower Neches Corridor Unit

Lower Neches
WMA

Visitor Center
BIG THICKET
NATIONAL PRESERVE

Beaumont Unit

...g Sandy
...reek Unit

Big Sandy Creek
Corridor Unit

Village Creek
State Park

Neches River

*Sabine
Lake*

Menard Creek
Corridor Unit

Lance Rosier Unit

Beaumont

Port Arthur

Little Pine Island-
Pine Island Bayou Corridor Unit

Trinity River

Loblolly Unit

*GULF OF
MEXICO*

LOUISIANA

TEXAS

Sabine River

area of
detail

Map by Molly O'Halloran

RIVERWOODS

RIVER BOOKS

Sponsored by

 THE MEADOWS CENTER
FOR WATER AND THE ENVIRONMENT
TEXAS STATE UNIVERSITY

Andrew Sansom, General Editor

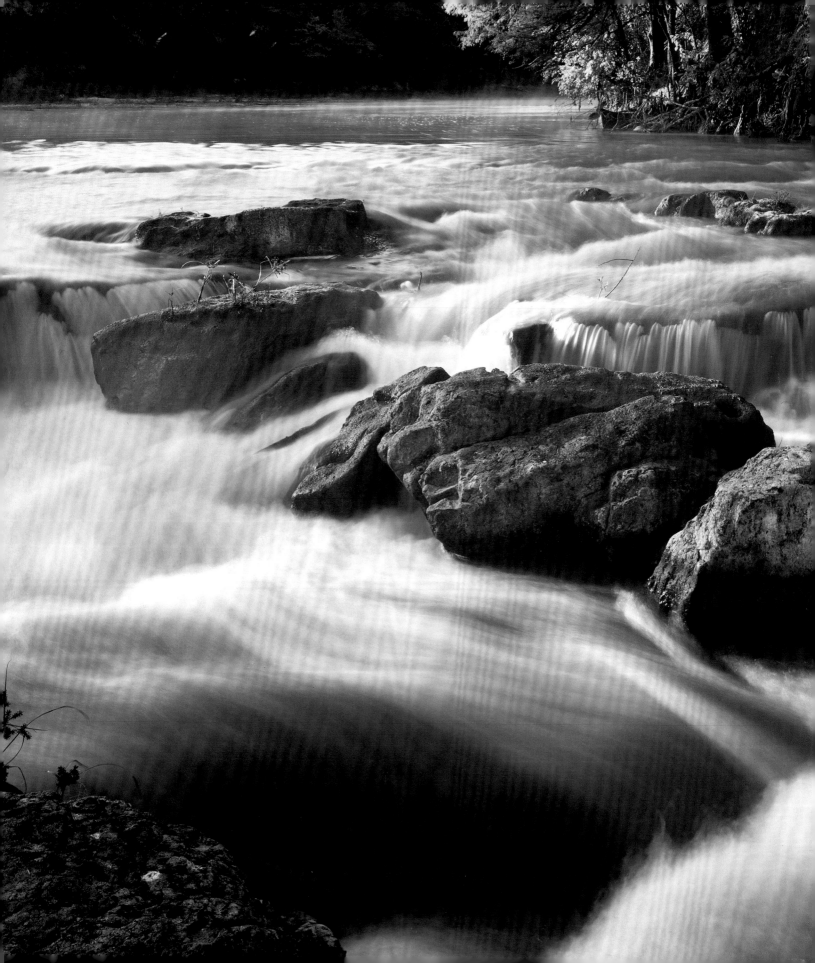

RIVERWOODS

EXPLORING THE WILD NECHES

Charles Kruvand

INTRODUCTION BY
Thad Sitton

FOREWORD BY
Andrew Sansom

TEXAS A&M UNIVERSITY PRESS
COLLEGE STATION

This paper meets the requirements
of ANSI / NISO Z39.48–1992 (Permanence of Paper).
Binding materials have been chosen for durability.
Manufactured in China by Everbest Printing Co.
through FCI Print Group

 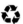

Library of Congress Cataloging-in-Publication Data

Names: Kruvand, Charles, 1956– author, photographer. | Sitton, Thad, 1941–
 writer of introduction. | Sansom, Andrew, writer of foreword.
Title: Riverwoods : exploring the wild Neches / Charles Kruvand ;
 introduction by Thad Sitton ; foreword by Andrew Sansom.
Description: First edition. | College Station : Texas A&M University Press,
 [2018] | Series: River books | Includes bibliographical references and index. |
Identifiers: LCCN 2018013992 (print) | LCCN 2018016601 (ebook) |
 ISBN 9781623496746 (Book/Cloth) | ISBN 9781623496739 |
 ISBN 9781623496739q (book/cloth :qalk. paper)
Subjects: LCSH: Neches River (Tex.)—Description and travel. | Wildlife
 refuges—Texas, East—Description and travel. | Kruvand, Charles,
 1956—Travel—Texas—Neches River. | Neches River (Tex.)—Pictorial
 works. | Wilderness areas—Texas, East—Pictorial works. | LCGFT: Travel writing.
Classification: LCC F392.N35 (ebook) | LCC F392.N35 K78 2018 (print) |
 DDC 976.4/15—dc23
LC record available at https://lccn.loc.gov/2018013992

Maps © 2018 Molly O'Halloran

A list of titles in this series is available at the end of the book.

CONTENTS

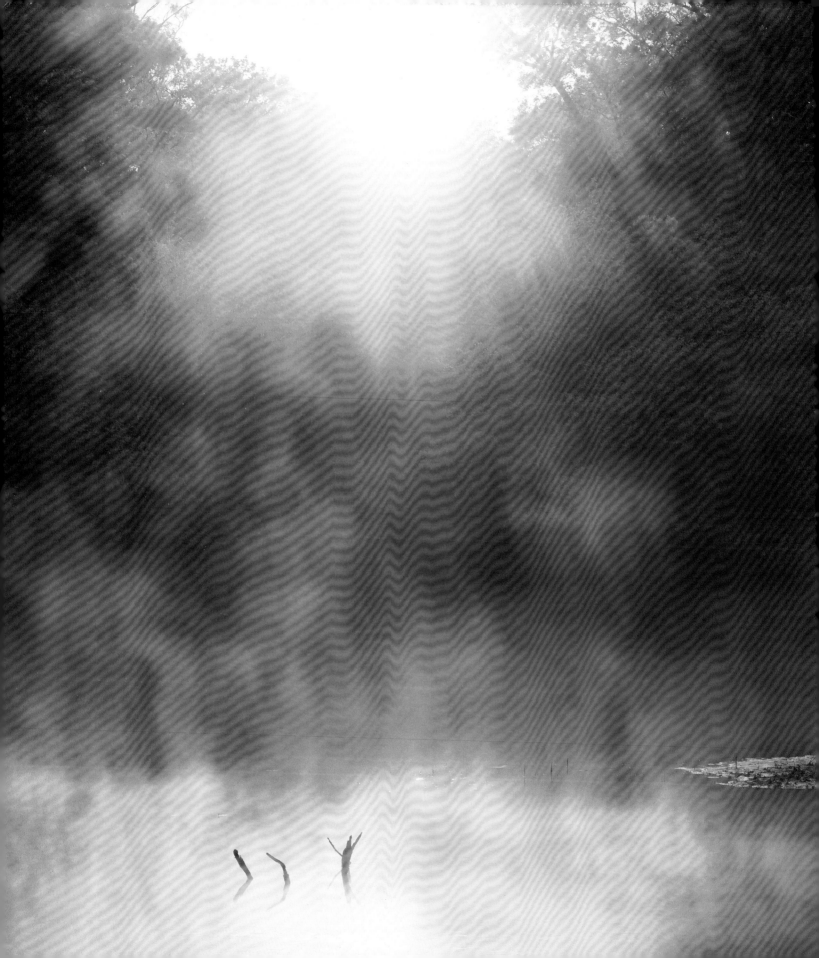

The first time I ever laid eyes on the Neches River was in 1972 while working for the Department of the Interior in Washington, DC. The secretary at the time sent me down there to educate myself on the Big Thicket, the subject of proposed legislation, which would make this unique Texas ecosystem a unit of the National Park Service. Although efforts to bring permanent protection to the Big Thicket had been ongoing since the late 1930s, opposition, mostly from the timber industry had consistently blocked these efforts. Everything changed in the early 1970s when Arthur Temple Jr., a giant of the industry, lent his leadership and support to finally make the dream a reality.

Geraldine Watson and Maxine Johnson, my guides on the first visit, were two remarkable women who had been introduced to me by the late Ned Fritz, an indefatigable advocate for conservation in the region. Geraldine, who has since passed away, was a remarkable daughter of the Big Thicket who, as a self-taught botanist, supplied the background for legions of authors, journalists, and historians writing about the area. Maxine, her partner in crime, has been dubbed "Godmother of the Big Thicket." Maxine's love of the Big Thicket began as a high school student in the 1940s when she wrote a paper on the folklore of the area, launching a lifelong commitment to its preservation that continues even as she approaches her 90th year.

Today, Maxine Johnson and Ellen Temple, daughter-in-law of Arthur Temple Jr., whose support made the Big Thicket National Preserve possible, are focused on efforts to designate the Neches as a Wild and Scenic River. Today, there is only one river with this designation in Texas: the Rio Grande. Again, there is opposition, but I am betting on the two of them.

Several books have contributed to the understanding and subsequent preservation of portions of the Neches. These works include Geraldine Watson's books *Big Thicket Plant Ecology*, now in its third printing, and *Reflections on The Neches*, which inspired me with its haunting images of both the natural and cultural history of this enigmatic but splendid watercourse.

In this latest volume of words and pictures of the Neches River, *Riverwoods: Exploring the Wild Neches*, Charles Kruvand and fellow photographer Adrian Van Dellen have created a remarkable tribute to one of Texas' most enigmatic rivers. Their work follows our earlier editions in the River Books Series, a collaboration of The Meadows Center for Water and the Environment at Texas State University and Texas A&M University Press. *Paddling the Wild Neches* by Richard Donovan and *Neches River User Guide* by his daughter Gina Donovan, Stephen D. Lange, and Adrian F. Van Dellen, surely laid the groundwork for Kruvand's eloquent plea for the need to preserve this unique East Texas river for future generations.

This book would not have been possible without the help of the T.L.L. Temple Foundation that has been a steadfast supporter of conservation in the region. And so, on the shoulders of formidable champions including Arthur Temple Jr., Geraldine Watson, and Ellen Temple's late husband, Arthur "Buddy" Temple III, may Charles Kruvand's moving portrait help make designation of the Neches as a Wild and Scenic River a reality.

—Andrew Sansom
General Editor, River Books

RIVERWOODS

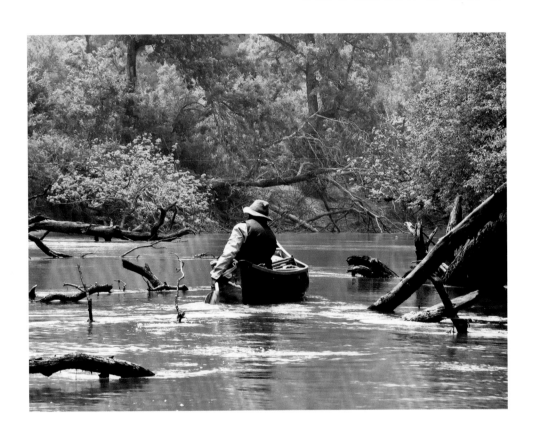

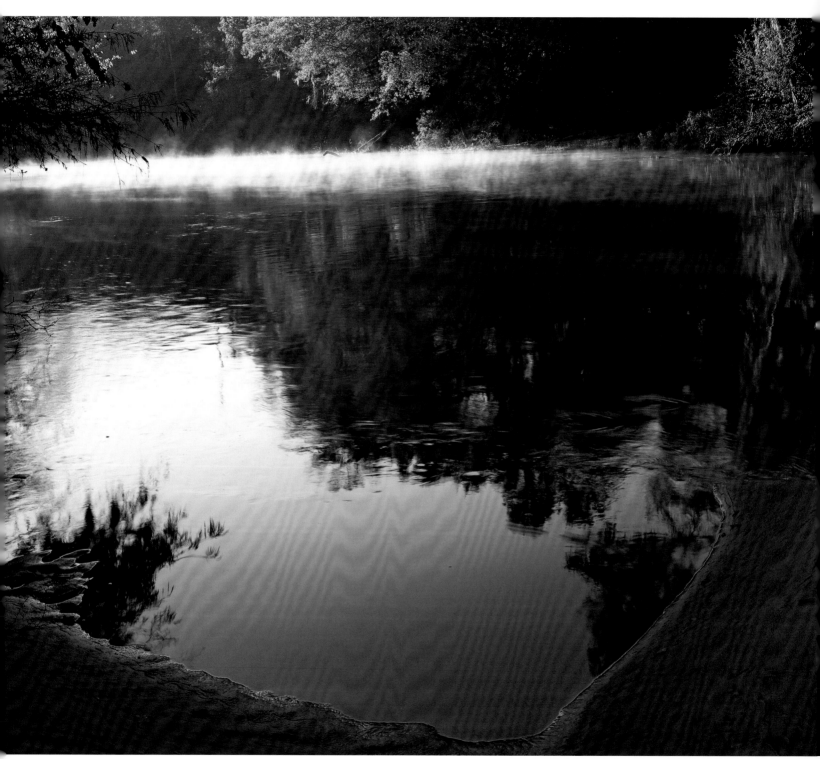

High water on Village Creek, tributary to the lower Neches River

The Riverwoods

Thad Sitton

*Once in his life a man ought to concentrate his mind upon the remembered
earth, I believe. He ought to give himself up to a particular landscape in his
experience, to look at it from as many angles as he can, to wonder about it, to
dwell upon it. He ought to imagine that he touches it with his hands at every
season and listens to the sounds that are made upon it. He ought to imagine
the creatures there and all the faintest motions of the wind. He ought to
recollect the glare of noon and all the colors of the dawn and dusk.*

—N. SCOTT MOMADAY, *The Way to Rainy Mountain*

The Native American writer N. Scott Momaday suggests a return to our
ancient experience of place. Hunter-gatherers' very survival depended on a
keen ecologist's eye for the natural world—and always a *particular* landscape,
a *certain* remembered earth. Nature photographers hone this same challeng-
ing skill set, which requires iron focus, total attentiveness, and a lot of waiting
—all things modern people usually aren't good at. In the Neches bottoms,
physical stoicism and endurance of discomfort also come into play, as mos-
quitoes bite, ticks crawl, sweat rolls down the back, and the snake slides under
your tent. Charles Kruvand had one do that. Charles and his friend Adrian
Van Dellen camped along the Neches in all seasons and for weeks at a time.

I first knew the Neches country in childhood, when experience of place
penetrates to some deeper level of memory. I often went to a hunting club

with my grandfather Ed Cochran to hunt squirrels, sit on deer blinds (or futilely try to "walk up" deer), and to cane-pole fish the summer sloughs. So the feel of this special place never entirely leaves me.

Probably because of this early experience, from 1987 to 1992 I sought out fifty-three elderly East Texans and recorded interviews about their early lives in the Neches valley during the first half of the twentieth century. I intended a scholarly history of people and environment, but for me this effort became like finding a great many grandparents and asking them all the interesting questions that we usually forget to ask close kin and that I had neglected to ask my own.

They told me about hunting, fishing, running hogs and cattle in the bottoms, and all the details of the hardscrabble, backwoods southern lifestyle people practiced along the Neches. They told me a thousand things—for example, how to "ditch a slough" for fish in late summer, position a "deer stake" to protect the family garden, or locate your earmarked hogs in the big woods.

Over time, oral history took me deeper than a casual conversation with an elder. I listened to tapes multiple times, transcribed long sections, took detailed notes, and revisited and studied the notes and transcriptions. Frontier lifeways came down close to the present along the Neches. Two interviewees had participated in the rafting of logs down the river, and most gave detailed information about the southern free-range stock tradition that persisted through the 1960s.

When the federal census taker visited these people and asked what they did for a living, they hardly knew what to say (one man responded, "frog-gigging"). They made money by stock raising, small-scale farming, tie-cutting, part-time timber company work, trapping, fishing, and a variety of other things, some of which would have involved poaching and trespass in modern times but were legal and customary in their day, when the woods were "open" and nobody built perimeter fences. They also hunted, fished, and foraged—from pine knots to possum grapes to hickory nuts—on this bottomland free range, but of course the census taker had no interest in that. Subsistence lifestyles always have been off the radar of a cash-based society.

People also told stories passed down from parents and grandparents, stories reaching back to settlement times in the mid-1800s. "Oral traditional history" recalled details about a wild East Texas frontier of bears at the hog pen,

panthers on the roof, and passenger pigeons darkening the sun. Handwritten jottings accumulated on the margins of fifty-three interview transcriptions, as one interview clarified and illuminated another and things fell into place. By the time I wrote my history of the Neches valley, I felt almost as much at home in their remembered world as in my own.

All book-length projects result from obsessive activity like the above and a great deal of the mind concentration recommended by Momaday. Works about the Neches include, in chronological order, *Texas Riverman* by William Seale (1966), my own *Backwoodsmen* (1995), *Reflections on the Neches* by Geraldine Ellis Watson (2003), *Paddling the Wild Neches* by Richard Donovan (2006), *Neches River User Guide* by Gina Donovan, Stephen D. Lange, and Adrian F. van Dellen (2009), and *Let the River Run Wild* by Francis E. Abernethy and Adrian F. Van Dellen (2013).

What *is* so special about the Neches River? It is a fine example of a largely intact, minimally impounded, southern lowland river system, and so it is a rare survivor of a "riverwoods" (or "overflow bottom") ecosystem once common across the southeastern United States but now down to a couple of million acres. The Neches has taken its hits, but almost everywhere else this kind of hardwood river bottom has been dammed, channelized, leveed, and clear-cut quite out of existence. Soybeans, genetically engineered loblolly pines, and hybrid black bass flourish where once the ivory-billed woodpecker sounded its tin-horn cry.

Accident preserved the Neches, as well as the Congaree River bottoms of central South Carolina, which also specialize in giant hardwoods. In both cases big timber companies came to own most of the land. For a long time they had only minimal and sporadic economic interest in the bottomland hardwoods, and their stewardship of (or benign neglect of) the river valley lasted into conservationist times, when various deals could be struck. Some but not all of the finest hardwood bottoms along these two rivers are now included in the Big Thicket National Preserve and the Congaree River National Park, respectively, both administered by the National Park Service. This is as protected as bottomlands can get (but knock on wood, because large new reservoirs upstream can alter everything).

The Neches runs 416 miles, beginning in a spring creek on a sandy hillside in Van Zandt County and ending in Sabine Lake and the Gulf of Mexico. And if you follow the course of the river on detailed maps, like those in *The*

Roads of Texas, or on topographic maps, you notice one thing special about it. It forms the border of, or flows across, a lot of wild country and public land. That is to say, public lands and conservation easements of various sorts have gravitated to the Neches in an attempt to save it. This includes (moving downriver) the new twenty-five-thousand-acre Neches River National Wildlife Refuge (NWR) still forming from slightly south of Highway 84 to slightly north of US 79, Davy Crockett National Forest, Angelina National Forest, the Big Slough and Upland Island Wilderness Areas located within those two national forests, the Boggy Slough Conservation Area owned by the Conservation Fund above Highway 94 west of Lufkin, two Texas Parks and Wildlife Department (TPWD) wildlife management areas (including Dan Lay's de facto wilderness area at Forks of the River, the Angelina-Neches confluence), one state park (Martin Dies Jr. State Park), and last but not least the eighty-mile stretch of river valley above Beaumont that is part of the Big Thicket National Preserve.

Government ownership of land protects both banks of that eighty miles, sometimes extending far inland, and hardwoods stand tall. The little-known Big Thicket Neches is a national wild and scenic river in all but official terms and is one of the triumphs of Texas conservation.

Conservationists fought to the last activist up and down the Neches to protect and preserve the Neches bottomlands, and many battles were lost but some won. The attempt by Richard Donovan and the Texas Conservation Alliance to establish the Neches as part of the National Wild and Scenic Rivers System is on hold, at least for a while, and even the big conservation wins included losses. In fall of 2016 the photographer Charles Kruvand told me that some landowners were rushing to cut the still privately owned hardwood bottoms formally designated for inclusion—landowner permitting—in the Neches River NWR. "It was good you got to see it," Charles sadly told me, meaning some of the giant riverwoods where he and Adrian had been camping and photographing for two years; perhaps they would never return, since nobody wanted to photograph clear-cuts. Hanging around weeping, wailing, and gnashing your teeth didn't do anybody any good. Better to go and set up camp in the Big Slough Wilderness.

Adrian Van Dellen actually showed up at a logging site in the national wildlife refuge to argue for the preservation of certain giant pin oak trees, but the loggers brushed him off and cut the trees anyway. From their perspective

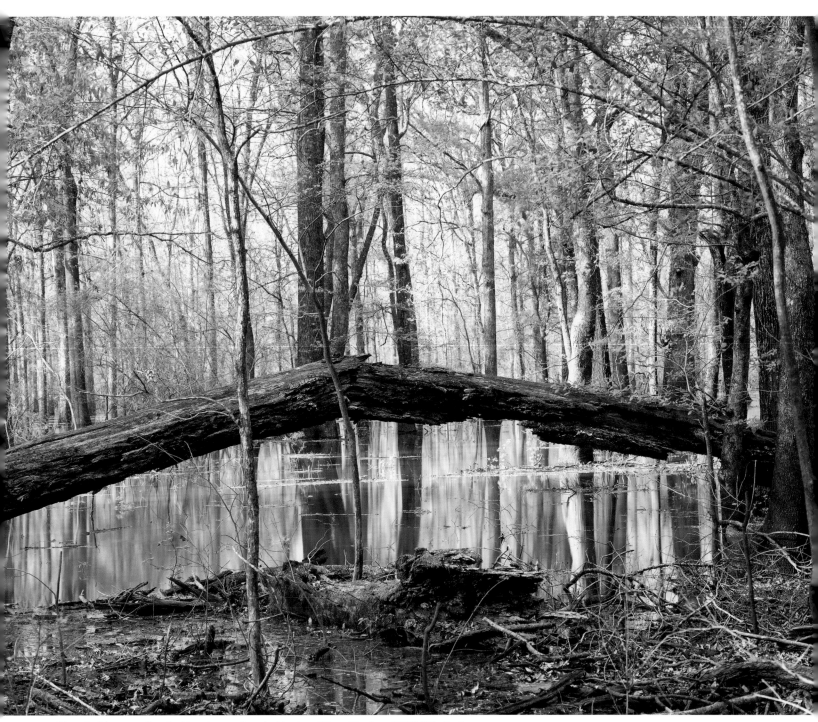

Flooded bottomlands, Hurricane Creek, Neches River National Wildlife Refuge

he was just another crazy environmentalist saying nonsensical things. "All through the years, economics have dominated the forestry decisions and the decisions of landowners who had forest property," the retired TPWD ecologist Dan Lay said in a taped interview in 1992, speaking blunt words from long experience in the environmental wars. Talk was talk, and wildlife was nice, but it almost always came down to the question, How can we make the most money from these woods?

Settlers in the Big Thicket sporadically harvested timber over the years, but from 1950 until the 1980s loggers left hardwood bottoms along the Neches pretty much alone, mainly because it was not cost effective to cut timber there. Some companies during that time proclaimed themselves protective "stewards" of the bottoms. But then, hardwoods—any hardwoods—became desirable as chips for paper pulp, the hardwoods in the company-owned pine uplands ran out, and the stewardship came to an end. With little fanfare, high-quality bottoms along the Neches began to be harvested for paper pulp, and harvested very badly.

Ecologists had long known, and often preached, how to cut bottomland hardwoods so as to preserve and improve the subsequent forest and favor wildlife. You "thinned from below," leaving the best trees to seed the new forest and fill in the gaps, or you cut in small clear-cuts of ten to twenty acres, scattered in undisturbed forest, so the big seeds of the valuable oaks and hickories from the surrounding forest made it into the disturbed ground to join the stumps putting up their shoots. But you rarely see these sorts of small clear-cuts along the Neches and certainly not thinning-from-below cuts. The hardwood specialist Jim Neal told me he had long advocated thinning from below but had seldom actually seen it in Texas woods—at least not on any scale. It remained an ecologist's dream. It wasn't the way to get the most immediate profit from the woods.

The norm in 2016 was big clear-cuts, eighty to one hundred acres or more, perhaps with a token screen of trees left along the riverbank as a streamside management zone (which in Texas is strictly voluntary). These great areas of stumps and devastated ground soon bristled with sprouts of gum, elm, ironwood, hackberry, and other small-seeded, less valuable species that regenerate well from shoots and reseed from afar. Such hardwoods served poorly as saw timber or for wildlife food and shelter, but any hardwoods, any at all, did

just as well for paper pulp. And it made good economic sense to do it this way. And Dan Lay's harsh judgment holds once again.

It didn't take long to make a hundred-acre clear-cut. Sacred groves could vanish in a week. At Eason Lake Hunting Club, a company property long managed for wildlife by one of my interviewees, a crew of thirteen workers cut more than one hundred acres of giant old-growth hardwood in very little time. The crew used huge machines but had only a few men. An enormous shearer machine, three Caterpillar skidders, a loader, four trucks, and a four-person limbing and topping crew did the job. Only the last worked on foot. (Operations with better road access often maneuvered big chipping machines right to the bottoms and chipped hardwood into special trucks.)

But occasionally, as before, individuals with power or money stepped in to try to save their parts of the Neches. Late in 2013, the T. L. L. Temple Foundation, nonprofit arm of the former Southern Pine (then Temple-Eastex, then Temple-Inland) Lumber Company announced a complicated deal with the International Paper Company and the nonprofit Conservation Fund. At the end, the Conservation Fund received a conservation easement donation from the Temple Foundation of nineteen thousand acres of the former North Boggy and South Boggy Hunting Clubs, which Southern Pine had owned. These nineteen thousand acres included eighteen miles of Neches River frontage and forty-five hundred acres of hardwood bottoms left virtually untouched for decades—some of the best and oldest hardwood in East Texas.

Arthur "Buddy" Temple, chair of the Temple Foundation and heir of the Southern Pine empire, engineered this complicated deal at the time that Temple-Inland sold out to International Paper. Buddy had grown up roaming anywhere he wanted on the wonderful bottoms of Boggy Slough. He never forgot that, and at the end of his life he did what he could to save them. The joint news release about the deal described Boggy Slough as an important part of linked lands—a "conservation corridor" of lands—along the river that included the Neches River Wildlife Refuge, Davy Crockett National Forest, Angelina National Forest, and the Big Thicket National Preserve.

The Neches and Congaree bottoms exemplify a fecund and exotic ecosystem that has almost passed out of existence before scientists have had a chance to describe it properly. They are overflow bottoms or, as I say in my own neologism, "riverwoods." In such places the river and the associated

bottomland forest are one entity; the trees go into the river and the river into the trees. In dry periods the river declines into the channel in which it flows, a channel lined and obstructed by dead timber felled from undercut banks. Then, at high water, once or twice or several times a year, the river submerges these dead things and pulses back across the river valley to fertilize the living hardwoods with new sediments. Cat squirrels then play in the trees while catfish forage below, and the forest floor becomes—perhaps for months at a time—an extension of the bottom of the river.

What you think about the riverwoods depends on what part of the year you see it. Twenty years ago a friend from my high school class in Lufkin learned that I was working on a book about the Neches, and he admitted that he hardly knew what it was. "Neches?" he said. "You mean that muddy ditch under the bridge out at Highway 7?"

That's what the Neches was for a lot of people—*if* you view it in late summer and don't get off the highway. If you get off the highway and drift away downstream it can be like entering another world. Just down from the bridge on Highway 7 a giant alligator gar people called Felix lived for many years. Locals often saw Felix lounging just below the surface in the way of gator gars, and they sometimes shot at him, but he went on about his business. He was sort of the spirit of the place, and for a long time he shrugged off the occasional rifle bullet. Lots of stories come from up and down the muddy ditch.

At low-water time, late summer or early fall, the upper Neches looks unimpressive. Steamboats on it are something you can't even imagine (though they once ran there). When the New Yorker Frederick Law Olmsted crossed the Neches during the fall of 1853, he found it only "three rods in width," or about fifty feet, and remarked that "like all the eastern rivers of Texas it is thick with mud." But when he recrossed the Neches farther downstream and a few months later, he had to cope with a mile-wide torrent flowing bluff to bluff across a timbered river valley. It took Olmsted two tries and two days to get his party across this late-winter "Mississippi" version of the Neches, and on the first attempt he almost drowned. Perhaps influenced by this experience or the high fees of the "pilot" who finally guided his party across the river bottom, Olmsted wrote, "Probably a more reckless and vicious crew was seldom gathered than that which peopled some parts of Eastern Texas

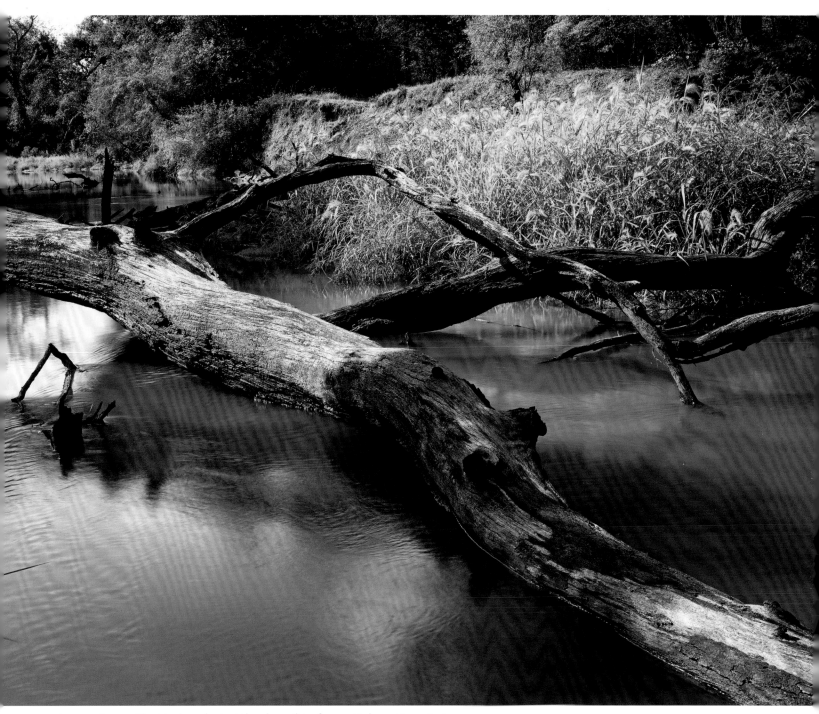

Low water on the Neches during the drought of 2011, Hobson Crossing

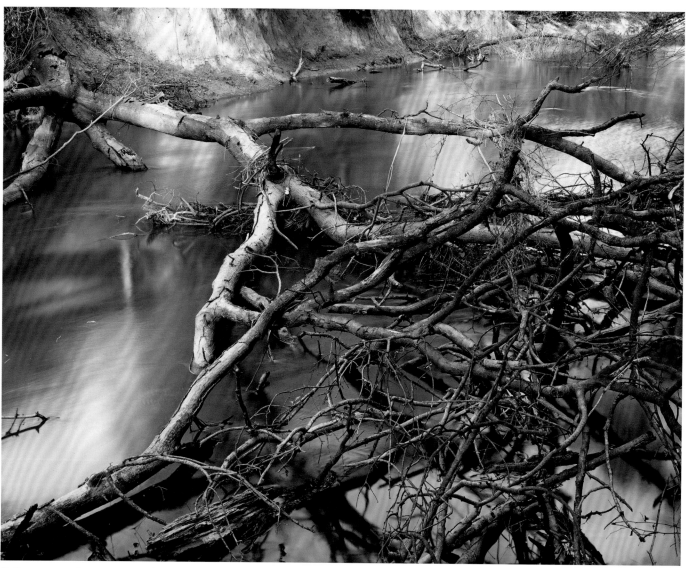

Fallen tree at low water, Hobson Crossing

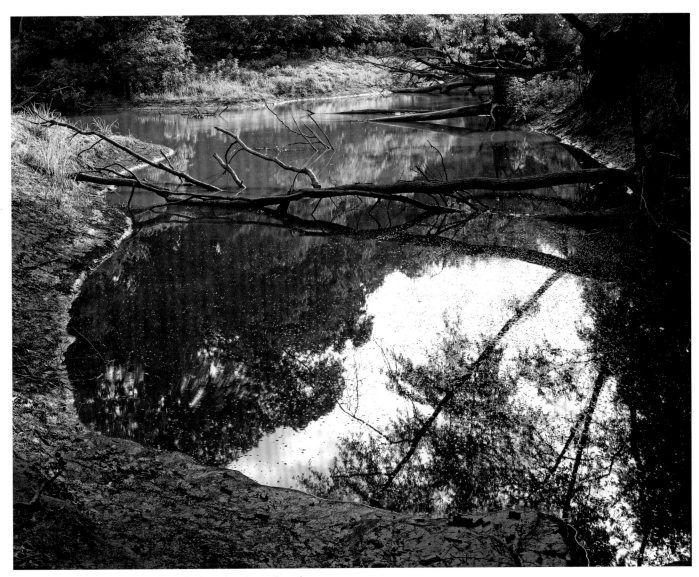

Low water, Chinquapin Ridge, during the drought of 2011

at the time of its first resistance to the Mexican government." Nor had all of them disappeared by my lifetime.

After a long absence I returned to the Highway 7 bridge in October 2011, at the dead-dog bitter end of the worst summer in Texas history, and when I waded in ankle deep to get into my small canoe at first light, the Neches felt as warm as blood. There had been more than ninety days when temperatures exceeded 100 degrees that summer, and the river did look like a muddy ditch. I paddled slowly upstream against an almost undetectable current—occasionally sliding over visible logs or sideswiping unseen ones in the turbid water. In most places water didn't flow enough to reveal what lay beneath it.

From time to time I got longer views upstream, and the Neches looked like an elephant graveyard, a place where giant hardwood trees had come to die. There were logjams and logs entirely across the river, but the water was so low I paddled under many of these. The usual late summer feel of doom and death hung over the river, a feeling made more intense by this terrible year, and I knew that in drying slough pools cut off from the river the toughest fish were making their last stands in oxygen-depleted water. Gar and grinnel (bowfin) lasted longest because they could gulp air, but in the end only bigger fish survived and finally only a handful, usually gar, were left, and then there were none. The diehards gave up or else feral hogs waded in to finish them off, all pretty much business as usual on the phasedown of the yearly cycle for the riverwoods.

But tomorrow was another day. I go out in these yearly low-water times to see the pulse cycle of the river at lowest ebb. It seems to me like the winter solstice of the Neches, when the riverwoods have turned toward death and oblivion as far as they can go and hang poised before the first one-inch rise back toward life and high water. Which always comes; in two months the Neches flowed twelve feet above where I paddled on this trip, with gar frolicking in the eddies.

In 1956 I had walked on the bottom of the river for a couple of miles at our club across from Pine Island. Actually, this was Old River, a "cutoff" or lengthy side channel of the main Neches. It still flowed—a very little—on the west side of the big island. But back then I knew it as the river, and it was dry—even the last gar death pools had dried up. But only three or four months later the great drought of the 1950s broke, and the Neches rose from the dead.

In spring of 1957 my grandfather and I waded in to the Criss-Cross clubhouse, to measure the present flood against the old floodwater mark left on a side building from 1934 and also just to see if we could make it. Flowing water, fresh and clear as strong tea, covered the club road through the hardwood bottom, and we put our feet down very carefully, since bar pits lined the road on each side. It was a foolish excursion for a boy of sixteen, let alone a mature man in his sixties who perhaps couldn't swim, but one of the nice things about Ed Cochran was that he could behave like a teenager.

At some point during most of my interviews, the old river people told stories of floods and high water. They respected the Neches and to a degree feared and dreaded it in flood. Most families ran hogs and cattle on the open range, which was not "range" but big woods at this place. Livestock went where it wanted, scavenging like wild animals in this backwoods-southern style of stock raising. In fall of the year cattle usually moved from pine uplands to bottoms in search of switch cane and the hogs in search of oak mast. This set up a sort of river trap for stock after the rains came in late fall and early winter and the river quickly rose, and stockmen saddled the rare and valuable horses that tolerated wading and swimming in the backwater to try to get them out. Rarely, the stockmen lost their lives from hypothermia or drowning. Mostly they returned from the cold river water "just as blue as a guinea egg," as the saying went.

But things could get worse. The Ramer family of the Big Thicket part of the Neches told the naturalist Geraldine Watson what had happened to them in the flood of 1884, the flood of record. The Ramers had settled on a high sand hummock in the wide bottom below Sheffield's Ferry, where they built a log house and raised a crop of corn, sugarcane, and garden vegetables. They had chosen this spot after a careful search for signs of recent flooding, as any prudent southern pioneers in the bottoms would have done, and it looked okay. In the fall their crops matured, and they anticipated a good harvest.

They had no warning, and there wasn't a cloud in the sky when the river began to rise—and kept rising—and in less than a day had covered their 125-acre hummock except several acres on the north end, where Bill Ramer had his house. All exits from the hummock being under water, the river still rising, the Ramers tore down their one-room log house and made it into a raft, on which they successfully poled their way to safety at the edge of the back-

water. (Later, maybe hungry or in the country spirit of waste not, want not, they returned to dive and dabble in their flooded garden for turnips, onions, and other surviving root crops, but they didn't rebuild on the place still known as Ramer's Island.)

Record floods seldom happen, but for twenty thousand years the Neches has risen in the late winter or early spring to claim the ancient valley where it flows. In October or November the autumn rains begin. Slowly at first, then more rapidly, the current quickens, the water level rises within the banks, and then at scour channels and sloughs the river breaks out to flood the bottoms. Creeks reach the river in sloughs, which now reverse flow to become distributary channels for river water. The river flushes out and refills the backswamps, oxbow lakes, and overflow channels deserted a few months before. It begins a slow tour of the old river courses and—with sharper and more purposeful current—resumes cutting away the banks of new courses.

At high water you see what the river is up to—where it's going and what it's leaving behind. You see that a big black gum on the edge of the cut bank is undercut and doomed and probably will crash into the river in the first spring thunderstorm, and on certain extreme bends you notice how water courses through the woods to shortcut the channel. If you reach the apex of the bend in very little current, you can bet that the river is on the way toward leaving that bend behind as an oxbow lake, as the river shortens the course in which it flows. In certain sandy stretches of the Neches, where banks are made of lighter soils, you sometimes actually *see* things happening at high water—undercut trees toppling in, banks slumping and sliding, cut channels deepening as you watch.

As the water rises and current speed doubles, the power of the river to transport materials downstream drastically increases. With awesome force it slams into cut banks at sharp bends, collapsing the banks and carrying the loosed materials downstream. At these especially turbulent places, corkscrewing vertical eddies scour the river bottom into deep pits. Larger and larger sand and gravel particles are carried by the current, and even heavier materials bounce and roll downstream along the bottom. At the surface, fallen trees accumulate into drifts, thrashed by the current. In the narrow upper river, they now may block your way downstream. You find that the open river of yesterday has a giant green and leafy pin oak across it, with current ripping through the branches (a "strainer," canoeists call this dangerous

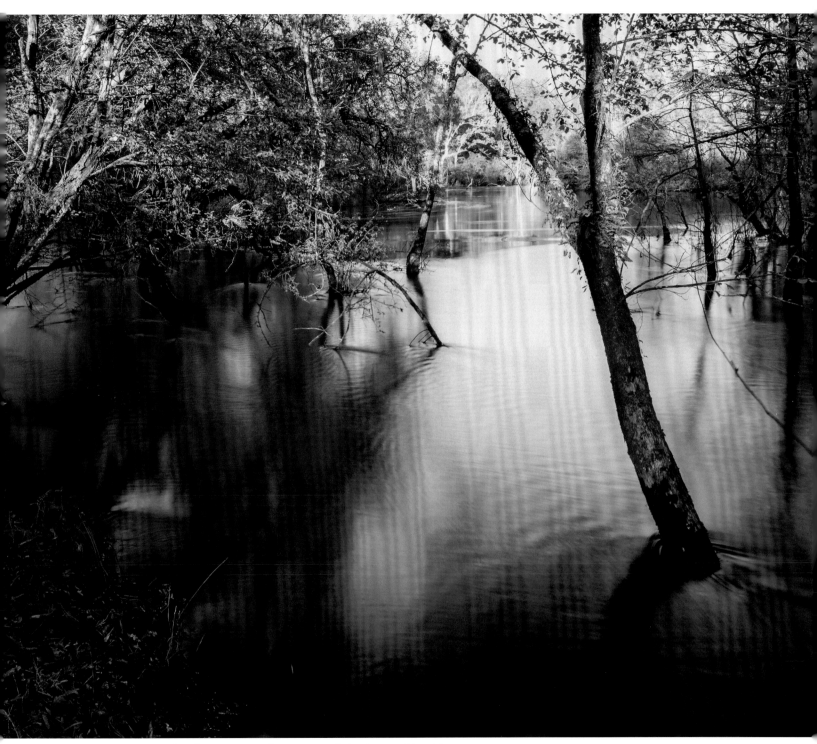

The Neches at flood stage, near the proposed site for Rockland Dam

circumstance). Scour channels cutting across the necks of meander bends deepen in a matter of hours, as the river moves to adjust course.

Along the straight stretches, the Neches slides by in silence, moving at a fast jogging speed. It goes most swiftly at the center, where water literally flows on water with little friction from bottom or bank. For whatever complex hydraulic reasons, a line of floating drift accumulates at the surface of the speed lane. Mesmerized, the canoeist often seeks out this flow. Here, in midstream, as a physical sign of speed and power, the surface of the water bulges upward ever so slightly in a convex curve.

I must admit I've never seen the current bulge on the Neches, although I imagine that if I submerged myself to eyeball level close to one bank I might see it. Physics and hydraulics require it to be there. Once, on the Mississippi near Cape Girardeau, Missouri, I looked across the swift half-mile-wide current from a perspective of a low-riding kayak and saw a fellow paddler seemingly armpit down in the Father of Waters. He wasn't down at the horizon like a distant ship at sea; he was on the other side of the great bulge of current, which at this point looked to be a good two feet.

Ruled by the power of the river, the valley through which it flows exists in a state of constant change. The river shifts course even within the finite span of a human lifetime. The small steamboats that once ran on the Neches up to Shooks Bluff in Cherokee County often piloted courses now on dry land. Over hundreds of years the river constantly moves back and forth in great loops across the shallow trough of the river valley, occasionally eroding the valley sides. The meanders of the ever-shifting river march downstream, like the loops of a shaken garden hose. The meander loops have a certain size and spacing—an amplitude and wavelength—determined by the average width of the river at any given point.

Meanwhile, as the river meanders back and forth, the whole substance of the river valley flows toward the Gulf of Mexico. Whatever particle of sand the river drops today at an accumulating point bar to become part of the forest floor under great oaks and gums will be picked up again by the river a hundred years or a thousand years hence and taken away. The constituent elements that make up a giant black gum are only in temporary residence. In time the tree will fall and decay, and the river will return to move these elements farther downstream.

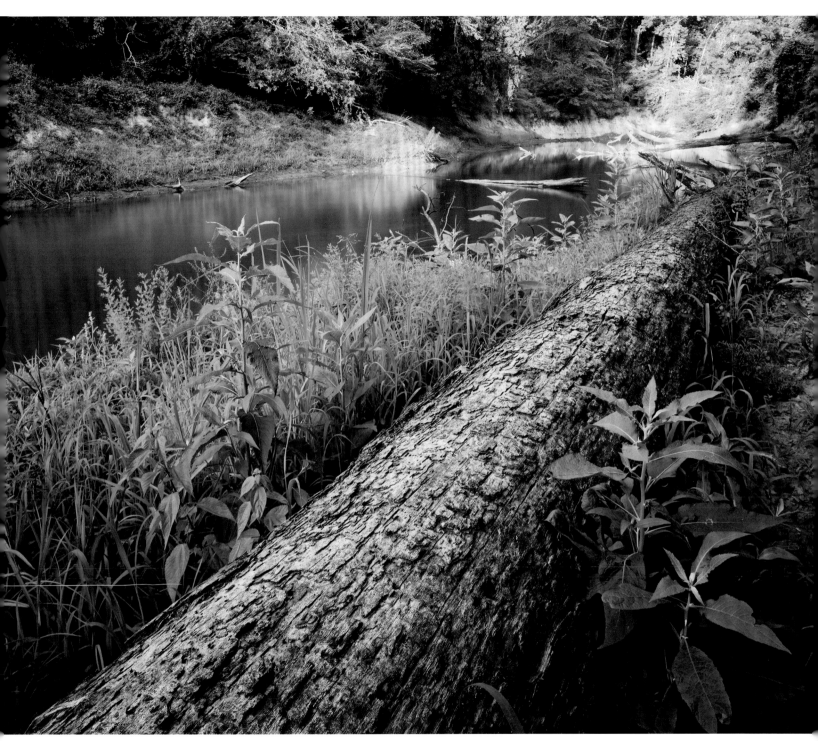

Flood-tossed tree on the bank, Boggy Slough

The Neches is both creator and destroyer of the bottomland universe, and at the apex of every meander bend both forces can be seen in action. On the cut-bank side, the outside of the bend, a mature forest of oaks, gums, and other hardwoods topples in as the river undercuts the bank. At the same time, on the inside of the bend, a point bar builds up from sediments washed down from cut banks destroyed farther upstream. Soon, black willow and river birch colonize this new ground. Across every sharp bend, a world coming into being faces a world coming to an end.

At any location along the river, the processes of erosion and deposition creating the immediate riverside landscape of meanders, point bars, cutoffs, natural levees, and backswamps reveal themselves. Farther away from the river, however, things get complicated. The river has visited every place in the valley not once but many times, often leaving remnants from one visit superimposed on remnants from earlier ones. Sometimes deep oxbow lakes created ten years ago lie beside marshy oxbows of two centuries before. Low ridges left by former natural levees, ghosts from old river courses, wind across the wooded bottom in every direction. (Natural levees form at the edge of the channel, where the current loses speed and drops sediment.)

At certain places where the river currently runs far to one side of the shallow valley, a maze of overflow channels parallels the course of the river. (For an extreme example, examine the Franklin Lake map from the US Geological Survey.) Are these old river channels in the process of abandonment or new channels into which the river is preparing to flow? It's often hard to tell, although at Franklin Lake the Neches clearly has been shifting westward, channel by channel. Certainly, the Neches has drastically altered course many times in the past, sometimes moving miles from one side of the river valley to the other in a relatively short time. This likely happened at the Old River and New River channels around Pine Island, as well as other places called "old," "new," or "cutoff." The Mississippi is well known for adventuring new courses forty miles away from the old ones, as it did in the Great Flood of 1927, and the Neches does the same thing in scale.

All life along the Neches, plant and animal, responds to the ebb and flow of the yearly river floods, which coursed across the bottoms no fewer than five times in 2016. To the casual eye, the river bottom appears basically flat, but slight elevation changes left by the ancient travels of the river back and

forth across the valley floor have major consequences for bottomland vegetation. Three inches is a life-or-death distance for plants evolved to tolerate just so much inundation of their roots. The vegetation reacts sensitively to the duration and frequency of river floods, and the slightest rise and drop along the floodplain floor creates very different combinations of dominant trees and other plants.

Buried deep beneath the surface of the river in times of flood, black willows and river birch colonize the developing point bars on the edge of the river. Cypress and gum stand in the edges of sloughs and oxbows. Sycamore, willow, and water hickory grow on the sandy bank above the normal water level. Higher up still are linden, black walnut, cherrybark oak, pin oak, sweetgum, and ash, and above them the giant loblollies stand on bottomland ridges where the floods infrequently reach. Finally, where the land slopes up at the edge of the valley, there grow shagbark hickory, pecan hickory (pecan), southern magnolia, dogwood, and other plants that don't like to have wet feet.

So rich are river-distributed sediments and so fast the process of soil building in the riverwoods that some species—especially the several kinds of oaks—take themselves to the absolute limits of water toleration. They adapt with wide shallow root wads to stay above the water table, buttressed trunks to resist toppling, and unusual surface root structures that remind botanists of cypress knees. These same kinds of oaks and other trees may grow in a quite normal way thirty yards upslope.

The result of the river floods and the sensitivity of plant species to elevation is a large diversity of plants existing side by side, and the biologist Bob Parvin has noted an extreme case. At the Forks of the River bottoms just above the confluence of the Neches with the Angelina River, the major Neches tributary, botanists distinguished 24 distinct community types, made up of different combinations of species from 189 kinds of trees and shrubs, more than 800 herbaceous plants, 42 woody vines, and 75 grasses.

This complexity of plants is vertical as well as horizontal across the surface of the land. The climax-growth bottomland forests along the Neches—the best of the best—exhibit what botanists refer to as "forest layering." As William Bray observed in 1906, at the top of the forest "are the masterful, dominant species like the white and the red oaks, hickories, ash, walnut, gums, magnolia, and the loblolly pine, which demand the best illumination

and so overtop the others." Bray noted that while any forest will have three layers—the tallest trees, the understory trees, and the ground vegetation—climax forests along the Neches have five or six layers, somewhat resembling tropical rainforests.

Two factors determine what grows where in this complicated riverwoods: the duration of water flooding across the land and the degree of sunlight reaching through successive layers of the canopy. "Now all these plants are, in a sense, messmates at a common table," Bray wrote. "They share the soil space and the air space together, and the sunlight, each according to its needs."

The diversity of plants in the riverwoods supports a corresponding diversity of wildlife, and here the public conception of bottomlands as swampy, muddy, snake- and tick-ridden no-go zones stands in greatest contrast to what biologists think. They see riverwoods as the rarest, richest, most abused, and most valuable ecosystems in North America—as biological treasure troves, animal refuges, and nurseries of life, which desperately need protection.

Not that biologists write very much about them, however. Little has been published about river bottomlands, and the nine-hundred-page *Norton Anthology of Nature Writing* offers nothing on the subject. Apparently, the popular bogs-and-snakes idea triumphed, and reservoirs proved far more desirable than riverwoods. Reservoirs destroy bottomlands in two ways: they inundate them and they alter their ecology for long distances downstream by withholding life-giving floods. Then, of course, pine trees expand downhill and people rush in to develop. Naturalists writing for the Norton anthology wax poetic about and celebrate mountains, deserts, seashores, lakes, and most other landscapes in North America, but not about overflow bottoms. Nor has a single scientist or writer of popular nonfiction done justice to the fecund riverwoods, where fish the size of hogs come and go in flood time around the trunks of giant trees and where until recently the passenger pigeon roosted (and devoured acorns) and the ivory-bill sang its song.

Woodpeckers like the lost ivory-bill, incidentally, relish river bottoms and are, along with other unexpected living things—vines and salamanders, for example—almost the signature creatures of the place. There are a lot of dead trees and dead branches here, and a lot of grubs for woodpeckers to eat. Biologists find that the biomass of salamanders and other amphibians usually outweighs the biomass of the much more visible birds at such places. And

botanists marvel at the number of vine species that grow there, flourishing at the edge of the river and in the small clearings in the forest where a big tree went down. Old riverwoods have old vines. I've seen muscadine grapevines as thick as my calf soaring straight up from forest floor to canopy, presumably having grown into the sky around some tree now vanished without a trace.

The "detritus food chain" woodpeckers take part in is only one of the major food webs of the riverwoods, joining the insect, mast, and backwater food chains—the riverwoods are a complicated place of eaters and eaten. As noted before, the bottomland hardwood forest contains a great variety of trees, shrubs, and vines, often growing close together and differing from each other in height, branch pattern, fruit, foliage thickness, and shade tolerance. Since these produce fruit or nuts at different times of year and send out leaves and buds on different schedules, food and cover are available to wildlife year round. Insects survive the winter in the shelter of trees and vines that keep their leaves all year, and they provide nourishment for flocks of over-wintering, insect-eating birds. Wild fruits like grapes, mayhaws, mulberries, highbush blueberries, pawpaws, and scores of others ripen at different times in the spring, summer, and fall, and a prodigious autumn mast drops from the thirteen species of oaks, seven species of hickories, and other nut-bearing trees that dominate the bottoms.

Along with the many food sources, varying with season and the pulse of water back and forth across the bottom, bottomland hardwoods offer shelter to wildlife in the form of cavities in the wood of standing or fallen trees. Few hollows occur naturally in the upland pines, but among hardwoods the broken-off branches, fire scars, insect invasions, or other injuries provide an opportunity for fungus to enter and develop a cavity, and the hardness of the wood means that the cavity may last a long time, harboring many generations of wildlife. Wood ducks, screech owls, flying squirrels, raccoons, opossums, and gray squirrels occupy high cavities in standing timber. Mink, otter, and (once upon a time) bear used hollow downed logs and butt rot cavities in tree trunks for shelter and winter den sites.

The availability of food and of den or nesting sites explains why the bottoms support several times the populations of birds and other animals found in nearby mixed pine and hardwood forests. And as the ecologist Larry Harris has noted, the return of the yearly river floods made the fallen mast available

to other species and set off a new chain of life in the shallows of the flooded forest. Harris wrote in 1984,

> Winter floods cover much of the mast [nuts and fruits] with water, making it available to millions of dabbling ducks, those that feed in shallow water. On slightly higher ground, deer, squirrels, wild hog and turkeys rely on mast for food. The presence of nuts and fruits from many different plants means that a reliable food source is generally available throughout the year and at different levels of the forest, from bottom to top. . . . Seasonal flooding produces shallow, warm water areas where many kinds of water life spawn and feed on the submerged mast and other dead matter. Flooded bottomlands are nurseries for many valuable fish. Small invertebrates, snails and crayfish become food for still larger animals like frogs, fish, young wood ducks and wading birds. Some of these provide food for still larger creatures like otter, mink, herons, egrets and many other water and land animals. In this manner, the richness and high productivity of the forest translates into a comparable richness of wildlife.

That rich ecosystem was once richer. Like the ecologist Dan Lay, I've been haunted by the Neches of two centuries ago, when huge trees and giant canebrakes flourished, black bears lurked in the cane, panthers screamed, ivory-bills bugled, red wolves howled, whitetail deer went around in herds of hundreds, and wild pigeons came over in such multitudes that settlers lit lamps in daytime.

At first settlement, creeks and sloughs harbored big fish, and pioneers casually took them with spears, plant poisons, or just by muddying the water. (I found people who still recalled all the old folk methods.) The early Neches so swarmed with fish that men shot them at riffles in low water. Buffalo fish spawning in spring backwaters sounded like herds of stock thrashing around, and wading men and boys stalked them with clubs.

For decades Dan accumulated archival bits and pieces about the ecology of primal East Texas, and with coauthor Joe Truett he used them to write *Land of Bears and Honey*. Then, after several years, Dan ditched his precious accumulation of notes as no longer useful to anyone—a few days before I showed up for my first interview. He sadly told me about his housecleaning. I thought

briefly of rushing to the Nacogdoches County landfill but soon cursed my bad luck and turned on the tape recorder.

Two centuries ago, as Dan told me, groups of buffalo often grazed the small prairies and openings along the edges of the Neches valley, and cougars, bobcats, gray fox, bears, red wolves, and an occasional solitary jaguar or ocelot prowled the forests. Depending on the season of the year and the availability of food, the valley sheltered deer, turkeys, wild hogs, and black bears, which moved from river bottoms to pine uplands and back again. Bears loved the dense switch-cane thickets of the deep bottoms, using them for food and cover for many centuries before settlers' cattle began to eradicate the cane. Besides the many kinds of river fish, creatures of the bottoms included the gray squirrel, otter, beaver, mink, heron, various types of duck, and other water birds. The green-and-purple wood duck dabbled (and still dabbles) in the fall backwaters for acorns, beechnuts, and the fruits of the black gum, and the red-shouldered hawk cruised the riverwoods by day and the barred owl, by night.

Bears, ivory-bills, jaguars, ocelots, and passenger pigeons are all long gone, though ivory-bills still exist in Cuba, and the East Texas panther (also known as cougar, mountain lion, puma, and deer tiger), once thought gone for good, seems to be dispersing in from the west in small, secretive, and almost invisible numbers. "Ghost cat" is another name for it, but there have been accidental sightings in broad daylight in the Neches riverwoods by sober persons, known and respected by wildlife biologists. Specimens have also occasionally been ambushed by deer hunters or struck by cars. It's hard to argue away a dead one, and since about 1991 TPWD has admitted the puma does exist in East Texas.

Pumas evolved to be "deer tigers," but the newcomers probably make a living on the same abundant food source currently sustaining the endangered subspecies known as the Florida panther. Those wild cats are preying on feral hogs, and everybody who loves the Neches bottoms says *bon appetit* to that. The wily and adaptable swine—the domestic hog gone wild and run amok—devours everything, from bird eggs to baby deer.

Researchers from Rice University once fenced off test plots in the Big Thicket National Preserve to prevent hog rootings and foragings, and over three years they carefully observed the differences in plant generation between those plots and other nearby test plots marked but not hog fenced. Huge differ-

ences emerged. Hickory shoots, oak saplings, and a sort of East Texas Garden of Eden soon flourished in the area where the feral hogs could not go.

The riverwoods must have felt different to early settlers when they had a lot of bears and panthers in them. These formidable predators sometimes overmatched settlers' nineteenth-century single-shot weaponry and closed for revenge. As in the case of the hunter Ben Lily on the cover of my book *Backwoodsmen*, most hunters carried a knife as big as a short sword to counter bear claws and jaws in hand-to-paw combat. You probably didn't want that to happen, but you knew it might. Frontiersmen called this weapon a "hack knife" or "bear knife" before naming it for James Bowie. (Some people who hunt the feral hog in southern woods resurrected the big knife for the original reason, and something called a "boar spear" now sells at Walmart. Medieval hunters in the north of Europe used a weapon exactly like it.)

Coyotes began arriving in the Neches riverwoods a half century ago, and when the barred owls hoot and chortle and gobble at night, they now sometimes hear these canines respond. In a way, coyotes have been here before, in the form of the vanished red wolf, which genetic analysis shows as more of a coyote hybrid than a pure wolf. All is not doom, gloom, and clear-cuts when you can hear owls hoot and coyotes howl (or, as I did at age eleven, watch a huge black boar walk by me in a pin oak flat). As the camping photographers attest, other strange sounds still come out of the deep bottoms along the Neches in the middle of the night, some readily identifiable and some not.

Many animal species live in the Neches bottoms throughout the year, while others use them as a seasonal resource and refuge—a function that has greatly increased across time, what with human development and disruption of the uplands. Migrating birds rely on bottomlands for shelter and refueling, and as lumber companies eliminate mast-bearing hardwoods from the uplands outside the river valley, many more birds and mammals depend on the bottoms for food and shelter. Den trees rarely survive in the managed woodlands.

From voles to wild hogs, animals migrate in and out of the bottoms, and they and other mammals also use them as a travel corridor. The riverwoods may be relatively narrow, but this type of environment stretches upriver and down for many miles. Dispersing adolescent pumas pad the bottomland trail. The bottoms serve also as a safe haven from increasing changes in the upland landscape and from woods fires, also mostly human caused. Many ancient creatures take refuge here—turtles, amphibians, reptiles, and primitive, air-

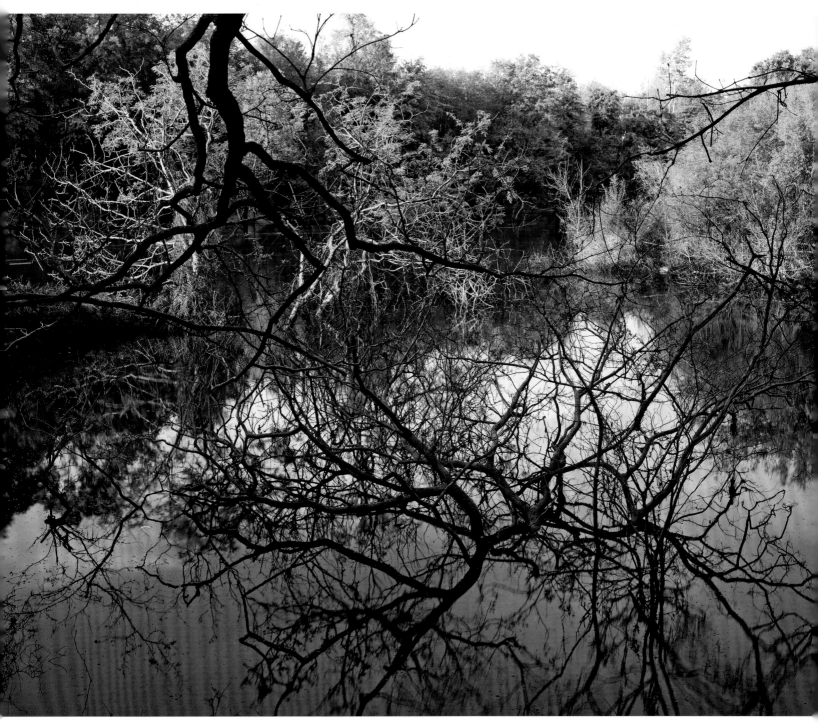

Dead vegetation from a receding flood, near the proposed site for Rockland Dam

gulping fish like the gars and bowfins. It is a place of last resort, of biological last stands.

Much of the refuge function of riverwoods is so ancient that it is wired into the genetic systems of living things, who depend on it in ways hard to change. Their life rhythms step to the pulse of river floods. Gars and buffalo fish wait for the annual floods and then move out over the bottoms to spawn, and songbirds migrating north across the Gulf of Mexico at about the same time keep flying over coastal regions until the hardwood bottoms come into view. Only then do they land.

Evolution programmed catfish to go foraging in the woods, and the first night after the rising river floods the bottoms, they move in, gobbling a myriad of small terrestrial things caught in the rising water. (People then take them with "tight lines," which are trotlines stretched taut from tree to tree, set right on the surface of the water.)

The riverwoods are a place of many foods and shelters for many kinds of life, but the periodic inundations of the bottoms tend to restrict humans to their old role of occasional visitor. As global warming and the "Anthropocene" increase their effects, the riverwoods function more and more as refuges from us. (But for us also—the ones who wish to take a break from suburbs and smartphones.)

I use only foolish phones, but I rarely take one of them on canoe trips down the Neches. Since the years when I hunted squirrels in pin oak bottoms, crawled up on ducks in river eddies, and fished with a cane pole in backwater pools with Ed Cochran, I mostly experience the riverwoods in this way. I like to go on the Neches at high water, when the river takes charge of the whole bottom, bluff to bluff, and canoeing feels like joining a big parade somewhere to the end of the world. I paddle down the strange ribbon of central current marked by the line of drift, the "fast lane" that becomes better marked with debris and drift as the river rises. At such times the water surface is so full of complex movement that it is confusing to look at it. At sharp bends in high water, the Neches goes insane in a complexity of current and countercurrent, back eddies and swirls, and only at the downstream end of the bend does the water begin to get in line and move on. All this is done rather gently, however, since the Neches has a low gradient and is a polite and canoe-friendly river.

I often look into the flooded riverwoods on each side of the river, but I only occasionally go out there and then only with many cautious glances over my

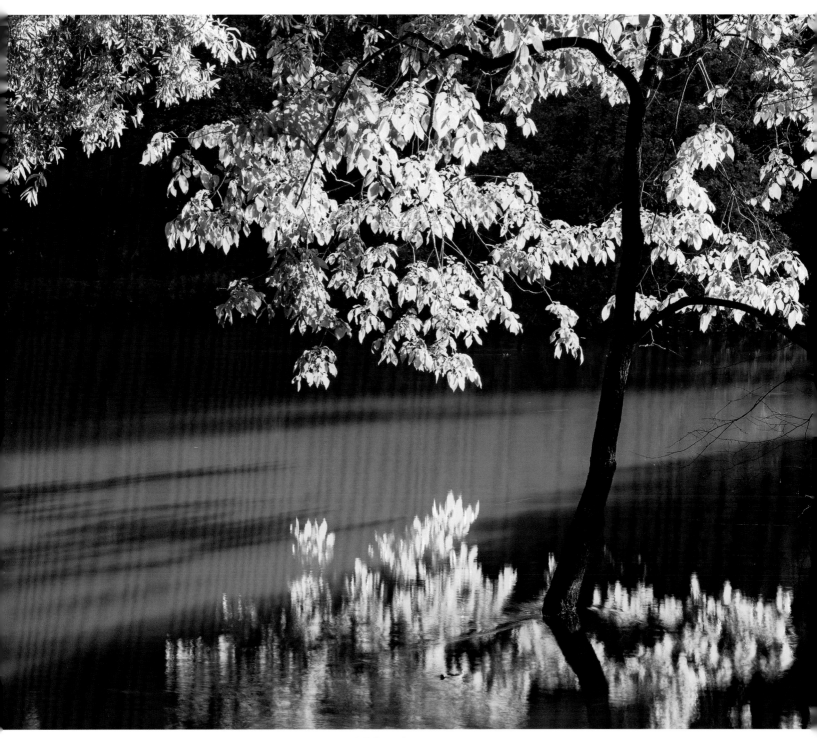

Black gum standing in water, Neches River National Wildlife Refuge

shoulder to memorize my way back. I've never been lost in the backwater and don't wish to be these days. I do know that no matter how far into the flooded woods you go, you still can look down at the surface and see water moving, if ever so slightly. The "river" is the whole bottom, bluff to bluff. At high water the riverwoods are alive and in motion.

And rightly so, as the canoe goes along with the flow. John Graves observed in *Goodbye to a River*, "Canoes are unobtrusive; they don't storm the natural world or ride over it, but drift upon it as part of its own silence." And I also would say of canoes exactly what Stephen Harrigan once did about bicycles, another human-powered, gravity-assisted vehicle that moves in silence: "It is a machine that restores the intimacy and dignity of travel, and that moves efficiently through the landscape without disturbing the ghosts."

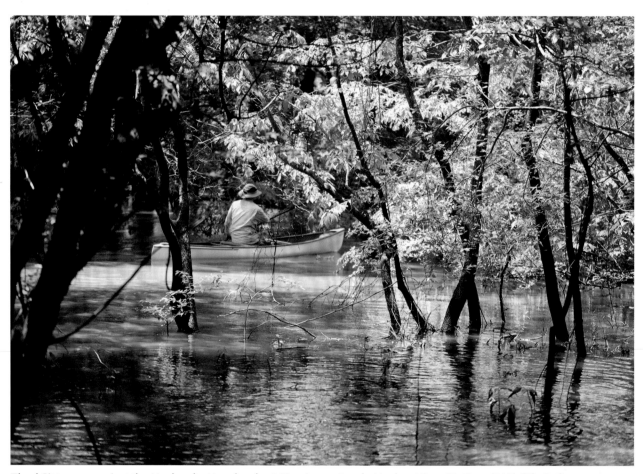

Thad Sitton canoeing the Neches bottomlands at Hurricane Creek, Neches River National Wildlife Refuge

Graves brought up the matter of ghosts in his book about the Brazos, noting that "sometimes you take country for itself, for what shows merely, and sometimes it forces its ghosts too upon you, the smell of people who have lived and died there." Then he filled his account of a long canoe trip down the Brazos with retrospections about a great many ghosts, and very violent ones, too, mostly the echoes of a bitter war for the country between two brave, hardy, and revengeful peoples: the Scots-Irish invaders and the native Comanche. Ghosts take over Graves's book for many pages at a time, as his peaceful canoe trip falls into the background and we hear bloody stories of rape and murder and countermurder.

The Neches has much milder ghosts, friendly like the river. But as a historian of the place, I don't know if I should disturb the local ghosts at all in the introduction to a book by landscape photographers, who always "take country for itself, for what shows merely." Historians, however, can't even pass silently by via canoe without stirring up a few ghosts, and I'm not sure photographers always just photograph what shows merely. They pick and choose, for one thing. The images in this book turn aside from clear-cuts and other human depredations on the land to focus on landscapes where the primal riverwoods—Dan Lay's lost Neches valley—show through to the present.

And I'm not certain photographers are entirely out of the ghost business either, as some of these photos attest. Plains Indians called these people of the black box "ghost catchers." Once, not all that long ago, most humans believed that the landscape was not dead but full of spirits of place, some of them human, many of them not, all of them possessing certain powers. Animism is the default religion of humankind, reviving with every bump in the night. It could be that some landscape photographers operate like Carlos Castaneda in *The Teachings of Don Juan: A Yaqui Way of Knowledge*, challenged by the shaman to find his "spot" on the front porch. Nature is not dead after all, as perhaps the photographers try to tell us. They're always looking for their spots, where the spirits of place burn with special life.

Native Americans—Atakapan-speaking tribal groups and the Caddo— resided along the Neches when the Spanish arrived in the eighteenth century, but they lived lightly on the land and had little impact on the river valley. Only their stone tools and pottery shards remain. On the narrow upper river, fallen trees were used as footbridges, often with ropes made of woven black

walnut bark stretched over the logs as hand lines. Sometimes a slow-burning fire might be kept going for days at the base of a tree to cause it to fall in just the right place. On the lower river, too wide for spanning with a single tree, early Anglo settlers noticed how Indian trails often crossed the river where big patches of switch cane grew at the edge. An Indian—or a settler—could in a matter of minutes construct from the buoyant cane a makeshift paddle float for river transit.

Settlers arrived knowing many such tricks for life in the big woods, learned over two centuries from the tribes of the Southeast. New arrivals from Mississippi or Alabama might put in their first survival crop of corn at a big switch-cane patch. All you had to do was cut the cane, leave it a while to dry, burn it off, then with a stick punch holes in the ash-covered ground and plant your corn. You might locate your permanent corn- and cotton fields on the higher ground just outside the river valley to avoid floods, but the thick canebrake offered an instant cornfield in the first year. Game was amazingly abundant at the time of first arrival, but settlers always thought they had to have corn for human food and "fuel" for work stock.

Anglo-American history along the Neches divides readily into two distinct parts—the river-focused era and the timber-company era, with the dividing line sometime around 1880. Both of these eras left marks along the river, often at the river bluffs. Fresh from travel on the awful, mud-plagued "traces" (no one called them roads) stretching back to the east, settlers located their lands along the Neches valley, where they would at least have a fighting chance to get their cotton and other frontier products downriver to market. Bluffs bordering the river were at a premium, and first-comers often chose them to settle on. A plantation house and fields might be just outside the flood-prone river valley, but the high point along the Neches (and the land just below it) often soon included a characteristic infrastructure of boat landing, cotton shed, and perhaps a river ferry. As more time passed a water- or animal-powered gristmill and cotton gin might be added, and even (in certain advantaged locations) a post office and small mercantile store.

Steamboats landed at such places, following the more primitive watercraft of flatboats and keelboats, though often only at high water. Canoeing the Neches, picking your way around logjams, you might find it hard to imagine a steamboat coming at you around the next river bend, but in the old days it might have. Neches steamers were small and specialized for shallow-water

operation, although a good many still hit snags and ended up on the bottom. When the first steamboats of the year reached communities far upriver in fall high water—Shooks Bluff on the Neches, Patton's Landing on the Angelina— they triggered celebrations known as "packet days." It was as if the starship *Enterprise* had just landed on a remote frontier planet. Locals brought out not only cotton bales to ship downriver but also deer skins, otter pelts, bear pelts, and bear oil, which they put up in fancy gourd containers. Many a hand-rived cypress shingle also went downstream.

After the railroads and the big timber companies arrived during the 1870s and 1880s, riverside settlements often packed up and moved "inland," relocating along the new railroad. People at Shooks Bluff did this over a few years, migrating to the new town of Wells in Cherokee County. Railroads brought a close to river transport, also gravely injured by log runs on the river. Floating logs and fragile steamboats didn't mesh well. To a considerable degree, mainstream economic history now turned its back on the Neches, leaving the wild bottoms to free-range stock raisers, anglers, and hunters.

Typically, as in the case of the Kirby Lumber Company and the Santa Fe Railroad, the big timber companies and the railroads came into the Neches country hand in hand. As railroads built north through the virgin pine forests, sawmill towns sprang up on the main lines behind the construction, and—as those began to cut out—side lines were built east and west into the remaining pine forests. Most early companies didn't focus on the hardwood forests of the Neches valley (with those frequent floods), but their tramlines crossed the river in many places to get to the uncut pines.

Everyone knows about the coming of cut-and-get-out lumbering to East Texas, but few fully appreciate the magnitude of the social change it brought. An animal-powered agricultural society of small, mostly subsistence farms and stock ranches—a place that was still half-primitive southern frontier—disappeared in a decade under a new steam-powered, heavy-industrial present. Backwoodsmen became industrial workers just like that. A lone fisherman on the Neches in 1907, at first listening only to the barred owl serenade, would have heard the wake-up whistles of several sawmill towns at first faint light of day. Anywhere on the river, that would have been true. Texas ranked third nationally in lumber production in 1907.

While this storm of change swept across the pine uplands, the Neches flowed on, and the yearly river floods helped keep development out. For the

most part, the timber companies did not want hardwoods, and the swampy bottoms presented problems for mechanized railroad logging. Southern Pine Lumber Company (SPLC) owned much of the land along the middle and upper Neches, and it took good care of the bottoms it owned, selectively harvesting parts of them from time to time and building logging trams across the river at a few places. The Texas-Southeastern Railroad trestle crossing the river below Highway 94 was part of the SPLC main line from Diboll to an ever-advancing series of timber camps up the Neches.

That trestle and one other still remain, but the ghosts of Neches history are largely invisible to the passing canoeist. Pete Gunter wrote that the river was scenic and "rich with bird and animal life. Stretches of the river are so world-lost and remote that one can, while canoeing, actually believe that one has lost touch with cities and suburbs forever." But living history persists along the Neches in one very literal sense: the feral hogs.

A canoeist can scarcely float a fifteen-mile stretch of the river without seeing one or several of these icons of the former free-range era. Such swine were variously called "razorbacks," "woods hogs," or "rooter hogs" by local people, and most of the men I interviewed between 1988 and 1992 preferred the last term. Until the 1950s, most of the county commissioner precincts along the Neches remained free range, which is to say, they had no stock laws requiring livestock raisers to keep their cattle and hogs behind fences, which meant that landowners had no perimeter fences. Earmarked hogs and branded cattle thus wandered across other people's land and were periodically located using dogs, then rounded up and "worked" by their owners, who freely trespassed to do so.

Many customary use rights—rights by local tradition—accompanied the legal right to range livestock and to move freely about to take care of them. You could, among other things, hunt, fish, build temporary camps, gather firewood or pine knots or hickory nuts, rob bee trees, and even improve the free range by setting the woods on fire. Some people pushed the boundaries of free-range rights to take landowners' animal pelts, railroad ties, and white oak stave trees. In truth, the laws of private property, the game laws, and to some extent the other laws of the land seemed to weaken as you approached the river back in those good old days, which include part of my own lifetime. A lot was implied when people said, "Let's go to the river!"

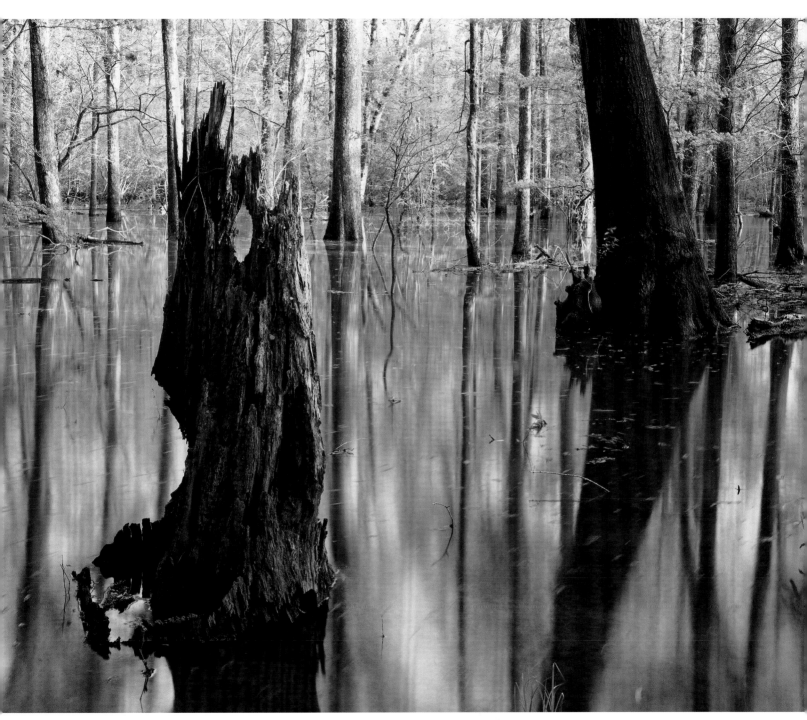

Flooded bottomlands of Hurricane Creek, tributary to the upper Neches River

You could also build fishing camps on other people's land. Some men did that for occasional weekend use, and others did it for good, dropping out of rural society to become permanent river hermits. A man Trinity County people knew only as Tomcat Red did this in the vicinity of the Highway 94 bridge. Red came down one time to fish and he never left. He "fished till he died," landowner Roy Smith told me. Thirty miles upriver, Old Man Scurlock did the same, soon giving his name to the slough and island he lived on, a place later renamed Big Slough by the US Forest Service. Scurlock scraped out a living selling fish from his live box to visitors and offering the services of his handsome stud horse. He needed little cash.

At Stirtle Eddy, Bill Evan's Island, and Cat Eason's Island, other river men also held place by squatters' rights, leaving their names on the land. People didn't live much in the Neches bottoms, and most of the names there were woods names, river names, wilderness names—Buck Lake, Lone Pine Ridge, Gourd Vine Eddy, Black Water Slough, Pine Island, and so on—but the river hermits left their names in the riverwoods.

I admire these men and feel affinity with them. They also remind me of the photographers who did this book, who stayed for so long in the Neches bottoms and took on much of the protective coloration of the place that they became difficult to distinguish from the modern equivalents of Tomcat Red. Most photographers do a "shoot"; Kruvand and Van Dellen have done something a lot stranger and more obsessive than any shoot. They became natives of the place. And I think the proof is in the photos.

"Tomcat" Van Dellen grew up in Minnesota and arrived at the Neches as a skilled canoeist, and Charles Kruvand learned from him, and had to, since the canoe is the only access to big sections of the upper Neches in low water. These are canoeists' photos, taken around canoe camps, and I believe that left a certain mark upon them.

Landscape photographers are hunters and very patient ones. They are familiar with Momaday's "glare of noon and all the colors of the dawn and dusk." They may wander the riverwoods on good days—days of good light—and watch for spirits of place to reveal themselves to be photographed. And on days of bad light, they may wander the riverwoods to spot good things to photograph when the sun returns and stands at the perfect angle and direction for these particular things. They work with light from the ancient star, and only that. I don't know the full mysteries of how they do what they do.

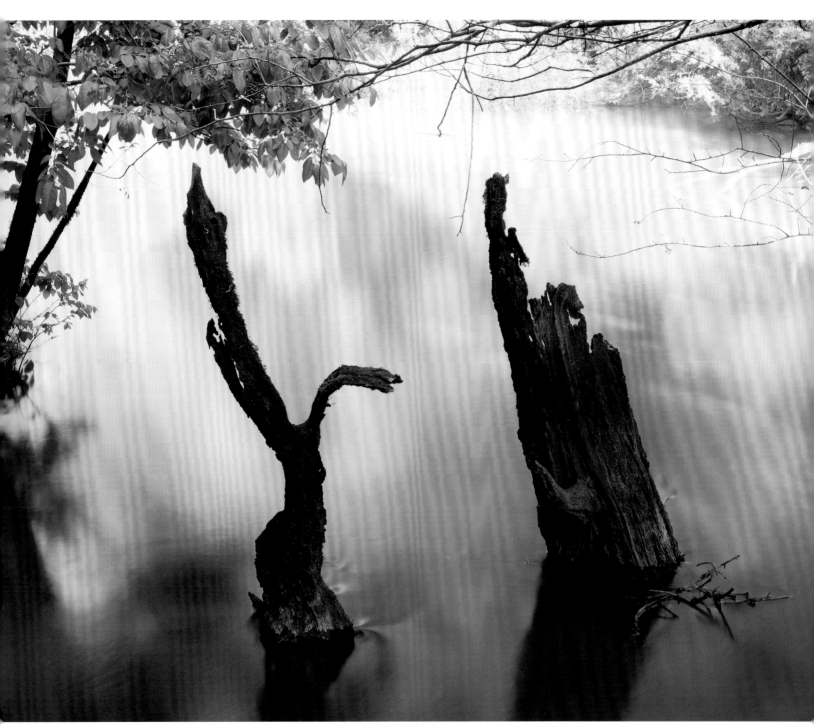

Stumps in high water, Neches River National Wildlife Refuge

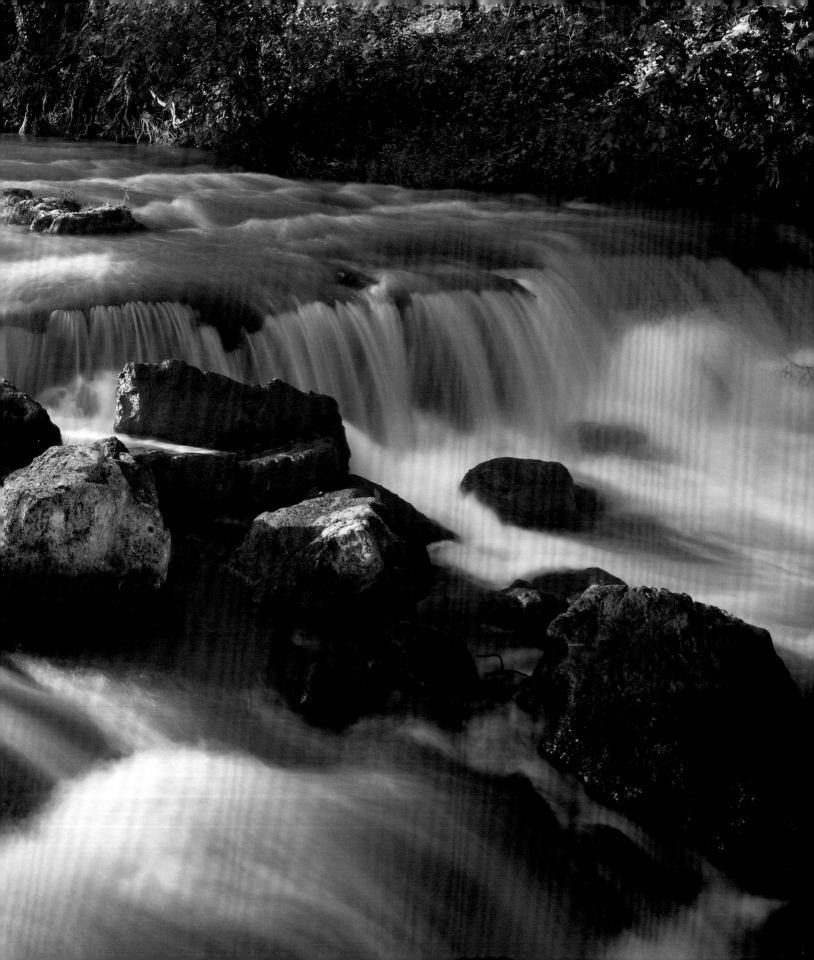

The Big Sell

April 2010

How we fall into grace. You can't work or earn your way into it. You just fall.
It lies below, it lies beyond. It comes to you, unbidden.

—RICK BASS

On a cloudy afternoon, I squeezed into the back of Adrian Van Dellen's decrepit Toyota for a quick trip to the Neches River. I owed Adrian a favor. Thanks to his guiding expertise I had photographed extraordinary East Texas places like Colerow Canyon in the Sabine National Forest and Graham Creek in the Upland Island Wilderness Area for my first photography book, *The Living Waters of Texas*.

Adrian often talked about the Neches River as if it were *his* river. "You've got to see my Neches," he liked to say.

I always told him, "No thanks, I like good-looking rivers," but without his help I couldn't have found the beautiful spots I liked to photograph, the natural free-flowing waters of my home state. We became close friends, bound by a love of wildness and picture taking.

Adrian drove us to a bridge and pulled behind a sign dented by bullets.

"Here she is," he said proudly.

It wasn't the first time I had seen the Neches River—we had driven over it every time I came to East Texas—but I tried to look at it in a new way. We walked to the middle of the bridge. Dead trees rocked up and down in the

brown current like they were trying to escape the horrible fate of being buried in mud.

"It's such a muddy . . ."

"Mocha," Adrian interrupted. "We say the Neches is mocha, not muddy."

I looked again. The Neches wasn't a nice cup of Starbucks coffee. Bottles, cans, and bits of Styrofoam floated in the water; a bag of trash was impaled on a tree limb.

"It's disgusting," I said, pointing at a hunk of half-buried metal. "Is that a refrigerator?"

"Come canoeing with me just once," he said in a soft, dreamy voice. "You won't have to do a thing, just bring your camera."

"Well," I mumbled.

"You've got to see her on a foggy morning when she's at her best."

I doubted this, but I crossed the bridge to see if the view upriver might be better. Adrian sidled in close and leaned his shoulder into mine. "In winter, her waters clear to translucent turquoise."

This seemed even more unlikely.

"I know she's not much to look at from here," he said, spreading his hands over the muddy muck below, "but believe me, she's mighty fine."

From where I stood, there was nothing fine about this river, and the more I tried to imagine photographing the Neches, the more I ached for the crystalline waters of the Texas Hill Country spooling down rocky canyons into deep blue pools. My kind of river was fed by springs flowing over a white limestone bottom, not a river that looked like a sheet of yellow plastic.

To his credit, Adrian had canoed the entire length of the Neches, some four hundred miles, from Lake Palestine to the industrial port at Beaumont. He had mapped usable canoe put-ins and take-outs, cataloged hundreds of creeks, and described what a canoeist might experience for Gina Donovan's *Neches River User Guide*. Adrian probably knew more about the Neches River than anyone.

"I'll make a deal with you," he said like a good sales rep. "If you don't like the river, you're under no obligation to continue."

And so it was that what I didn't want to happen happened. In April 2010, I met Adrian at his house along Steinhagen Lake for our first canoe trip.

I knew something of his early life. Adrian was born in 1942, and his parents and siblings had fled war-ravaged Holland in 1951. They settled on a

hardscrabble farm in Minnesota when Adrian was twelve years old. Raised a Calvinist, the Christian theology professing that humans are forever cursed with original sin, Adrian became a youth minister in college.

A farm boy, he could fix anything, and yet his house was falling apart. The front porch was missing, as was the front door. Hurricane Ike had done it, he said. The stove didn't work, buckets dotted the floor wherever the roof leaked, and getting to the only bathroom required a sideways crab walk down a narrow, dark passageway. Six-foot-tall weeds, abandoned vehicles, and a cabin that had been crushed by a tree surrounded his house. He lived alone but ate lunch and dinner with a mouse, which he had respectfully named Mouse.

Although he apologized for the chaos, it was obvious he neglected his decaying home because he put all his energies into one endeavor—protecting the Neches River.

We gathered our gear and made the three-hour drive to Lake Palestine. He maneuvered us down a rutted dirt road below the dam and parked on the edge of a swamp. We were in an unofficial campground, which is to say, there were no rules, no park rangers, and no bathroom. He pitched his tent behind his car and canoe trailer like a pioneer hiding behind a wagon. I placed my tent in a grove of small trees as far away as possible from spiraling arms of toilet paper that traced previous bathroom locations.

I had trouble sleeping. There were violent screams during the night from what I assumed were animals being hunted and eaten, as well as shuffling noises like a body being dragged through the leaves. When I went outside to investigate with a tiny flashlight, I saw nothing. Around four in the morning, irritated at wild pigs snorting and grunting near my tent, I strolled over to the nearest one and shouted close to her ear, "Get the hell out of here!"

That proved to be an exceptionally stupid thing to do. All at once two dozen pigs started squealing and running in all directions. I yelled "hey" and "get away" and a few curse words too. Dark hairy beasts brushed past within inches, and then for no reason that I could comprehend, the feral hogs organized themselves into a single file and splashed into the swamps like galloping horses. I lay in my tent wide-eyed and waited for dawn.

At first light I asked Adrian if he had heard me yelling, and he thought he might have; possibly he interpreted my outburst as a dream I was having. I found out he could sleep through almost anything.

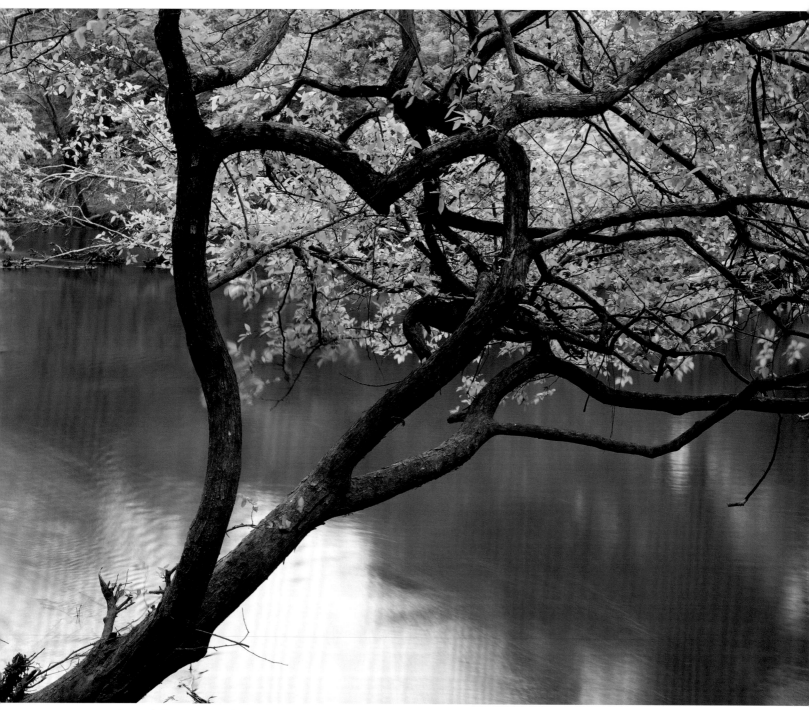

Heart-shaped elm, Flat Creek campsite

I followed Adrian's canoe to Flat Creek, the first tributary to enter the Neches below Lake Palestine. Within half a mile of leaving the campground in our canoes, the trash disappeared. A multitude of trees, oaks of all kinds, hickories with shaggy bark, sweetgums, sugar maples, and pine trees that had to be more than a hundred feet high crowded the riverbank. Underneath the canopy, river elms leaned over with twisting branches brushing the water. It felt like I was in a wilderness.

"I want you to take some photographs here," Adrian declared when we arrived at the Flat Creek campsite. "A Dallas developer wants to divert Flat Creek into three lakes for a new subdivision. I'm suing to stop him. He's taking public water for personal gain."

I was surprised to learn I was a pawn in a lawsuit, but the big Dallas developer needed to learn a lesson. I found a splendid river elm twisted into a Valentine's-style heart with the Neches glowing in the background. I hadn't expected anything like that.

Around midday, I asked Adrian for something to eat. He rummaged inside a container but came up empty-handed. He had said he would take care of everything. Certainly food should be at the top of any preparation list for a trip like this one. From a different container, he pulled out two cans of beans. "I've got some canned chicken here somewhere," he said with an eager look on his face. "I mix it with the beans."

"Dammit, Adrian," I sputtered.

I stomped off into the woods chastising myself. I had no one else to blame for being so unprepared. Before we started the drive, Adrian had told me that he sometimes fasted for health reasons. I hadn't paid enough attention to that statement.

I took a mental inventory of the food I had: six Pepperidge Farm chocolate chip cookies. I'd started with eight but had already eaten two.

In a mixed-wood meadow, I snapped off the tender tips of spring-fresh greenbrier shoots, one of the few wild foods I knew. They tasted like raw green beans. That was a good start.

I decided to explore a dark thicket. After crawling on hands and knees under dense trees, I stood upright in a small clearing. Shafts of light spotlighted the earth, hidden birds called, and some black ants familiar from my youth crawled up a dying tree. In a flash, I was transported back to the shadowed woods behind my childhood home in Meyerland, then on the outskirts of

Houston. I was four or five years old, roaming the backyard under my mother's watch. When the telephone rang inside the house, she left to answer it. Alone outside for perhaps the first time, I made a beeline for a hole my father's English pointer had dug under the fence. I removed the branches my father had stuffed in the hole, looked at the sliding glass door one last time, and slipped under the fence.

In a small clearing stood a massive tree riddled with dead limbs. Festooned in Spanish moss and scarred by cavities, it looked nothing like the groomed trees of my backyard. I ducked under branches, crawled on my hands and knees, and reached the furrowed bark of this ancient coastal live oak. A lizard jumped down to spy on me. Black ants marched up and down the tree, and a woodpecker paraded across the oak's dead and dying limbs. There, in the chaos of the wild woods, totally beyond parental care, I felt at home.

I had the same sensations in the dark thicket along the Neches—an overwhelming attraction and a sense of being somewhere strange and alien. But I must have felt jumpy. I turned to get a better look at my surroundings and a limb bumped my head, woody spikes poked me in the back, and another branch pressed against my neck. I crashed off toward the light, tore my clothes, scratched my arms, and finally emerged from the thicket confused and embarrassed.

Adrian was nowhere in sight, which was a relief. I wouldn't have to explain how the Neches had bewitched me in the deep gloom. Noisy flocks of cedar waxwings passed through the trees, a rose-breasted grosbeak landed ten feet away, and high in the canopy neotropical warblers from Central and South America sang more beautifully than anything I had ever heard.

I walked the riverbank remembering the last visit to my Meyerland woods, at age ten. It seems that ecoterrorism came naturally to me. I had been pulling up wooden stakes that marked a new road when a truck arrived. I threw a rock at the workers, and they gave chase, banging their fists on the truck doors and yelling at me. I ran to the greenbriers under the coastal live oak tree and hid. I couldn't bear the idea that my mighty oak and the rest of my childhood forest were destined to be chopped down and buried in cement. My family moved to Dallas before complete destruction, but in my mind everything I valued most in the small wilderness around my first home had been lost.

These thoughts and what I saw around me made up my mind. I decided to help Adrian, take the photographs he wanted, and try to stop the destruction. On my way back to camp, I passed by a tree covered in webs, like ghosts from the past.

Adrian had good news. He had plenty of oatmeal to sustain life and said, "We can live off of it."

I showed Adrian a line of catlike paw prints going down to the edge of the river. He looked at them closely, found a fresh mound of partially digested crayfish shells, and pronounced it a "river otter latrine."

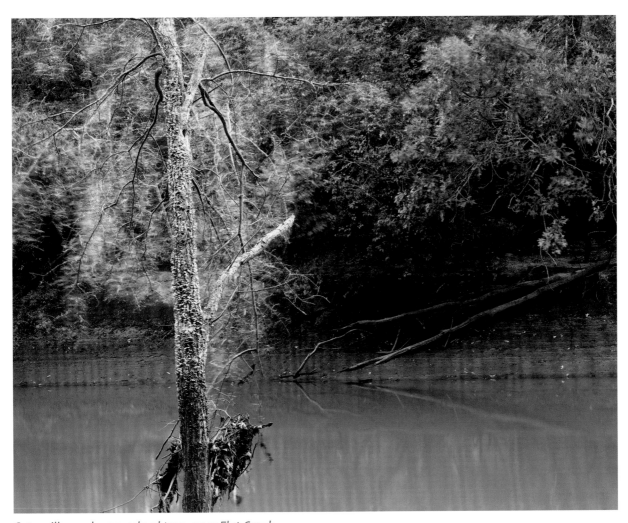

Caterpillar webs on a dead tree, near Flat Creek

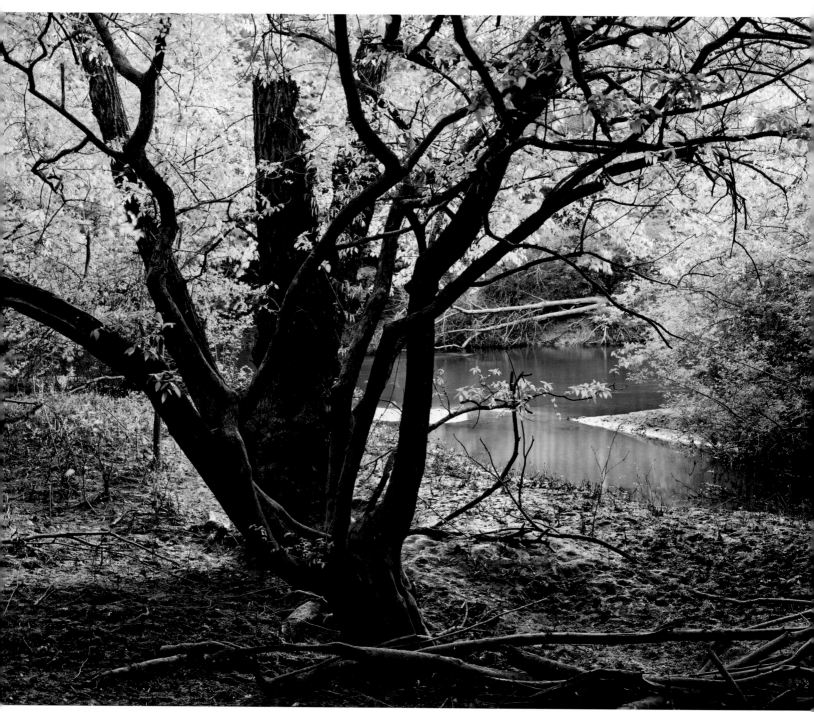

Hickory tree stump and Flat Creek at the Neches

River otters had almost gone extinct in Texas, and the Neches River had been one of their last refuges. Now they were here in substantial numbers. Adrian grabbed his digital camera to look for otters, while I explored upriver. My camera technology couldn't deal with wily mammals. It took me ten minutes just to set up my 4×5 Sinar, a primitive large-format camera essentially unchanged since the Civil War.

A river elm leaned toward the water and intermingled with more elms on the far bank. In the tunnel, cedar waxwings snatched white moths from the air above the river. They headed toward nesting grounds far to the north.

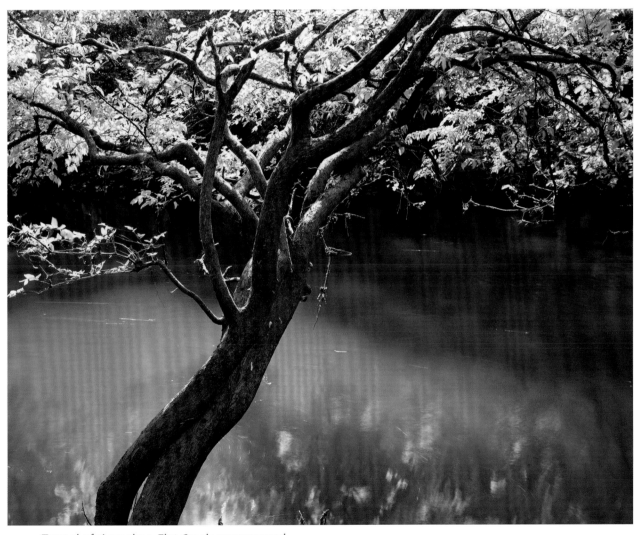

Tunnel of river elms, Flat Creek campground

Migrating birds like the waxwings use rivers like the Neches as we use highways with leafy rest stops and feeding places along the way. Running from northwest to southeast, the Neches funnels migrants south in winter and north in spring, providing both food and shelter.

The following morning, as we prepared to leave Flat Creek for the next campsite, canoe instruction seemed in order. Adrian suggested I try his slim, shapely solo canoe that knifed through the water like a kayak. I had Adrian's two-seater flat-bottomed boat, the supply canoe. It wasn't sexy.

But it was more stable. Adrian had one last thing to say. He described his solo boat as "rather tippy."

Once settled into his "tippy" canoe for my trial run, I wielded a double-bladed kayak paddle and skimmed downriver to a fallen tree blocking the river. I climbed out, pulled the boat over, stepped back inside, and promptly fell overboard.

"You've been baptized," Adrian shouted when I resurfaced.

I coughed and then swam back to the fallen tree. I felt concern about his camera equipment getting wet during my mishap, but it proved safe and dry; he had packed well.

Adrian felt that some necessary event had been transacted. "Everybody falls in eventually," he said. "You're one of us now. How does it feel?"

It felt wet and cold. I switched back to my more stable canoe and after a while paddled alone under a tree arching across the river. Such trees are best scanned for reptiles, as I learned when a small alligator crashed into the water inches from my boat. That was an important canoeing lesson Adrian had forgotten to mention—always look for reptiles in overhanging limbs. A bit shaken, I immediately pulled to a shaded spot and parked on a muddy bank. I looked above and off into the woods.

Another wonder arrived: a leopard frog chased by a yellow-bellied racer snake. In three bounding leaps the amphibian reached the edge of the river and sat there calmly. The leopard frog stared across the Neches from the top of the bank. He seemed unaware that he was about to be grabbed and swallowed whole, but when the racer came within inches, the wily frog jumped into the river and disappeared.

The yellow-bellied racer pounced on the spot where the frog had been sitting, seemed to sniff the mud like a bloodhound, and scanned the water with bright eyes. Perhaps angry that a simple-minded frog had outsmarted him,

the racer scooted up and down the bank, then slithered back down to the edge of the river and curled up to wait. But the jumping frog of Cherokee County did not return.

I pushed off and followed Adrian to our second campsite, watching the banks and trees and the sky above with wary respect for the Neches and its creatures. After settling at our new camp, I told Adrian about the alligator.

"You're lucky to see a tree-climbing gator. I've never seen one," he said. But when I told Adrian the snake story, he snorted. "Snakes don't sniff like dogs," he said.

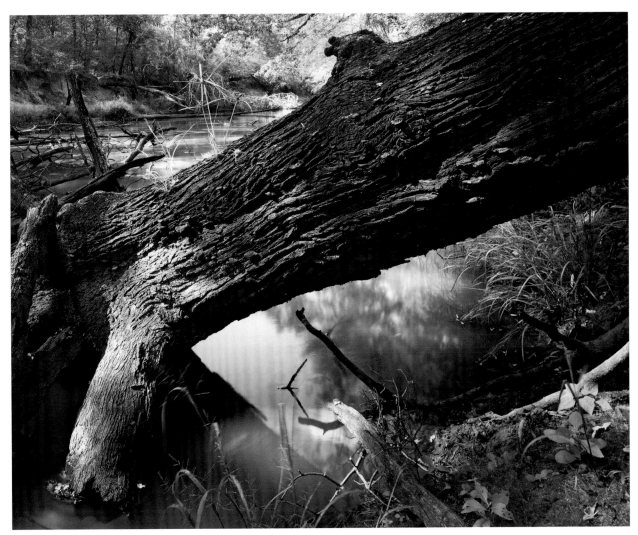

Typical fallen tree across the Neches

This proved the first of many discussions about nature and animals in which Adrian and I disagreed. He believed the natural world was governed by instinct, though complex and at times mysterious. When I told him that the frog taunted the racer snake and the alligator climbed the tree not solely by instinct but by choice, this seemed anthropomorphic to Adrian. "Birds and animals don't experience emotion the way we do."

I had a different belief. I thought nature baffling because we didn't understand the emotional languages of the creatures around us. Of course the alligator needed to get some sun, but he also wanted to enjoy the view.

We finished our first river trip, but on the drive back to Woodville I felt disoriented by being back on pavement. A part of me remained on the Neches, canoeing through an emerald forest. What with all the photography, we'd been out four nights and canoed only four miles, and yet it felt as if I had traveled a much longer distance and been gone a long while. I'd had my first taste of "river time."

Adrian felt the same. Thirty minutes away from his house on Steinhagen Lake, he suddenly asked. "Do you want to canoe another section of the Neches? I've got enough oatmeal for two more days."

We detoured to the Angelina River, a major tributary of the Neches that joins the larger river at Steinhagen and stopped at Bevilport. Today, nothing is left of this antebellum steamboat port except a historical marker and a wooden dock from which we launched our canoes.

Before railroads penetrated East Texas, steamboats had served as the dominant mode of transportation. They brought people and provisions to Bevilport and then took on loads of cotton, pelts, hides, and bear fat (the pioneers' cooking oil) for the return trip to Beaumont. There the cargo was off-loaded onto bigger steamboats to ply the Gulf of Mexico to New Orleans.

Paddling down the wide Angelina River seemed very different from the narrow upper Neches. After a while we set up camp with the Angelina on one side and a swamp on the other. I was thirsty and went to Adrian's canoe for water.

But there wasn't any.

He shrugged sheepishly. "I guess now is a good time to test my new water filtration pump."

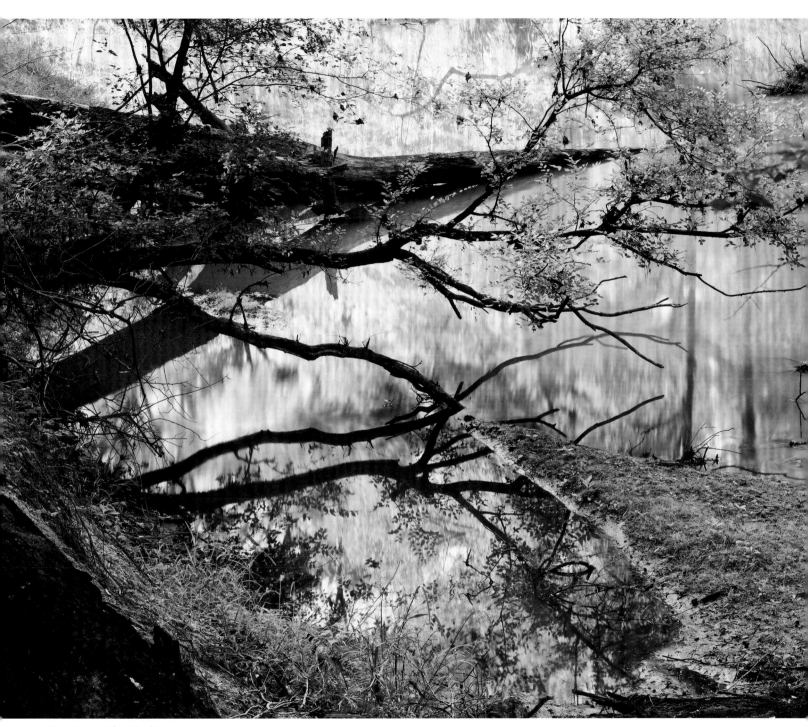

Beauty on the Neches

Adrian assembled the device, and by mutual agreement we chose to pump water from the tea-colored swamp rather than the muddy Angelina.

I didn't understand how the pump functioned to make the water perfectly drinkable, but Adrian had complete confidence. "This pump is rated for five hundred gallons and will take out bacteria, most viruses, and many pollutants." A retired veterinarian, he was a man of science.

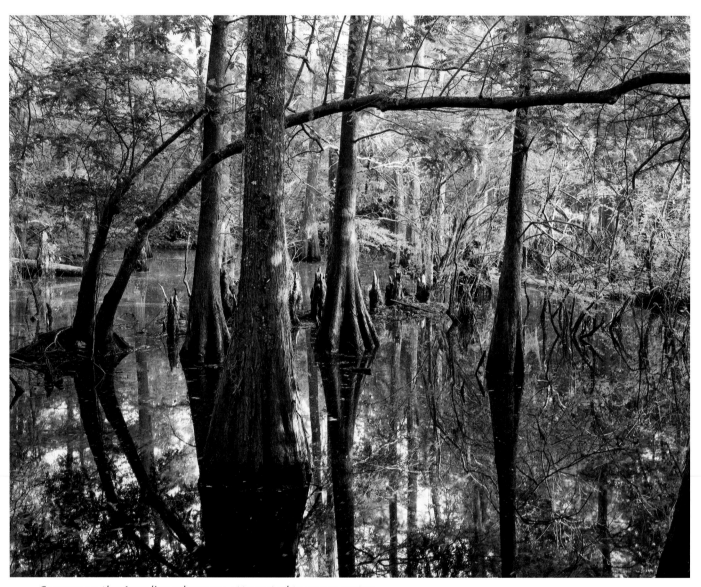

Swamp on the Angelina where we attempted to pump water

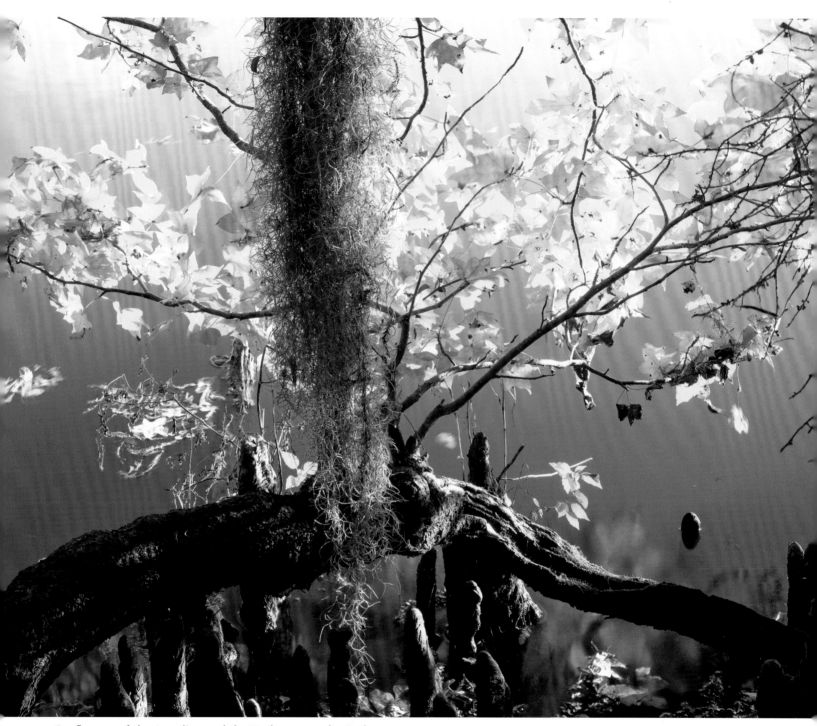

Confluence of the Angelina and the Neches, near the Forks

Adrian dropped the filter tube into the swamp and commenced pumping. Water at first gushed into the plastic bottle, but soon slowed to a trickle. He didn't understand that but handed me the bottle to sample. I took a sip, then another, finally a big gulp. I noticed a variety of sweet flavors and an equally pleasant dry, tannic aftertaste. It seemed quite a concept, drinking water that really tasted like something.

Adrian took the pump apart. We saw the problem and perhaps the source of the flavoring. The ceramic filter was choked by a mass of pale green squiggly protozoans squished into a sticky goo.

"Let's make more protozoan-flavored water," I said. It was some of the best water I had ever sampled. But Adrian feared for his pump, and we processed no more swamp.

We shared the half pint sip by sip like a fine wine, then moved the cleaned filter to the Angelina and took turns pumping bitter-tasting water.

Our two-day trip over, we canoed down the Angelina and passed through the Forks of the River area. This maze of sloughs and backswamps is still rich with herons, alligators, and every sort of wildlife. Once, paddlefish up to seven feet long and two hundred pounds swam here, while raven-sized ivory-billed woodpeckers pounded dead trees for grubs. I could only imagine what an extraordinary place it must have been before Steinhagen Lake and the upstream dam creating Lake Sam Rayburn tamed the Angelina.

I brought my canoe close to Adrian's, suggesting that we should return one day, fill our boats with gallons of flavored swamp water, and get it tested. Not only did the water taste remarkable, changing from sweet to dry, but I felt energized after a few sips. Was it possible that juiced protozoans from a Neches tributary swamp worked as a health tonic?

Adrian admitted that our first two voyages had equaled the total number of nights he had camped on the Neches. He had experienced *his* river in a new and intimate way.

He asked when I would be back.

"Soon," I said.

Rocky Shoals

December

Months later, Adrian met me on his driveway the first day in December and wrapped me in a hug. "So you're ready to canoe the Neches again?" he asked.

"I think so," I said, squirming a little. I hadn't been completely pleased with how my first photographs had turned out. They looked too much the same, all greens and browns and trees. I told Adrian I needed something special to photograph besides the usual Neches.

He had the answer. Rocky Shoals was that sort of place. He had been saving it for later, but we'd go there now.

We launched the boats from underneath the same bridge over the Neches that we had used months before to view the river and all the trash. Within a mile, rocky islands appeared. Most were small, but one large island sprouted a cypress tree there in the middle of the river. I pulled to the right as Adrian had instructed, pitching my tent against a high bluff on a narrow strip of sand.

A sloping shelf of rock angled down to a waterfall. Below the cataracts, a broad, deep pool spread to the opposite shore where the Upland Island Wilderness Area began in a dense forest.

Rocky Shoals rose before dawn the next morning, shrouded in fog, a sculpture of sound.

I moved my Swiss-made film camera to a knob of rock on the edge of the falls. With my accordion bellows and a big lens, I huddled under a dark cloth like photographers from a hundred years ago. Rocky Shoals appeared as an abstract image on the ground glass, upside down and reversed, a process of "seeing" that I liked very much.

Rock outcroppings near
Rocky Shoals

Rocks and early morning
fog near Rocky Shoals

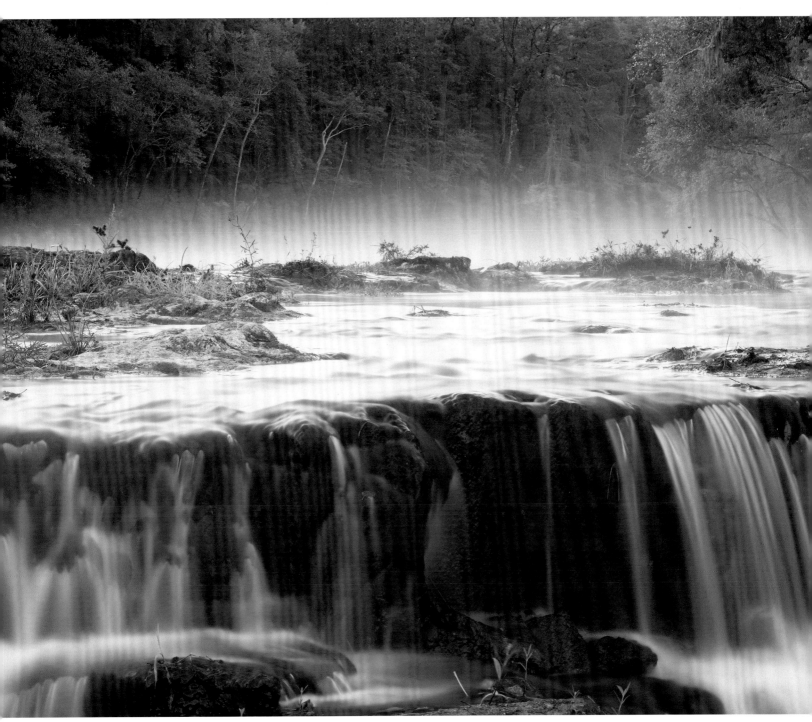

Falls at Rocky Shoals before dawn

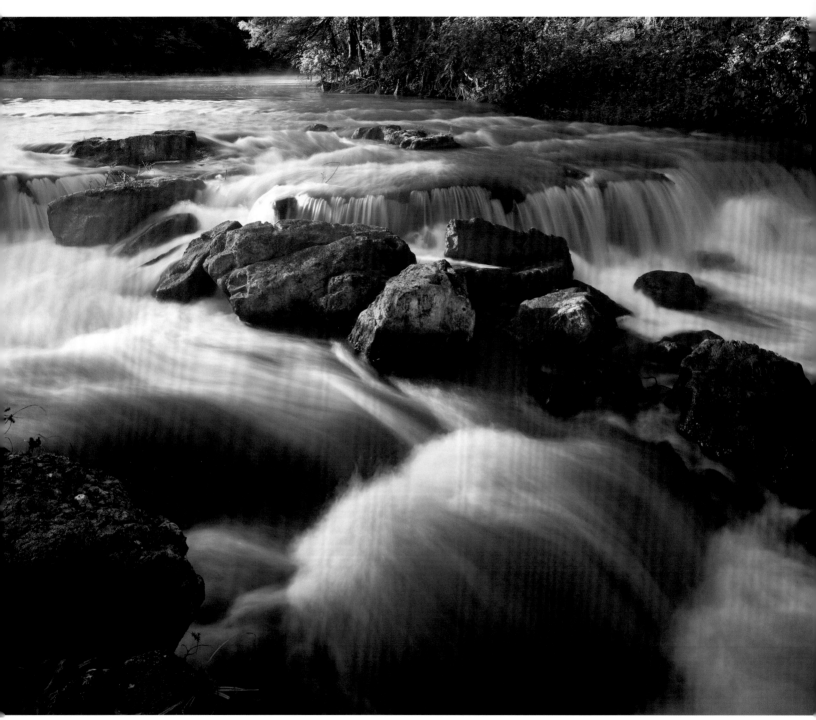

Rocky Shoals, the only waterfall on the Neches, at sunrise

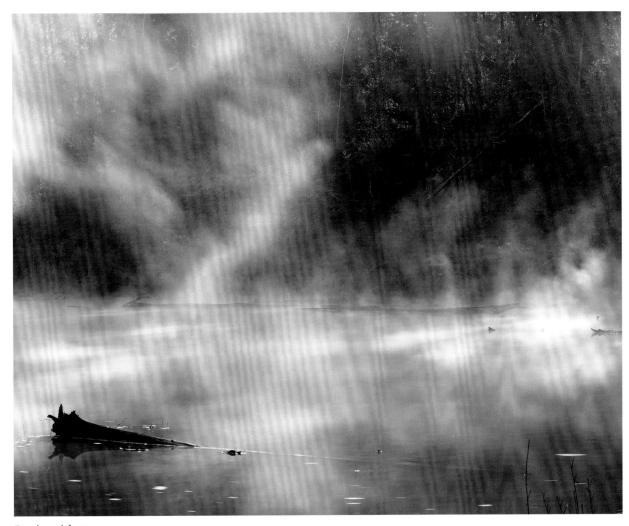

Pool and fog

Mist rolled off the river like wet smoke. A dash of amber light brushed the rocks, and magnificent blues emerged, lapis lazuli and aquamarine. Where the Neches fell upon itself, water frothed like steamed milk.

The sun was coming fast now. Colors intensified. A tree behind the falls exploded into yellow-green. The light was perfect, glorious. It was a vision into the colossal reach of time.

Between twenty million and thirty million years ago, volcanoes in Mexico and West Texas blew ash eastward to Rocky Shoals. The ash, mixed with mudstone and sandstone, became a hard, impervious conglomerate. There

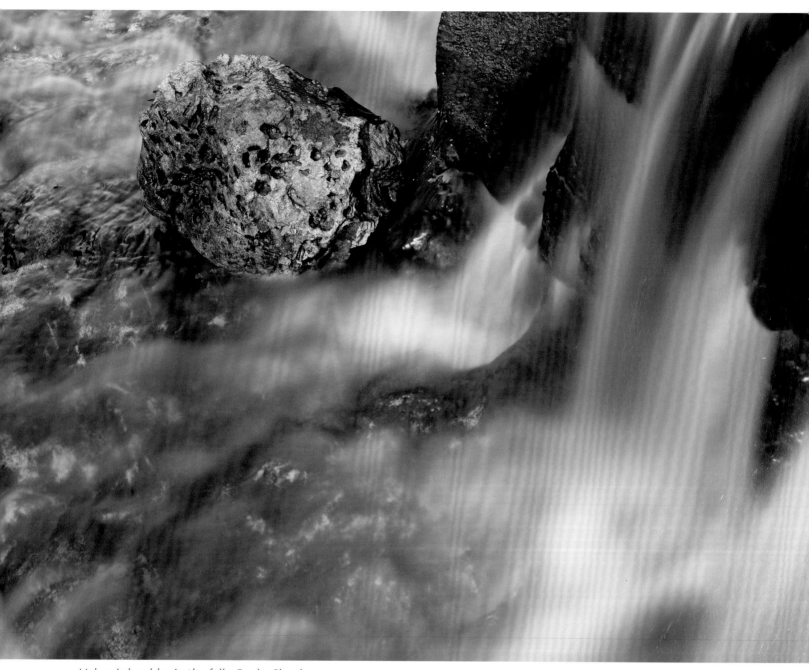

Volcanic boulder in the falls, Rocky Shoals

was softer rock underneath, which the river undercut to form the only waterfall on the Neches River.

A friend of Adrian, Jonathan Gerland, director of the History Center in Diboll and editor of *Pine Bough* magazine, arrived by canoe. He carried his canoe over the rocks to the wide pool below and photographed Rocky Shoals for the cover of his magazine.

Adrian had chosen the right experience to get me back on course. A warm night arrived. Under a full moon, the river glittered silver. A large diamond-back water snake lay motionless, half its body and head under the water.

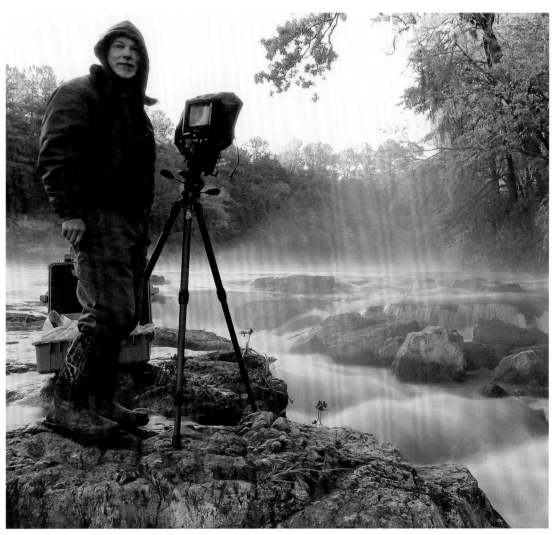

The author at Rocky Shoals. Photo by Jonathan Gerland

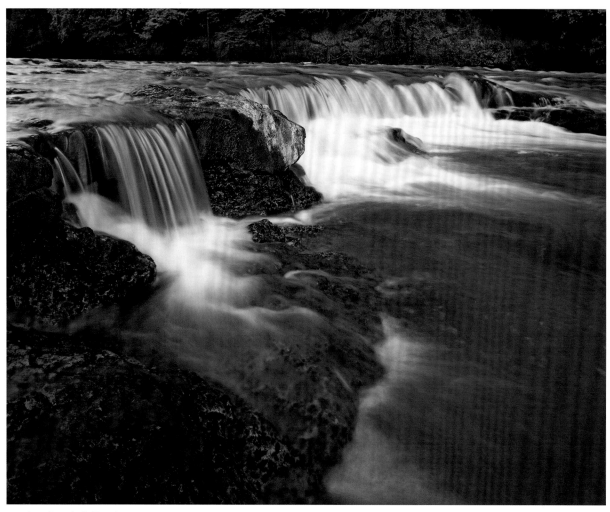

Rocky Shoals falls after sunset

Time passed, then a geyser of exploding water. The diamondback water snake threw itself out of the river and onto the shore while holding a large-mouth bass by the face. I couldn't believe it. For a brief primitive moment I wanted to grab the snake by the throat and steal his fish. Instead I backed away and yelled for Adrian. Snake and bass then lurched a foot off the ground, battering themselves against the rocky shore.

Adrian arrived and began taking photographs. The bass lay still in the snake's mouth, its fish eyes steady and calm. Then the four-foot diamondback slowly worked its mouth over the fish's head, down the body, and swallowed

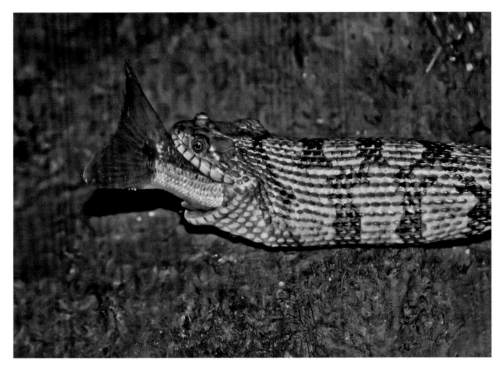

Diamondback water snake swallowing bass, Rocky Shoals.
Photo by © Adrian Van Dellen

the bass. I followed as it slithered to the waterfall and curled into a loose coil. I moved close enough to touch the reptile, which had overeaten in a normal sense of the term. It appeared to have fallen asleep.

Nearby, a smaller diamondback water snake chased minnows in a small rock-enclosed pool. Long and slender, this snake displayed none of the bigger snake's hunting prowess. He chased the minnows, which easily escaped by leaping over his head.

Diamondback water snakes are common on the Neches. They eat anything they can swallow and are often confused with the venomous water moccasin, which is just as well. Diamondbacks are quick to bite when harassed.

The next morning all the minnows were gone, and so was the light. Clouds from the Gulf had moved in. There were no blue jewels, no sparkling diamonds, and no brush of amber light. We had arrived on the perfect day. I experienced a change of heart: the Neches was a fine river after all, even if I couldn't tell just by looking at it from a bridge.

Rocky pool downstream from Rocky Shoals

Rock-enclosed pool and mussel shell, downstream from Rocky Shoals

Village Creek

May

Village Creek has thankfully—amazingly—escaped the curse of Texas development. Not a single dam mars the flow of this stream. No industries dump effluent, and most of the fifty-mile navigable length is under the protection of the Big Thicket National Preserve. Considered one of the top ten canoeing creeks in the country, Village Creek is sometimes called a "black river," because of the tea-colored, tannin-stained waters. Surrounded by lush green forests, with sandy beaches as pure and white as any in the Caribbean, this tributary of the lower Neches was a place where Adrian thought I could find lots of good photograph opportunities.

In early May, air filled with water from the Gulf of Mexico pushed north over Village Creek, and a foot of rain fell in a week. Once the weather cleared, Adrian and I launched our boats into the headwaters of Village Creek from County Road 420.

Around hairpin turns, each twist in Village Creek scrubbing the Austin city life from my bones, I looked over my shoulder at Adrian. Was he feeling like a waterfall falling free into the air like me? I couldn't tell. He looked the same as always. Ripped blue jeans, a tattered T-shirt, and grinning calmly, he flowed with unbroken time. It was hard to believe that Adrian had once been a lieutenant colonel in the United States Air Force, a pathologist who studied anthrax in South Africa.

We stopped on a sloping beach. He pitched his tent close to the orange-black water, while I placed my gear higher, where the sand met the forest.

*Tea-colored waters
of Village Creek*

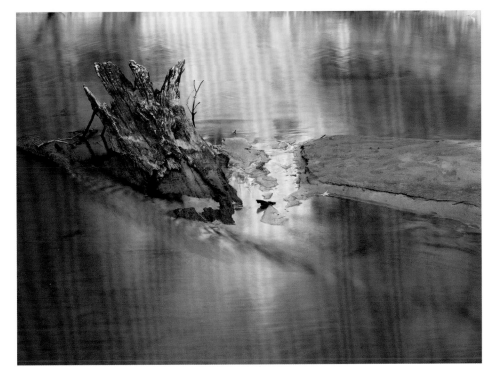

*Side channel of Village
Creek at sunrise*

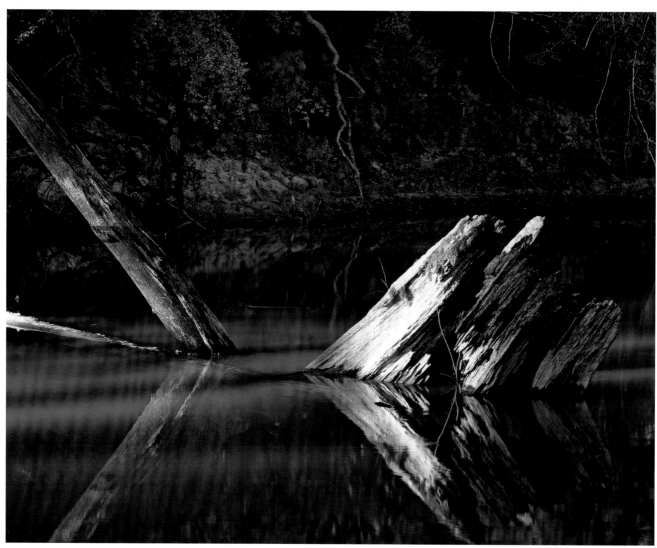

Fallen cypress tree, lower Village Creek

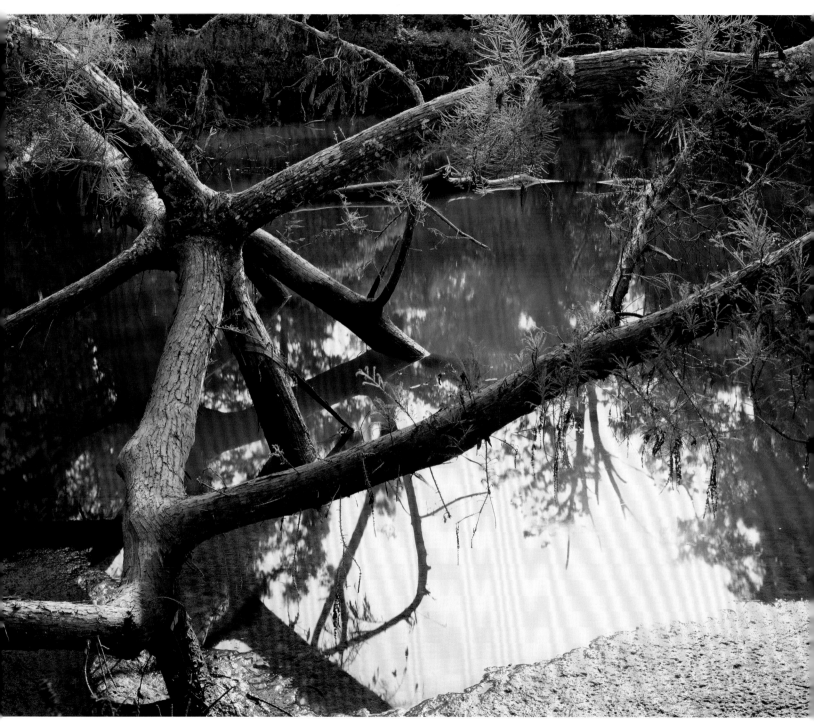

Stump in Village Creek

After a while, I heard what sounded like voices emanating from the far side of the creek, as if people were approaching, a boy and girl. I walked down to the edge of the water, where a collapsed tree and flood debris rocked up and down in the current. The talking and giggling stopped. I considered asking Adrian if he could hear the children, then decided not to expose myself to humiliation. After all, we were in a wilderness. How could there be children in the woods? I trudged uphill to my tent, and then I heard the boy say, "Mary." I strained to hear more. The voices faded, then swirled from several locations. There were more than two children now. There had to be a logical explanation.

I asked Adrian if he heard children playing. He had not, but he had heard something.

"It's just the creek vibrating from the release of pressure as the flood subsides," he explained. This possibly made sense, but the voices continued, as if Village Creek were speaking to me. Asked again later, Adrian was no more encouraging.

"You're making more out of it than there is," he said, without looking up.

I left my camp unfinished, canoed across the river, and entered a long and deep slough in search of the voices. Amber leaves floated on the dark water. Strands of spider silk attached to branches glowed green and copper in the slanting light. I parked the boat against a hill of inland sea oats and set up the camera on an image of cypress tree roots surrounded by reflections. A mirror of a wild and free Village Creek, this was a place I wanted to be.

I couldn't hear the children, though. I expected to find the voices at the top of the hill. High-stepping over logs and briars, dragging my mud-bloated boots, I suddenly faced tangled brambles that stopped my progress. Where the children could be hiding was impossible to reach.

I had no choice but to go back to the canoe. Skidding downhill through inland sea oats, I snagged a boot and fell hard into soft mud, which cushioned my tumble like a sponge. I lay there waiting for the voices. I waited for a long time. Nothing.

Back at camp, I had trouble sleeping that night. The laughing children seemed to come closer then go away. At times I could almost make out a conversation. At dawn I awoke full of energy. Adrian, however, didn't come out of his tent. I found him lying inside, pale and sickly. He felt bad, the world spinning uncontrollably.

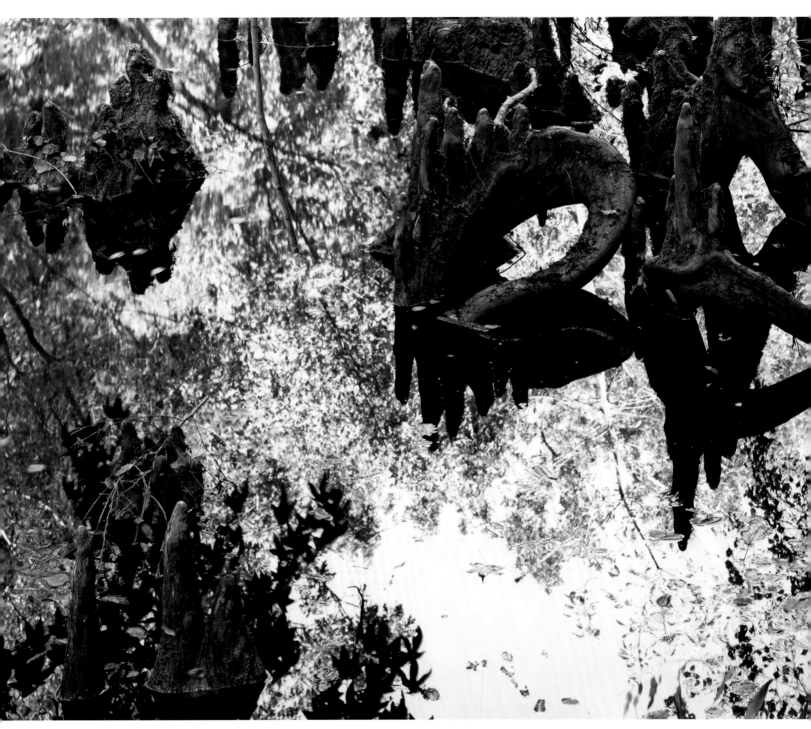

Cypress roots, mirrorlike slough

I wanted to put him in the bottom of my canoe and leave immediately, but he insisted we stay. He thought his symptoms might pass. After breakfast I checked on him again. He was resting in his tent, eyes closed, feeling better.

I still thought we should leave, but Adrian waved me away. "Go on, get a good photograph."

I launched myself into Village Creek and paddled against the current to the other side. Once on shore, I heard no voices, no children playing, but I sensed something strange happening here.

Clues were everywhere. A meadow of inland sea oats lay covered in dried silt from the receding flood, but all the plants were undamaged, and of course the voices and Adrian's sudden illness. Then there was the beauty of Village Creek straight-lining into my brain. I couldn't take my eyes off the creek.

I felt like a blind person at the movies, seeing flashes of brightness and darkness. I knew there was much more to see. Could it be that we have a sixth, a seventh, maybe an eighth sense from our evolutionary biology, so that when we are exposed to full-throttle nature in a rich environment like Village Creek, we go a bit crazy from sensory overload?

The naturalist E. O. Wilson, in his book *The Meaning of Human Existence*, said that twenty thousand new species are discovered each year and that the rate of new species discovery will accelerate as we explore the unseen world of "new bacteria, archaeans, viruses, and . . . scavenging picozoans of the sea, the latter so small they cannot be studied with ordinary light microscopy." Besides our inability to see the ultra small, humans see only a small spectrum of the available light. "When we see a yellow or red flower," the naturalist writes, "the insects see an array of spots and concentric circles in light and dark." What if Wilson underestimated our ability for greater awareness?

A rhythmic wave from inside the woods pulled at me like a magnet. I walked into the dense brush and saw a bursting light above cypress knees arranged like soldiers ready to fight off intruders. I took a photograph. If I had heard the children laughing, I would've worried for my sanity.

I returned to camp and looked in on Adrian. "Slowly improving," he reported.

I pointed uphill and told him I'd be exploring for a couple of hours.

I hiked into one of the last stands of longleaf pine trees. Named for their long needles, these trees can live for five hundred years, survive countless

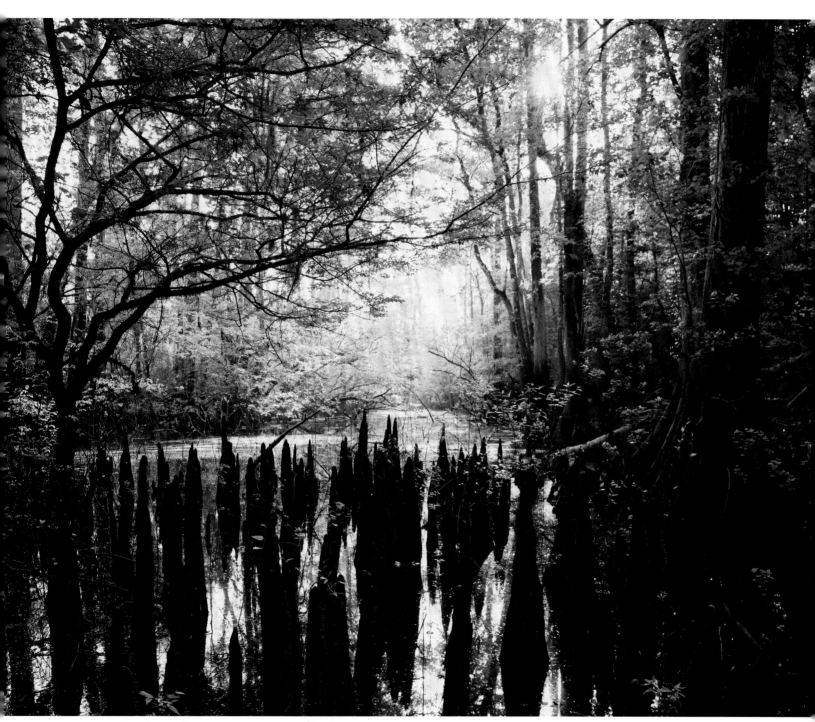

Cypress knees, flooded Village Creek cypress slough

fires, and grow 150 feet straight up. At one time they covered sandy ridges across East Texas from Beaumont to the Red River, but they were cut down everywhere for fast money.

Not long before my visit the Nature Conservancy had burned the undergrowth so longleaf seedlings could sprout, the effort thus mimicking the natural process of longleaf germination. I scrunched against a blackened trunk, mashed a sweet bay leaf in my hands, and inhaled the incenselike aroma. The longleaf pines were well spaced, the views open and expansive. I could smell the ash from the fire. A breeze slid through the pine forest like a river rustling over rocks. Warbling robins moved through the trees and streamed toward Village Creek as if they were leading me back to Adrian.

I found him on his feet and smiling for the first time. "I'm mostly recovered," he announced. Later we would learn that Adrian's dizziness was a middle-ear problem.

I listened for the echoing voices by my tent, but the only sound I could hear was flood debris rubbing in the fast water. The wind turned to the north during lunch, and we decided to pack in a hurry, harried by gusts and an angry sky. We floated downriver to a sandy shore where two Village Creek channels intersected. The new channel ripped through the remains of a lush forest while overflow from Village Creek meandered into the old channel, gracefully forested by large overhanging trees, quiet and serene.

A swallow-tailed kite, its head and body smooth white, wing tips and tail smooth black, glided over the treetops looking elegant enough to attend a black-tie event. Swallow-tailed kites occasionally fly up from Central and South America to nest in tall trees. Texas Parks and Wildlife considers them so rare they ask that each sighting be immediately reported.

I stepped into the stream flowing though the old channel and cupped my hands in the clear water. Baby crayfish floated into my palms. Tiny and helpless, some were translucent and others were red as boiled lobsters. At the end of the shallow stream, the crayfish grabbed the sandy bottom with their pincers and slowed themselves to a stop. They gathered in still water by the dozens.

Apparently they didn't want to go directly into the pond where the stream emptied, but I had no idea why. Along the rim of the pond, an inch below the surface, a line of baby crayfish walked the edge to the shallow end where leaves were piled up from the flood.

One crayfish raised its tiny pincers. Three menacing minnows charged. In the skittering commotion the baby crayfish vanished. I heard a splash from the stream. A dragonfly larva shaped like a bullet burrowed under the sand, then dashed into the deep pool where a fish much bigger than a minnow grabbed it.

Bluegills hovered in the black water like miniature killer whales. If bluegill "perch" had teeth instead of serrated bony lips, they would be the North American version of piranhas. One of the most adept freshwater predators in Texas, bluegills can consume one-third of their body weight in a single day. Released in the waters of foreign countries such as Japan, where there are no predators like largemouth bass to keep them in check, bluegills devour their way to the top of the aquatic food chain.

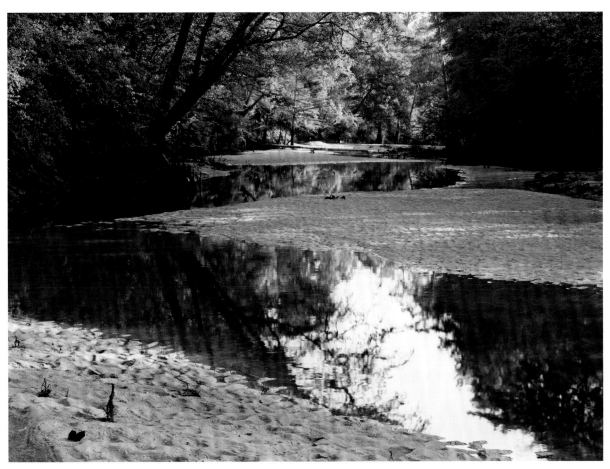

Old channel of Village Creek from campsite at dawn

In the gloom of early evening the minnows and bluegills swarmed the crayfish as they walked the edge of the pool. I decided to put a stop to the mayhem. When the killers appeared, I waved my arms. They retreated.

The crayfish kept coming. I was their protector. Shadows crept through the forest. Katydids replaced the rasping of the daytime cicadas, and a soft darkness enveloped us all. I was tired but pleased. I had saved hundreds of baby crustaceans.

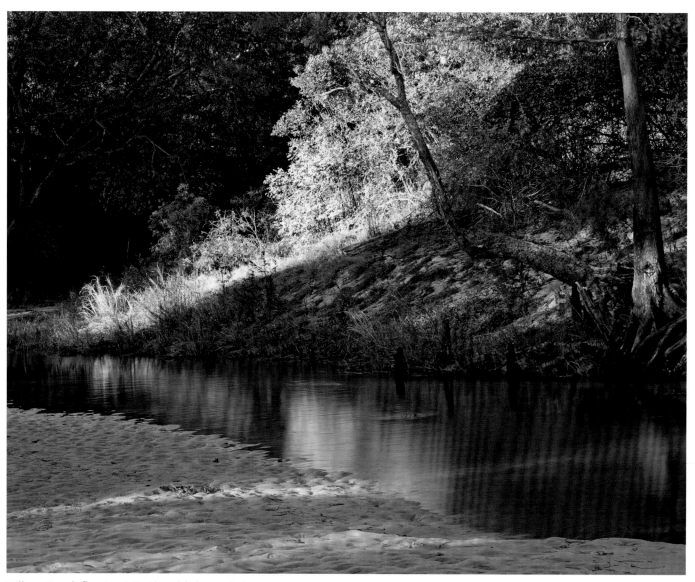

Village Creek flowing into the old channel at sunset

After dinner, Adrian and I returned to the stream. I expected to find a few crayfish but counted more than a hundred. Adrian found what we presumed to be the mother crayfish molting her exoskeleton, her body soft and squishy like jelly.

On our last day camping along Village Creek, the crayfish pool glowed like a fine jewel. I walked over the ribbed white sand to the end of the stream, where hundreds of crayfish had huddled like frightened immigrants. Not a single one could be seen.

Mussel tracks on the edge of Village Creek

I knelt in the sand, grateful I had seen baby crayfish by the hundreds. The luxuriant forest drew morning shadows like a mother pulling children to safety. I touched the water with both hands, prayed that the crayfish pool would always be here. I didn't want to lose the old channel like so many special places I had watched disappear in Texas.

I told Adrian that I felt addicted to nature and didn't want to leave.

"I think you're on to something," he said, raising his hands into a shaft of early morning sunlight.

We canoed toward the take-out where charred wood from campfires, like black scars against the white sand, broke the spell of the wilderness. It hurt to see all the trash, beer cans, and potato chip bags waiting for gusty winds to go sailing down the creek. Once we reached the bridge, there was a canoe rental business putting hordes of people on the water. Adrian and I approached the young man in charge.

We told him of a terrible trash problem upstream.

"What?" the young man said.

Adrian showed him sandbar locations on his GPS. The young man said he loved Village Creek, loved kayaking, and to prove his sincerity, he promptly paddled upstream to look at the mess we had described. His passion caught us off guard, made us hope the whole place wouldn't go to hell, that it wasn't just us who were mesmerized by wildness.

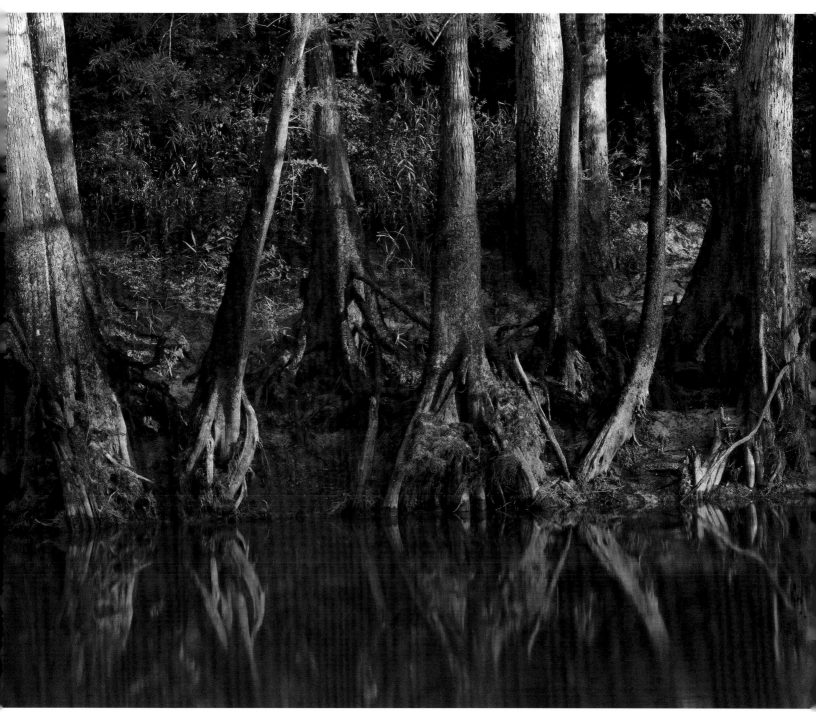

Cypress trees, Village Creek

Hobson Crossing and Lower Neches

August

With no rain since May, the Neches fell deep into the channel. Adrian chose a segment in the middle part of the river for our next trip. After we made camp and Adrian went off exploring, I watched the tail of a carp hovering above the river in a peculiar manner, like a mallard duck feeding upside down, but carp don't feed that way.

I canoed over to have a look. The carp raised its head above the water and fixed me with a desperate eye. I thought, *What's wrong, are you caught on a fishing hook?*

The fish disappeared under the water. I thought it must have been a temporary problem and all was well. I gazed downstream, pleased that I had photographed a twisted tree when the light was just right.

The carp pushed out of the water again. There was something black, like a branch from the bottom of the river, attached to the fish.

What can I do for you? I asked silently. The carp twisted its body nearly flat on the water. I leaned forward. Opening and closing its yellow lips in shallow breaths, the carp lifted the branch, which now appeared to be attached to its lower jaw. The fish seemed to be trying to show me its problem. I actually said out loud, "Go ahead, I'm watching."

As if the carp understood, it strained against the black branch until its eyes bulged grotesquely. From the murky depths, a knobby shell, rough like the skin of an alligator, rose to the surface. An alligator snapping turtle had its

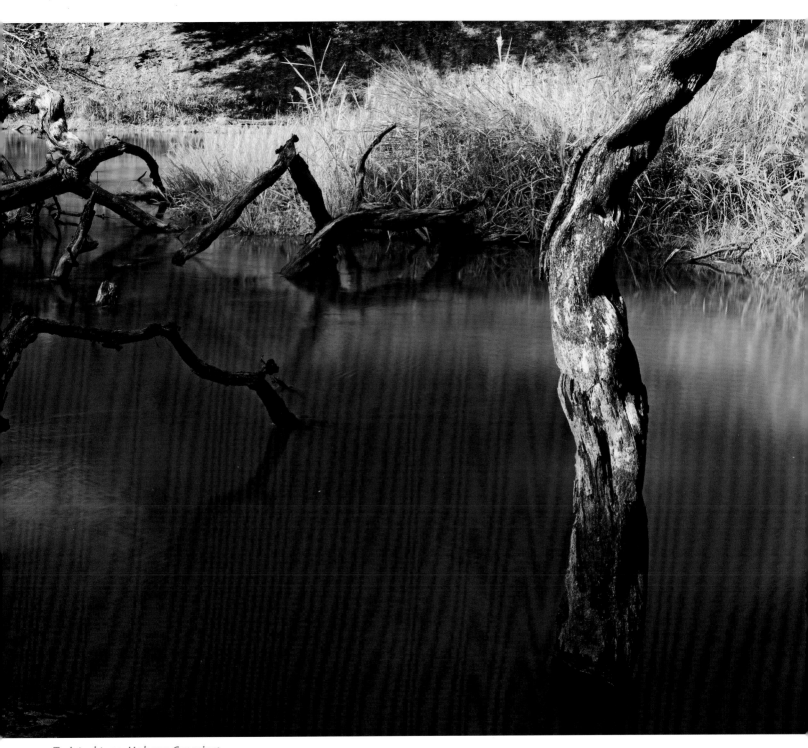

Twisted tree, Hobson Crossing

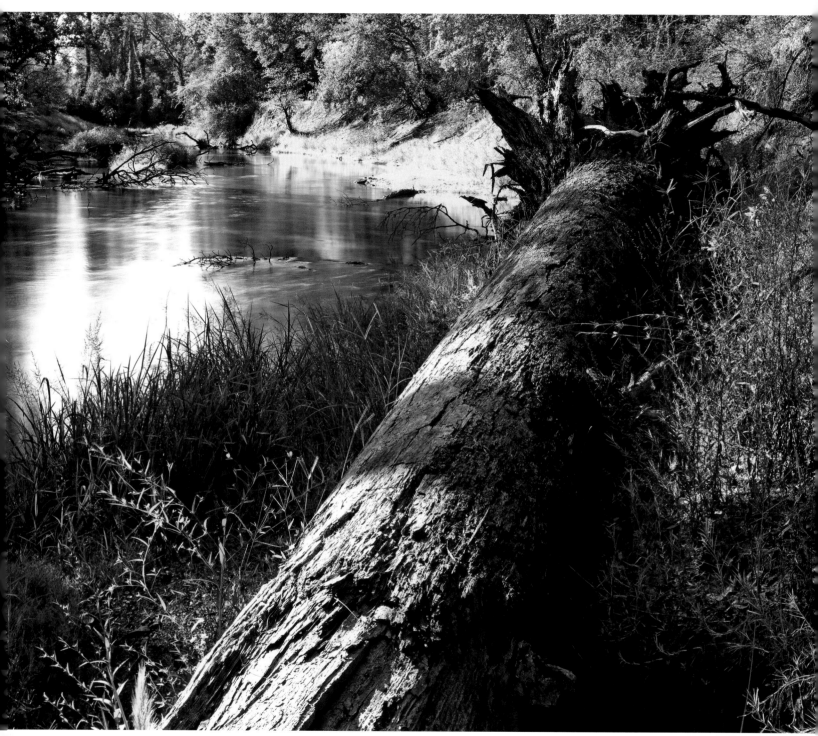

Uprooted tree from long-ago flood, Hobson Crossing

beak clamped on the carp's throat. The turtle jerked violently and the fish vanished in a swirl of water.

I scanned downstream, heard splashing upstream, and paddled there just in time to see the carp surface again, eyes more frightened than ever. Jaw and throat had been partially eaten away, its rich red gills exposed, and down it went.

Insects hummed like static. Vultures swooshed overhead. Dark and feathery, a cloud of blood spread into reflections around the canoe. *It's the way of nature; there was nothing you could do. Alligator snapping turtles need to eat too*, I told myself.

An hour later I found the carp's body snagged on a log. I waded into the river, gathered the fish in my arms, and placed it gently on the sand. The alligator snapper had eaten only the carp's fatty throat. I reached my hands under his supple body and slipped the fish back into the Neches for other turtles and minnows to eat.

Alligator snapping turtles are among the largest freshwater turtles in the world. In the wild males can exceed one hundred pounds, and in captivity they have grown close to three hundred. The one I saw probably weighed twenty to thirty pounds.

Snappers hunt live prey. By night, they actively swim around hunting. By day, they lie completely motionless on the bottom of a river while wagging a pink tongue that mimics a helpless worm. When a fish swims in close to investigate, powerful jaws clamp shut like a steel trap. Alligator snapping turtles, called loggerheads in East Texas, don't look tasty, but they are considered

Mutilated carp. Photo by © Adrian Van Dellen

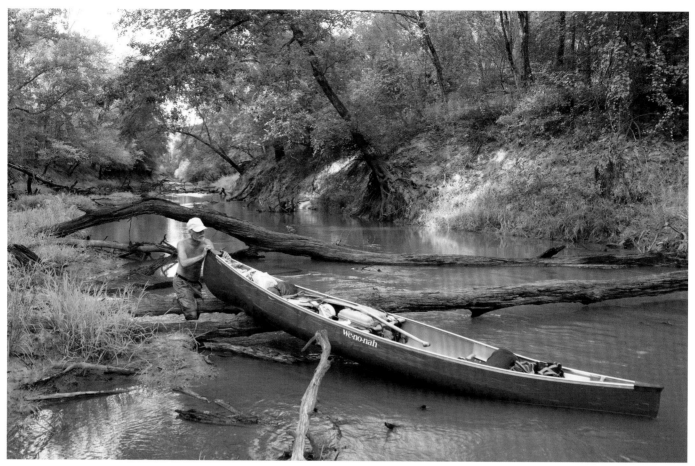

Author pushing canoe over fallen trees, Hobson Crossing. Photo by © Adrian Van Dellen

so delicious that people trap them and sell them out of state and abroad. Snapper numbers have decreased to the point that scientists have difficulty studying them in the wild. The Neches is one of the last rivers where they can still be found.

We moved camp in the morning. The logjams were so difficult that I had to get in the water and lift the back of our canoes up near my head while Adrian pulled from the front. Eventually we came to a stretch of more open water. Hundreds of common burrower mayflies fluttered from foxtail grasses. Three inches long, with a brown body and gray wings, they landed on my skin like soft kisses. One mayfly attached itself in the deep shade under my cap brim. We rode together as shadows chased away the heat. When a breath of cooler air swept the river, my mayfly flapped to the shore.

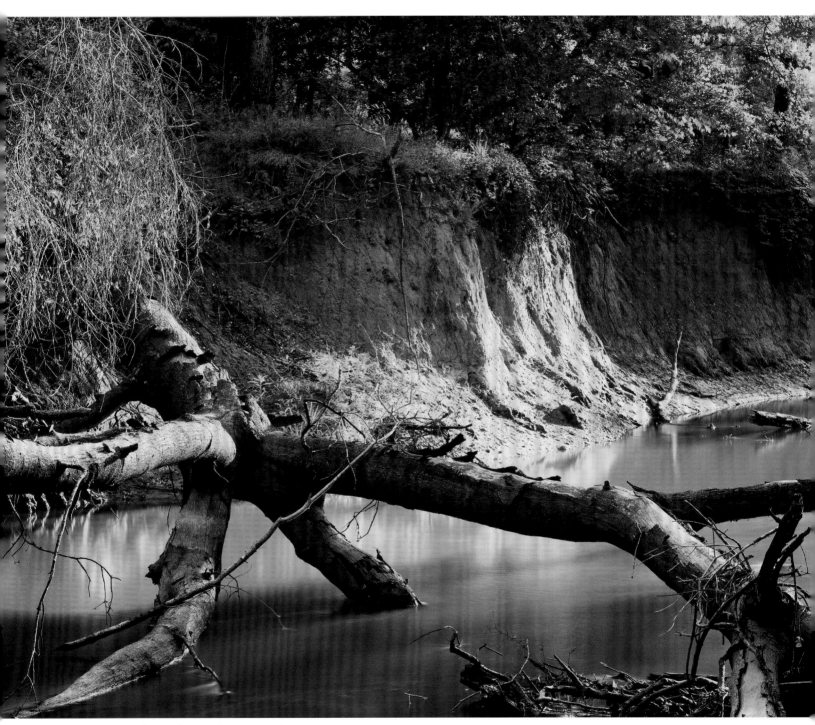

Logjam across the Neches, Hobson Crossing

Mayflies spend most of their lives as nymphs. As adults they usually hatch all at once in a brief flurry of mating before they die. Medieval Christian philosophers and artists celebrated mayflies as a link between heaven and earth. In the transformation from larva to winged adult, they were a symbol of Jesus's resurrection and the soul's redemption.

At our new campsite, I sat on my stool in the shade while Adrian cleaned his canoe.

"How can you be so energetic?" I said.

Adrian patted his flat stomach. "Sugar is a poison," he said, pointing at my second chocolate chip cookie of the morning. He grabbed several bags from his tent and placed them on the ground near my feet. "I start with the most complete multivitamins on the market." He showed me oblong brindle-brown pills that looked like speckled bird eggs. From other bags, twenty more supplements. "All designed to boost the immune system and suppress internal inflammatory responses." My stomach churned at the sight of so many pills, though I couldn't argue the results. At more than seventy, Adrian had the energy of someone half his age.

By late afternoon, I was ready to return to the place I most wanted to see, the reason we were canoeing this stretch of the Neches again—the red and green oxbow—one of the most interesting places I had found on the Neches. On our first visit a year ago a slight wind blowing from the southeast had pushed duckweed against a fallen tree, creating a surface of vivid green, while on the other side the water lay open and stained red.

That trip had been in October. It was hotter and drier now in August. I stripped to the waist, grabbed my camera, and headed out past familiar trees: water and willow oaks, sweetgums and shagbark hickories. Crossing a desolate sandy area where trees had rotted into gaping holes, I arrived at the high bank above the oxbow. Wonderful afternoon light streaked through the forest. I looked down. There wasn't a drop of water in the oxbow.

Returning to camp, I slipped into the river, water up to my nose. Above, two red-headed woodpeckers chattered softly on a dead tree. A third woodpecker arrived, and a fight began. I presumed that it was the two males wing-slapping each other like boxers. The female approached the dueling males and squawked so loudly that the entire woodpecker colony erupted in frenzied screaming until the interloper left.

Red-and-green oxbow, Hobson Crossing

I felt so grateful to be in an environment where so many creatures flourished. Adrian's Neches was indeed a special place, but it presented challenges for photographers. Greens and browns dominated, trees everywhere blocked the light, no rocks or deep canyons broke the green jungle. The Neches River belonged to the plants and the animals.

Strangely, in all the trips we had taken together, Adrian and I had never encountered other canoeists and campers. We had the Neches mostly to ourselves. We occasionally encountered people fishing, as well as lots of distant shooting, but otherwise the Neches belonged to *us*. Probably, modern Neches locals didn't like pulling loaded paddle boats over logjams.

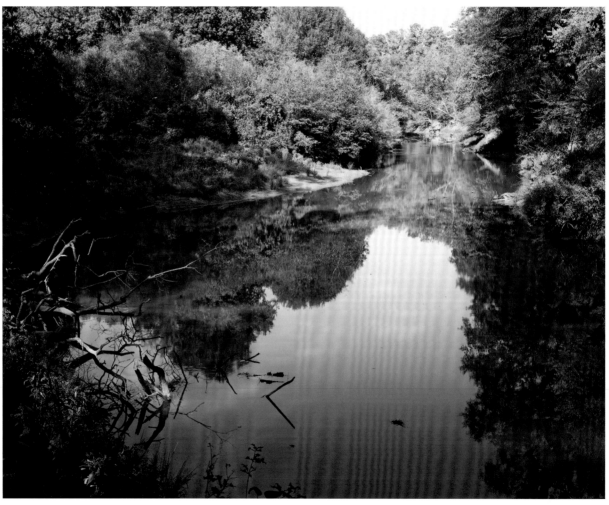

To the left, the entrance and exit of the red-and-green oxbow

I put on pants and walked the riverbank looking for Adrian. I found him working on sound recordings, with one of his microphones pointed toward the woodpeckers and the other at the water near his feet.

"Now I understand what you've been saying all along. The Neches is alive. Last night I got some good recordings of an owl and coyotes, and a strange tweet."

I told him I had heard the tweet and had prowled around looking for the source with a flashlight but didn't find it—as usual, I admitted.

"There's always something new, something surprising with every trip," Adrian said, hunching his shoulders, but he had a problem. His sensitive microphones reached beyond the Neches bottoms to pick up jet and truck sounds, and "that metallic sound that never goes away." I heard it too, a background noise of machines, cars, and fracking wells, the drone of human activity never entirely absent.

Sad to tell, we weren't really in the wilderness, just in a small part of Texas that had yet to be fully exploited. The grind of vehicles on pavement, compressors pressurizing fractured shale, trains, and heavy-duty saws shearing pine plantation trees corrupted all of Adrian's sound recordings.

The red-headed woodpeckers suddenly began squawking, a pair of crows cawed from across the river, and deep in the forest a barred owl hooted. Adrian jabbed his fist at the grating twenty-first-century noises. "It's not right. It's not fair to them." A strange thing to say, I thought, but Adrian was right. The bird sounds were millions of years old, the voice of the Neches bottomlands.

We sat by the water, clanking modern civilization be damned, and watched and listened to one of the greatest wildlife shows left in Texas. The next morning we packed up, left the river, and began driving home, but rather than stopping at Adrian's house, we kept driving south. I had plenty of film left.

Through a jumble of vines and dry swamps, we drove the long Timber Slough Road to the sunken Neches, which usually looked more like a lake than a river this far below Steinhagen. Hundreds of feet of sand separated us from the water. We slogged our canoes and gear down to the river and slipped into slack water under a cerulean sky. Within a short distance, we stopped on a pristine beach.

Trees sunk to the bottom of the Neches for decades lay exposed to the sun.

An old stump riddled with holes lay in a pool of blue water.

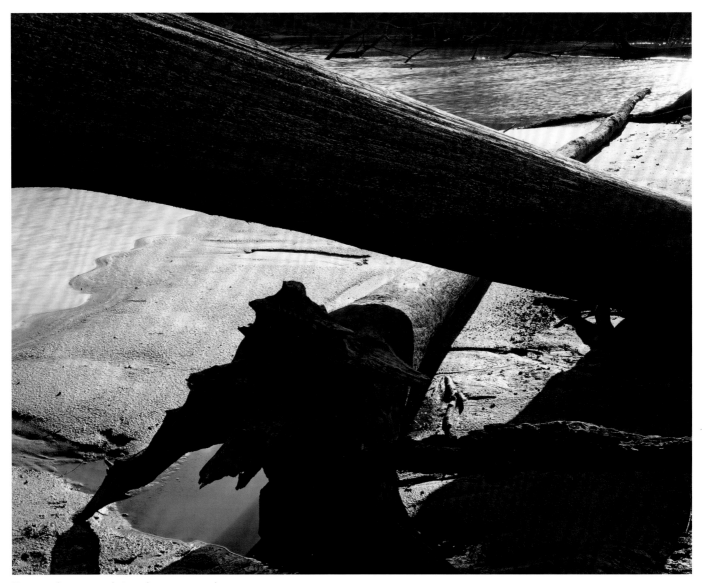

Exposed trees and river-bottom sand

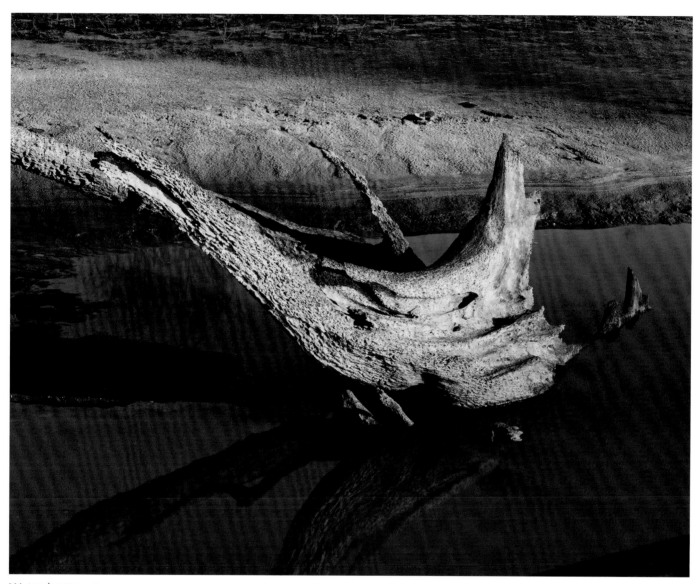

Water-beaten stump

Mussel tracks in river mud

Mussels burrowing through wet mud etched wandering loops that resembled hieroglyphic messages.

And a spiked tree hovered over the blue river like a war club.

I changed to a wide-angle lens and photographed a ghostly forest of long-dead trees.

The moon chased Venus across the southern sky during the night, and in the morning a slanting sun illuminated coyote tracks around my tent. I had used up all my film in just one day.

We left our private beach, and a mile downstream we found a simple one-room shack resting on dry sand. Screened in on all sides and connected to the high bank by steel drilling pipes, the owner had built his river house on top of oil barrels so it floated when the river rose.

Adrian walked up the wooden steps. I tested the screen door and turned to him. He shook his head. "It's dangerous," he said, so I went inside by myself. There I found beds nicely made and the kitchen table clean and a wind-up clock ticking past one fifteen. Somebody lived there.

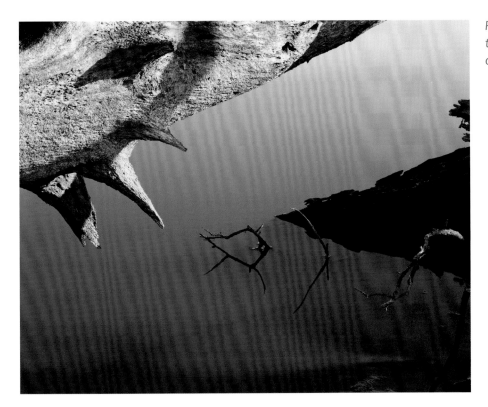

River-weathered tree hovering over the Neches

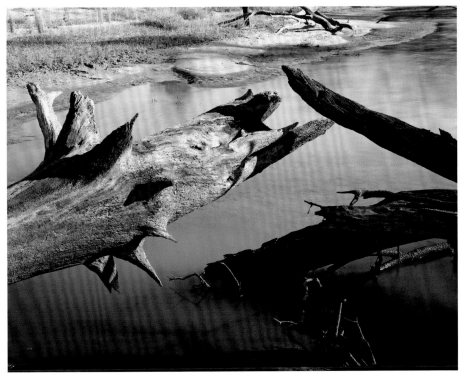

Exposed trees on spit of land

Outside on the wooden stairs, we ate our last ham-and-cheese sandwiches in the crisp sunshine. "My neighbor Budreau was married to an Eason," Adrian mused, pointing at the Eason name spray-painted above a window. "I think she was the only woman he was faithful to, though I'm not even sure about that." I nodded without comment, only vaguely interested in his story. "Budreau told me that if Barbara found out about his visits to dance halls, and she told her kin . . ." Adrian drew a hand dramatically across his throat. "They'd kill him."

If Budreau the wild man had been that worried about the Eason family, and we had been at their river house uninvited—the thought hit us at the same time. We jumped off the steps simultaneously.

I knew something about the Eason clan from a book, *The Stories of I. C. Eason, King of the Dog People*. The Easons had lived in the Big Thicket for nearly two centuries, hunting black bear while they lasted, then deer and wild hogs with cur dogs. The Big Thicket cur wasn't just a mongrel but a special kind of fierce stock and hunting dog. The Easons maintained minimal contact with the outside world, and their kids rarely went to school. Not until the 1960s and early 1970s, when the timber companies began to log their area, did the national spotlight shine on the Easons. They didn't have good title to their land. Nobody had ever wanted their swampy bottomlands before, but when the loggers had nothing left to cut they moved in with fake land deeds and tried to take the land. The Easons resisted, built a fence around their property, and with the help of a local lawyer battled the timber companies. There were threats, and fights, shots were fired, and the local lawyer died mysteriously, alone in his car from a blow to the back of his head.

Eventually, I. C. Eason went to court and saved the woods from the saw. Later he agreed to include his land in the thirteen-thousand-acre Jack Gore Baygall Unit of the Big Thicket National Preserve, the place where we were canoeing.

Thinking those thoughts, I heard something approaching on the bank above the river. I held my breath, worried my worst fears might be coming true. I waited for a one-eyed, tobacco-chewing, mad-as-hell Eason to arrive. Instead, an armadillo tumbled down the bank and headed straight for us. With a pinkish snout, a dull-gray plated leather body, erect ears, and black beady eyes shiny as wet mud, the armadillo bumped into Adrian's foot and sat up on its hind legs.

We backed up a few steps. The armadillo grunted, shook its head, sauntered toward Adrian's canoe, and walked into the Neches River. Just walked right in and disappeared from sight. A chill ran over my body. We stared at the water then stared at each other. After a few moments the armadillo poked above the surface on the far side of the river and climbed to the top of the bank. Then the armadillo turned toward us.

Instinctively, I waved. I felt we had received a communication.

The armadillo didn't wave back.

"You don't think . . . ?" I said.

"No, Charles, I don't," Adrian responded. He knew what I was thinking.

I wasn't sure what had just happened. I went back to the shack and apologized out loud to the Easons. "I'm very sorry. That was rude of me to come inside uninvited. Please forgive me. I meant no harm."

Adrian snorted. He watched me wearily as I approached his canoe but then shoved off before we could have a conversation about the odd armadillo. Adrian was never one for superstitious musings.

Silently, in single file, I followed Adrian's canoe down the river and into the dark, spooky waters of Johns Lake. We slid under cypress trees that blocked out the sky and passed a derelict clapboard house spread across the soggy land. An old woman emerged. Her growling dogs rushed at us. She screamed at them. I cringed.

At the boat landing, I rushed up the hill expecting to find my truck ruined, but my vehicle was fine. Even more amazing, I had left the doors unlocked.

"I guess I was being superstitious back there," I said to Adrian as we piled our gear and canoes into my truck. "I had this weird premonition—"

Adrian cut me off. Obviously, he didn't want to hear a word more about the strange armadillo or my dark thoughts.

I drove us down the long Timber Slough Road to Adrian's car, where a strong smell of gasoline hung in the air. "Might as well start driving and see what happens," I suggested.

His car started, moved fifty feet, then stopped with a coughing sputter. Someone had punctured his gas tank and stolen all the gas. I had read about this happening in Great Depression times, but apparently people still did it in the Big Thicket.

Without wasting a moment complaining, Adrian rooted inside his trunk for supplies. In the growing darkness, he crawled under his car and methodically

patched the gas tank with epoxy and something resembling a stick of chewing gum. I held the flashlight during the thirty minutes or so it took him to finish the work.

We drove to the nearest gas station in my diesel truck. As Adrian filled a water container with gasoline, a friendly sheriff arrived. He rubbed his hand along my green canoe, all the while describing his happy paddling days when he was a young man. We listened politely, nodded, and agreed that canoeing was indeed the greatest thing ever. When the sheriff finished his story, Adrian told him our story.

Immediately, he stopped smiling and backed away. "Gentlemen," he said waving a dismissive hand at us. "Timber Slough Road is not my jurisdiction." He drove off in his squad car without offering a word of help.

"Geez, that wasn't very nice," I said, watching his taillights vanish into the darkness. "I guess he was scared to go into outlaw country."

River-bottom people have lived around Johns Lake for a very long time. During the colonial era, when Spain owned Texas and Louisiana belonged to France, the two European powers couldn't agree on the border. This part of deep East Texas became a no-man's-land. Criminals from Kentucky and Tennessee and parts in between settled in the Big Thicket. Probably every family at Johns Lake had a relative who had fled justice.

With two gallons of gas in Adrian's car, we limped home near dawn. At the Triple Creek RV Music Park the following night, I asked around about the Easons. "Y'all be careful out there," a lanky, big-boned fiddler told me. "Them Easons aren't people to be messed with. They'll cut you before you can say Jack Daniel."

It occurred to me that we were very lucky. We had lost only eight dollars' worth of gas.

San Pedro Creek

September

The Spaniards traversed the breadth of Texas in 1690 to stop the Louisiana French from advancing west. They built a mission, San Francisco de los Tejas, on the upper section of San Pedro Creek a few miles from the Neches. Four years later they abandoned it. The French weren't that interested in Texas, and the local Caddo Indians listened to the Gospel only for trade goods and horses. Nor did they like the Spanish soldiers paying attention to their women.

Close to the Neches, downstream from San Pedro Creek, history has left another mark. Behind the Caddo Mounds State Historic Site and within walking distance of El Camino Real (meaning the king's highway, which once stretched from Mexico City to Natchitoches, Louisiana, and is now known as Highway 21), lies the African American community of Weeping Mary.

Nobody knows the origin of the name Weeping Mary for certain. According to the *Cherokeean Herald*, "The name is derived from Mary Magdalene weeping at Jesus's tomb as described in the 20th chapter of the Biblical book of John."

Perhaps, but O. Rufus Lovett, during an interview on NPR's *All Things Considered*, suggested an equally likely story: "There was a lady named Mary who lived there. Folklore has it, anyway, that a white man wanted to purchase her land. And she did not want to sell it to a white man. The man in question persuaded a black man to purchase the land for him instead. So Mary was tricked out of selling her land to another African American. She became very distraught over this and wept and wept. She became known as 'Weeping Mary,' and the community later adopted the name."

On the record, two freed sisters, named Nancy and Emily Ross, purchased land that included a section of Bowles Creek to found the community now known as Weeping Mary. In 2000 the population had been estimated at forty, but as Adrian and I drove past the Baptist church of Weeping Mary on the way to the put-in for San Pedro Creek, I thought I saw a lot more people than that, perhaps as many as two hundred. Dozens of folks walked the dirt streets or visited outside ramshackle houses, and a young man rode a horse bareback, trailing a pack of children.

The Weeping Mary inhabitants eyed us warily as we drove past the Baptist church glistening in the sun, sitting alone and majestic on top of a hill. We lowered our windows and waved. A young woman smiled and a few waved back.

Finally, at the end of a dusty white road, Adrian pulled over and announced that we had arrived at the put-in for San Pedro Creek. As the plumes of caliche dust settled, there didn't appear to be enough water in the Neches for a canoe trip. I had discussed low water and logjams with Adrian before, and he had agreed such things should be avoided. But now here we were once again. There seemed hardly enough water to get our canoes into the river.

"There might be a few problem spots," Adrian admitted, "but we'll manage. We always do."

I sloshed warm river water over my head and moved into the shade. Adrian claimed to have given up organized religion for science, but I wondered if that was entirely true. I pointed out that a heat index record of 114 degrees had been predicted.

"It is a touch warm," was his assessment, delivered in an even tone that suggested the weather was just about perfect. He whistled as he trudged up the hill for more gear.

"We'll manage," I had been told, but the sun burned like a blowtorch, and somewhere in the woods a fire burned. A smoky haze hung over the Neches. Normal people would go home, but I supposed there were none of them out here, only crazy photographers. Although I didn't have Adrian's Calvinist upbringing, I had a religious willingness to suffer for wholeness, a desire for mind-body unity, a giving of oneself to a higher power—except that, for us, that higher power was a semiwild river that might take us into a forest fire or a heat stroke.

For seven hours we yanked and sawed and pulled boats, each logjam a boiling misery. At one point the smoke grew so thick I wanted to turn back. "So, you want to repeat all those logjams?" Adrian said. I tossed a scoop of water over my head and followed him into the whiteness, expecting to see flames, but we never did.

We arrived at our campsite too late for photography. We ate dinner in the dark and stumbled into our tents, wet as sponges. Morning came. Adrian worked on his sound recording equipment—very technical stuff, with eighty-seven different settings, he reported. I sat under a tree, listening to crows and insects. We had camped on a sandy beach where a toppled pine tree reached

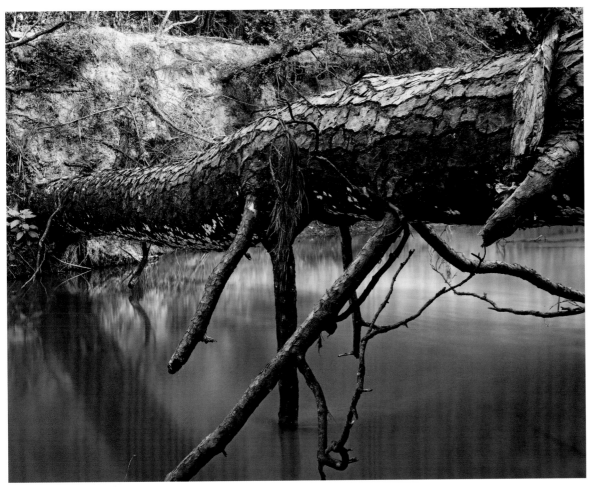

Pine tree spanning the Neches, like a bridge to the Promised Land

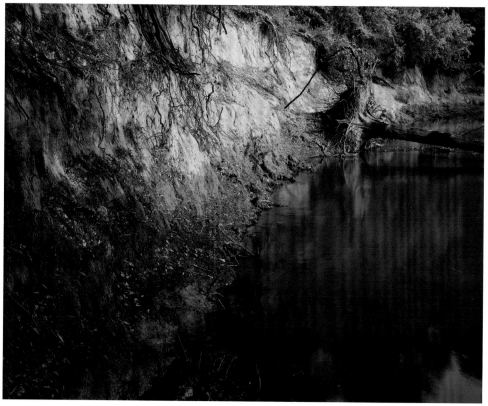

Sunset on curving high bank

across the narrow Neches. On the other side, a glow widened, as if the tree served as a bridge to the Promised Land.

The battle with the logjams the previous day required a day of rest. I spent most of it in the river or napping in the shade, and by sunset I felt invigorated enough to take my camera and hunt the fading light. Along the curving high bank, the sand glowed red as if the forest fire burned underneath.

After taking that photograph I went to my tent, whose unzipped door uncharacteristically flapped in the breeze. I had left it open all day, a fateful mistake on the Neches River. I poked at the sleeping bag, moved items around just in case there was a snake inside, and in the process disturbed mosquitoes, green lacewings, daddy longlegs, flies that buzzed like wasps, beetles that buzzed like flies, and two hairy wolf spiders.

I wasn't sure what to do—spend thirty minutes chasing down the bugs or let the spiders take care of them. Like tarantulas, wolf spiders are vigorous

ground hunters that eat pretty much anything they can catch. Since I couldn't recall ever being bitten by a wolf spider and I felt very tired, why not let them hunt all night? I slept the night drenched in sweat, a deep wonderful sleep, and awoke to the familiar cardinals heralding the arrival of a new day.

I felt pleased that the insects were gone, though I did note swollen bumps on my face and red welts on my arms. Well-fed wolf spiders rested on the floor near my pillow. I tossed them outside, rather angry the ungrateful spiders had chewed on me.

Originally, wolf spiders were believed to hunt in packs like wolves, but actually they hunt alone. They are venomous, though their bite is mild. The bumps and welts didn't hurt or itch, and they soon went away.

Light graced the curving bank from the opposite direction of the spot I had photographed the day before. A ray of sun sliced the gravel bar. Daddy

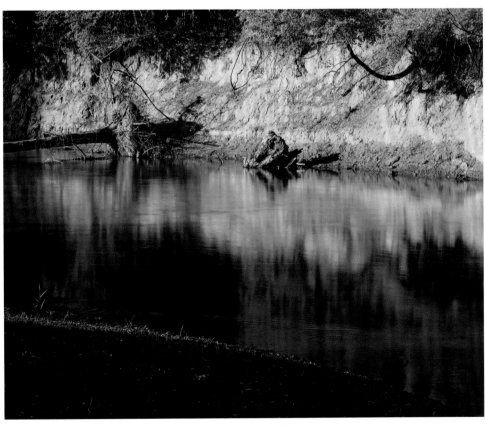

Morning light slanting across the gravel beach at the edge of the river

longlegs crawled up my legs, little guys mostly. They explored my hands and camera, and one reached my forehead and gently probed my eyeball with a long feeler. This happens because I often stand in one place for long periods looking at photographic possibilities.

Daddy longlegs have two eyes, like us, rather than the eight eyes of a spider. A long-held myth that they are venomous with sharp fangs is completely false. Daddy longlegs are vegetarian harvesters, but when they group together, always in a dark place like the ceiling of a shed, they vibrate all at once like a dangerous mass of angry spiders.

The following day we began packing our canoes for the trip farther downriver to San Pedro Creek. The heat still seemed almost unbearable. I jumped

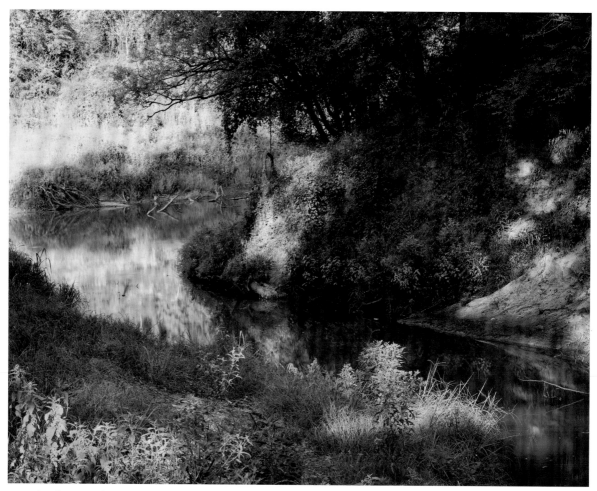

Mouth of San Pedro Creek

in the river to cool off, and Adrian finally got in the river for the first time. "Only to wash the sweat from my clothes," he explained.

Soon we set out, me with a small wet towel draped over my head. It helped with the heat and I noticed an added benefit—wild animals didn't seem to recognize me. At one point a young boar with six-inch tusks followed my canoe along the shore. Sniffing the air, he moved into the water only a few feet away. I waved the paddle and yelled. He grunted and moved up the bank, hesitated for a moment, and then seemed to finally catch my scent. He barked and bolted for the woods.

During the fierce heat, wildlife had come down to the river. Near San Pedro Creek, I flushed a coyote resting in the cool mud. He scampered through tall

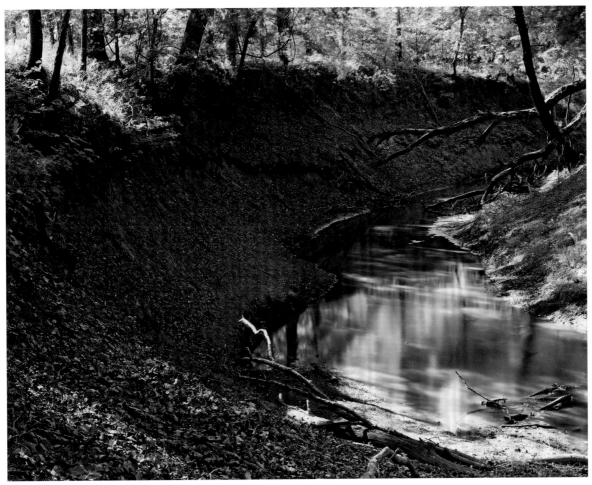

San Pedro Creek

grasses, had second thoughts, turned to face me, and then sat on his haunches. If I didn't move, I wasn't a threat, and I didn't have a human head.

I turned into the mouth of the creek and eased the canoe to the shore. Eyes burning from the intense light, head throbbing from a long day in the sun, I walked a narrow game trail down the steep bank of San Pedro. I became groggy in the thick air, settled on the ground, then fell into a sleepy trance.

As I began to awaken, a black-winged damselfly flew over my face and landed in dense green foliage. It had a glowing iridescent turquoise body, with ebony wings opening and folding. I rose up on an elbow to get a better look. An indigo bunting bathed in the riffles. Chickadees, tufted titmice, and kinglets flashed in brilliant catches of feathery sunshine.

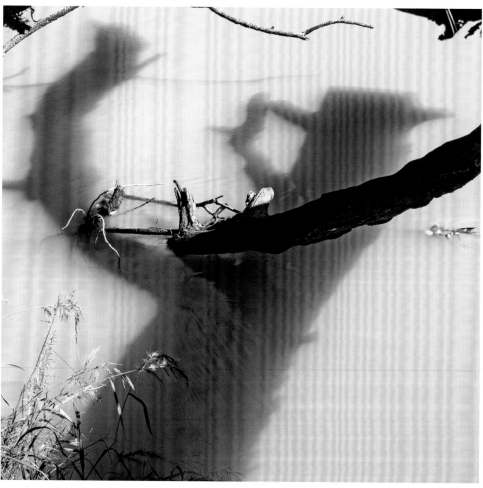

Shadow with hat

The effort to pay attention seemed too much. I fell back onto the hard dirt into a stupor of light and darkness. Birds sang intensely. I rolled over onto my stomach, expecting to see one of the singing birds a few inches away, but there were none. I rose again, wobbled into blackness, and crumpled to the ground as if the earth were pulling me inside.

San Pedro Creek whispered. Crows in the distance cawed insistently, and then the unexpected happened. Rumbles of thunder, a flutter of cool wind, and the birds went quiet. I rolled over onto all fours, managed to stand. In the shallows of the Neches, the shadow of a tree branch wore a hat and waved at the divine life of the river, or so it seemed.

A cloud passed over. The shadow wearing the hat waved goodbye. I looked up into the sky at gathering blackness and rushed back to camp. The twin overcup oaks above our tents clapped their big leaves as if cheering the coming storm. "We've got to cover the kitchen," Adrian said, working frantically.

Kitchen secured, Adrian saluted me like the military officer he had once been and jumped inside his tent. Day turned into night. I lifted my face into the rain, soothing and cooling.

I kept myself busy sopping up small pools of water gathering on the tent floor. A gust of wind ripped through and a massive tree crashed to the ground. Staccato cracking, then silence. Tension drained from my body. I opened the rainfly and found that the storm had passed to the north. Green leaves fluttered ever so slightly, and a hazy sun suffused the air. I stepped outside.

A passel of small frogs and toads the size of quarters hopped into the camp kitchen and sat on top of our food containers like lords of the wet earth. They lifted their glittering heads toward the sun, grateful pilgrims like us.

Barred owls visited our camp that night. I scanned the trees with a flashlight and disturbed a great blue heron fishing by moonlight in the drying pond above our camp. Passing overhead honking like he was being strangled, the bird dropped a wet load of excrement on my tent.

There was a splash and then another, somewhere down the creek. I saw nothing, but the next morning I found mysterious skid marks and indentations. As usual, wildlife had done something weird that I couldn't figure out.

On the canoe trip out that day, I covered my head and shoulders with the same wet brown towel. Adrian lingered behind with his sound-recording equipment. After a while I came upon a dead branch over the middle of the river with a hawk perched on it. The current swept me forward.

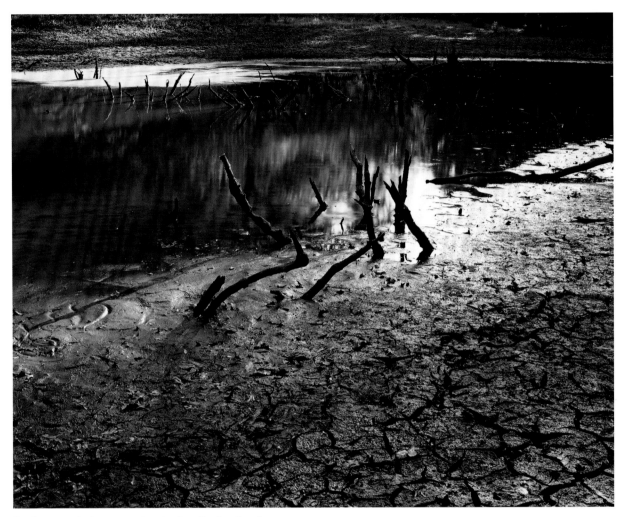

Drying pond above our tents, San Pedro Creek

Sitting proud and intense, the red-shouldered hawk looked at me with fierce yellow eyes. The hawk, like the wild pig and the coyote, didn't seem to know who or what I was. Humans never go around under brown towels. He bobbed his head side to side and up and down and opened his black beak as if to speak. Ruffling his tawny breast feathers, he never took his eyes off me. I floated directly underneath him, close enough I could have grabbed his yellow legs had I launched myself from the boat.

I looked over my shoulder expecting to see startled eyes, but I was the one who was startled. The branch was empty. He had flown off without making a sound.

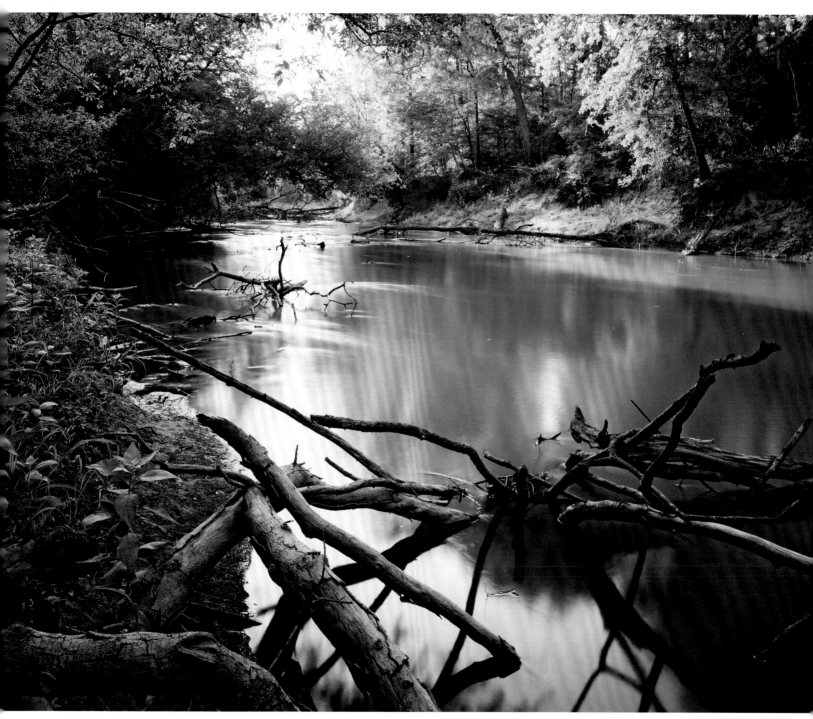

Neches River and branches near sunset

Big Slough Wilderness Area
October

The drought intensified. I could handle the low water, but I had serious doubts about traveling the Neches River in late October as Adrian suggested. East Texas hunters begin the deer season early, at least a month before the legal date in November.

East Texas hunters are fast on the trigger. In the 1970s, Texas Parks and Wildlife tried to crack down on illegal deer hunting. They set a life-size plastic deer close to a well-traveled dirt road. Almost every vehicle that passed by stopped to shoot at "Bucky," as it was known among game wardens. Children as young as ten hoisted high-powered rifles and fired away. As the story goes, this antipoaching operation ended when ninety-year-old Ethyl arrived in a beat-up truck. She laid her rifle across the hood and emptied an entire clip into the deer's head while cursing a blue streak because the deer wouldn't fall over dead.

"We can't arrest everybody," one of the game wardens said later. "Besides, it ain't right to put an old woman in jail."

Adrian promised that the Big Slough Wilderness Area remained so inaccessible we wouldn't run into hunters. From the bridge over Highway 21 we launched our boats and became immediately entrapped by trees resting on the bottom of the river. We labored throughout the day across logjam after logjam. The sky darkened. Drizzle turned into a steady washing. Through a misty world of vague shapes, rain hissed on the water like an angry snake, and a thrashing storm ripped across the Neches.

Suddenly, the channel came to an abrupt end, and a wall of forest blocked our passage. Before I could figure out what to do, Adrian pulled to shore, stepped out of his boat, and yelled over his shoulder. "I have to be certain this is the wrong way."

"We should turn around and look for the right channel," I yelled back, but Adrian had vanished into a curtain of rain.

Astounded by his abrupt disappearance, I pulled my canoe under a fallen tree for protection and waited. Nestled inside a tarp covering my gear, I noticed an American green tree frog staring at me. Its eyes resembled dark marbles speckled with flecks of golden foil. The rain whooshed, brown rivulets poured off the dead tree, and water in the canoe rose over my ankles. I leaned closer to my visitor. Almost eyeball to eyeball, I gazed into the frog's eyes— yellow mirrors shining like galaxies on a bright clear night.

A gusty wind blew my canoe into the open. I fought to get it back under the shelter of the downed tree then relaxed a little. I wasn't in serious danger. The water was shallow, and when I thought about it more, I was exactly where I wanted to be: ringside to a raging thunderstorm with a tree frog for company.

My new friend appeared to be smiling. A beige line curved from the side of its mouth and angled down its green torso like a racing stripe. Clusters of small bumps distinguished its head and back, and its long toes had suction cups on the tips. But most extraordinary was the color contrast of the frog's vibrant green body against my bright blue tarp.

A fearsome rush of wind climbed up the trunk of a nearby oak tree, and leaves became green confetti. Branches rubbed suggestively then parted as if embarrassed at so much intimacy. The milky curtain opened, the woods materialized. It was as if a new act in the thunderstorm was about to begin.

"Oh, what a great storm this is," I said, turning to the frog. But the frog was gone. I pulled apart every fold of the tarp and canoed into the storm looking for my lost friend.

I had a sudden thought. Why linger on the frog's disappearance? I had been given a gift. The frog's joy had been my joy, his wet world my world. Lashed by rain, water filling my canoe, I looked around without concern. I had been thinking about the river all wrong. The Neches wasn't a series of photographic opportunities but a muddy kingdom, an intact ecosystem of incomparable quality. The Japanese had come up with the concept of the forest

bath, *shinrin-yoku*, where one experiences health and wellness from a day in the woods breathing organic compounds. The Neches had that effect on me.

And today I had received a damn good *shinrin-yoku*. When Adrian the pathfinder returned, deeply chagrined by his mistake of taking us down a dead-end slough, he wouldn't look my way even though I said soothing words as he passed by.

I followed him down the Neches, bailing water, drifting in the fading light. By morning at our new campsite, majestic silence folded around our tents. Trees barely stirred. Cool air lay upon the sleepy forest, and rich organic odors signaled relief from the long sorrow of heat and drought. We were camped on the northern corner of the five-square-mile Big Slough Island. Bounded on the west by the slough, an old channel of the Neches, and on the east and south by the Neches River, the island was a primeval world. An undisturbed bottomland hardwood forest of willow, overcup, water, and swamp chestnut oaks covered the landscape. Along the bank near our tents, a thick stand of river elms twisted toward the river. Farther away were hickories, sweetgums, and on the highest ground a few towering loblolly pines.

I moved down the Neches River, detouring around pockets of impenetrable vines, greenbrier, switch cane, and yaupon. Leaving my camera beside a giant tree sprawled across the ground, I walked toward the unseen slough, scouting another photograph. I found a promising spot, but for a while I couldn't find my way back to the sprawling giant tree or my camera. I was, as the locals say, "turned around." The light slid into gloom, the forest closed into blackness. I hurried back to camp by following the river and bumped into Adrian, wandering lost like myself.

The next day, walking the edge of the Neches in the somber gray of dawn, I saw a river otter climb onto a log. Tracks abounded, but this was the first otter I'd seen in more than two years of canoeing the river. I expected it to dive and disappear at any moment. I didn't move. I didn't blink. Bugs crawled around my eyes.

Thin, lightly colored, and probably born the previous spring, the young otter straddled a sunken tree and held a good-size carp in its mouth. Face to face, the carp and otter looked like they were smooching, though I doubted the fish enjoyed the intimacy. Firmly held, only the carp's tail moved in a feeble twitch.

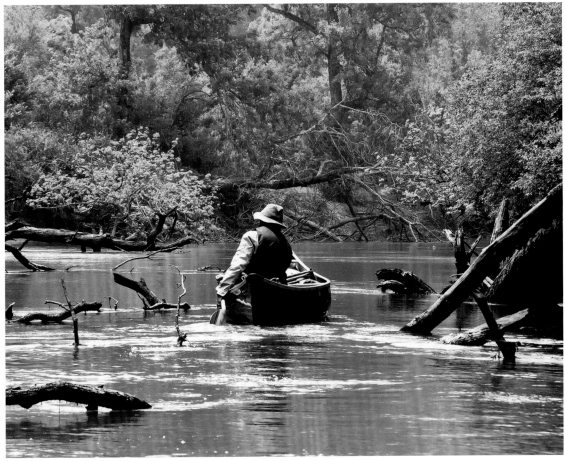

Author canoeing the Neches, Big Slough Wilderness Area. Photo by © Adrian Van Dellen

The otter positioned the fish's head somewhat sideways in the back of its jaw, and the gruesome sound of crunching began. Fish scales popped off into a pile. Bones were pulverized, guts eaten. Finally, the otter looked skyward and swallowed the tail. Its meal finished, the young otter sipped water, then slid into the river without a backward glance.

I would have liked to stay longer and look for more images, but we had planned for just six days on the river, and it was already the seventh day.

For the next two days we rose in the morning, ate lunch in our canoes, and paddled and struggled over logjams till dark. The fierce storm had raised the Neches no more than an inch. Big Slough Island divides the river into two channels, making the main channel even narrower.

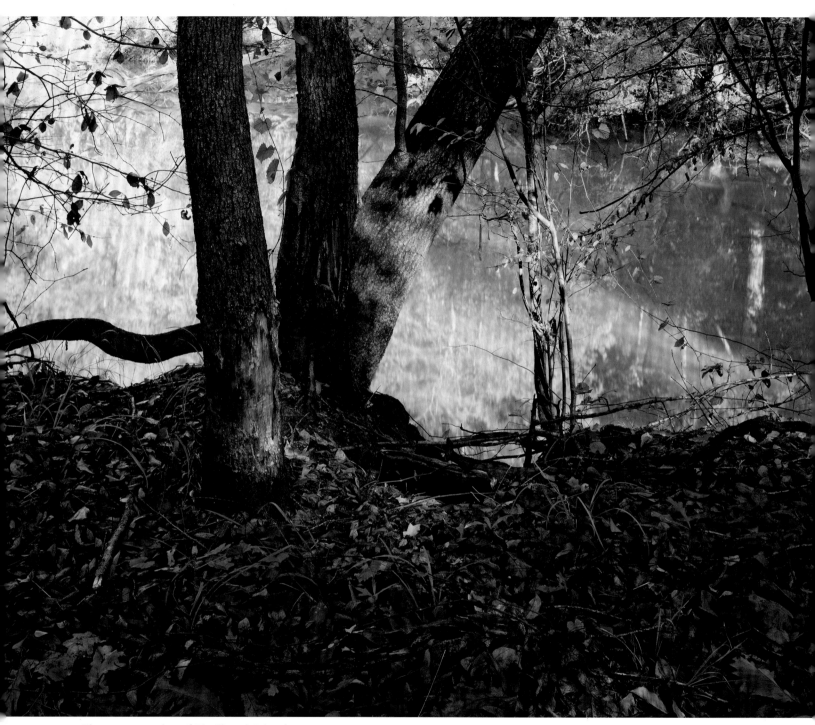

Three trees, edge of Big Slough Island

Time ran together, but at one point a blue-winged teal appeared overhead with a red-shouldered hawk in close pursuit. Flashing wing tips to maintain control, the hawk's talons dropped open and extended. At the final moment before contact, the blue-winged teal pulled her wings in tight and dove into the river directly in front of a sandy bank. The hawk frantically pulled up and crashed into a tree. The last thing I saw before rounding a bend was the hawk sitting on a limb grooming its wings, while the duck paddled underneath, calm and unharmed. Apparently, a duck on water is as safe from a red-shouldered hawk as a rabbit in its hole.

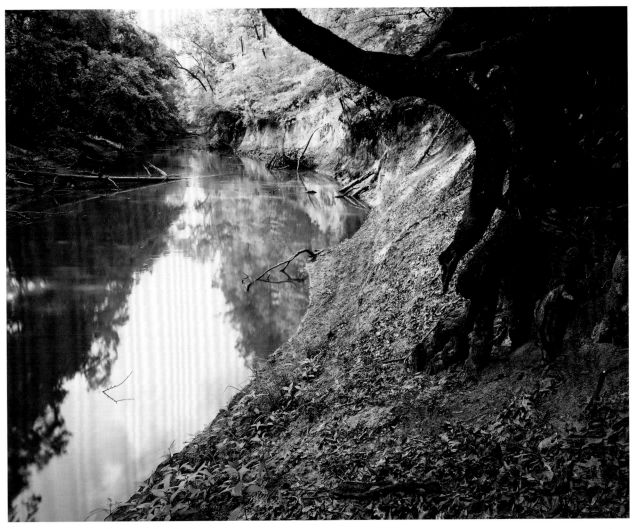

A rare clear stretch down the Neches

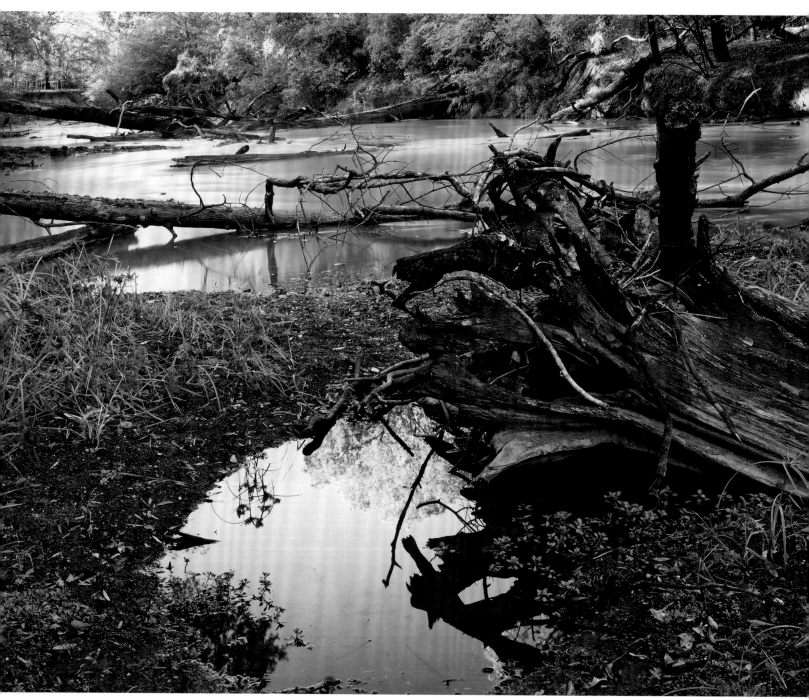

Small pool at the edge of the gravel bar, near final campsite of Big Slough Island trip

We stopped on a gravel bar. "This is it," Adrian announced, checking his GPS unit. "This is our final camp. We've made it through a difficult part of the river and all is well."

At breakfast the next day we were finishing the last of our food—tomato soup and pine nuts—when a sheriff's helicopter that wouldn't go away disrupted the serenity of our camp.

It circled around and around. Was the helicopter pursuing deer poachers? Deer season was a week away, but you would never guess that from all the gunfire, now that we were out of the wilderness area.

Then a booming voice commanded, "Move to an area where we can clearly see you."

I looked at Adrian. "Are you in trouble with the law?"

He dismissed my question with a shrug, and we obeyed the helicopter and moved to an open spot.

"Are you Adrian Van Dellen and Charles Kruvand?"

That's odd, I thought. The man in the helicopter had pronounced my last name perfectly. Three times the sheriff's helicopter circled and asked the same identifying question, and three times we waved as instructed.

"Do you need food?" We didn't. We could take care of ourselves.

"Do you need medical attention?" I was indignant. Who did he think he was talking to, a couple of amateurs?

"Okay, we will notify your wife Pamela that you're okay."

So, that explained everything. When we didn't show up after nine days, Pamela had called the Cherokee County sheriff. Based on the description she had given him, he wasn't sure Adrian and I could safely canoe the Neches River during a historic drought.

The Beavers of Chinquapin Ridge

November

On a cool and clear November day, I circled an island on a section of the Neches called Chinquapin Ridge. Discovering a bank hole where tree roots were rubbed bare from beavers crawling in and out, Adrian insisted we immediately camp on a peninsula jutting toward the island. He placed his digital camera on a tripod and pointed it down at the underground beaver house.

He planned to stay up all night, if necessary, to photograph a beaver. Adrian had been trying to photograph one of these nocturnal creatures, with unimpressive results, but he never wavered. Beavers were an integral part of the Neches ecosystem, and Adrian wanted to document feeding habits. Contrary to what some locals believed, beavers don't eat fish. They are strict vegetarians, and the trees along the river showed that.

The first night by the beaver island a barred owl chose a limb above my tent to practice hooting. He went on and on, and finally I got up and shined a flashlight up into the trees. There was nothing there. I went back to bed, and the owl started up again. I took two flashlights outside and pointed them up into the trees like searchlights. Nothing. I prowled the woods around camp without hearing or seeing anything, went back to the tent, got undressed, climbed inside the sleeping bag, and then WHAM—BANG, BANG, BANG—a beaver slapped its tail on the surface of the river. That cursed owl started laughing: *He he, ha ha, oo-hoo-whoo*. I got out of bed, flashlights blazing, and it was as quiet and still as if I were on the moon. I needed earplugs.

Groggy from lack of sleep, Adrian called me over the moment I stepped out of my tent the next morning. "You've got to see this," he said. Was it possible his plan to wake up every thirty minutes and photograph the beaver hole had actually worked? Adrian scrolled fifty static images of the beaver island on his camera screen. "Did you see that?" he asked.

I wasn't sure what he was showing me. I didn't see a beaver. In fact, I didn't see anything. I shook my head, no.

Adrian motioned for me to come closer. "See, there's a branch," and he showed me a photograph of a stick close to the hole, then he scrolled to a new image. "And now—look, it's gone!" he said, triumphant.

"Well, I'll be," I replied, studying Adrian's jerky movements. I suspected he had been sipping coffee all night. His hands trembled and his eyes blinked in sudden fits like a bad lightbulb. While I considered the possibility he was tipping over into beaver psychosis, a red sun lifted over the horizon. Mist and fog boiled from the river. There was a rush of light. The beaver lagoon erupted in luminous brilliance.

I raced to set up my camera. Under the dark cloth, completely absorbed in composing the photograph, I flew to the trees, skimmed the river, and blew in and out of red and yellow fog. I saw the whole scene and all the details at the same time as if I had multiple eyes, and I was everywhere at once. Whether the composition process lasted three minutes or thirty seconds, this photograph was one of the most exciting I had ever taken.

The sun pulled higher. Morning light swept over the beaver lagoon, and all that remained were tendrils of fog and a blue sky.

I found Adrian down at the river photographing the beaver island, which pleased me; at least he wasn't photographing beaver paw prints. On one of our recent canoe trips, he had been so obsessed with following where the rodents had walked that he never saw the stout limb blocking his path. After a violent crash, he got to his feet, wobbled a bit, tilted his head to the side (presumably to keep the trickling blood out of his eyes), and resumed the paw-print investigation.

Night descended, and from inside the island a baby beaver mewed like a kitten crying for milk. Then the beaver kit stopped mewing, and the mama beaver began gnawing on a tree limb like a grinder stripping bark.

Adrian planned something different for this night shot. He had rigged a custom-made, fast-shooting beaver camera attached to a gun stock. His set-up

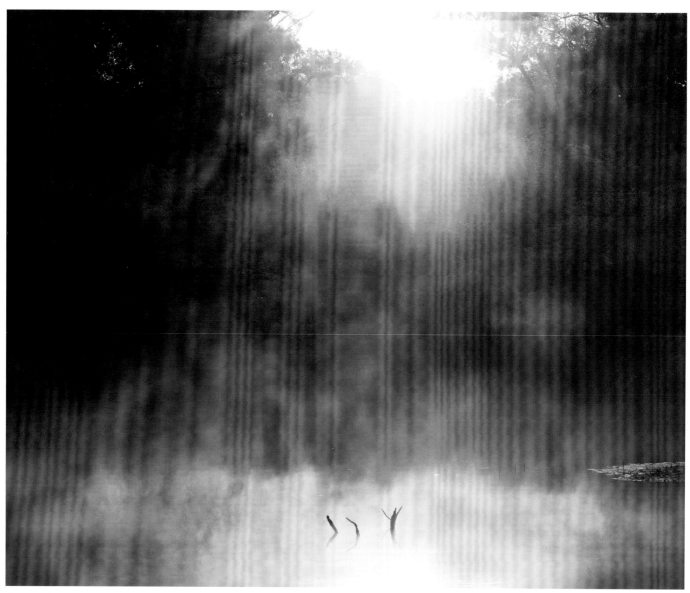

Beaver lagoon

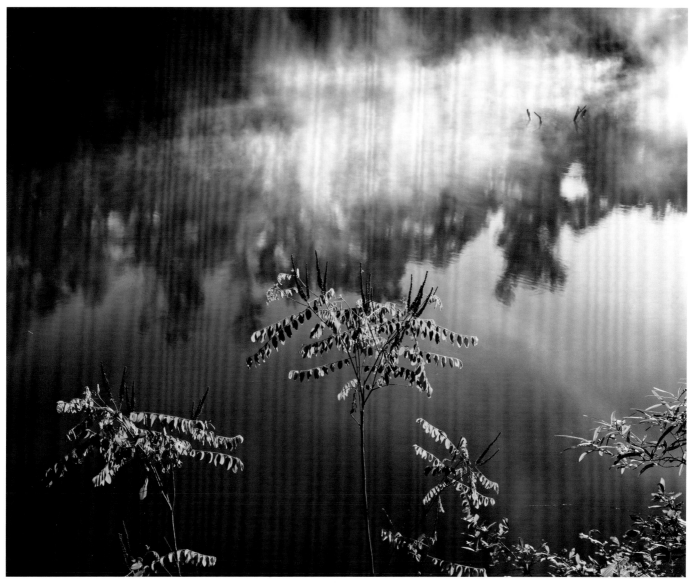

Another view of the beaver lagoon

resembled a rocket launcher with a flashlight taped to the top. I pushed his camera rig against a shoulder and lowered my head as if sighting in a rifle; the eyepiece seemed perfectly situated to make a quick close-up of a beaver doing something beaverish. I was impressed and asked if I could tag along.

He somewhat discouraged this, but I followed him anyway. With a flashlight pointed ahead and a full moon shining in front, the woods had no depth. There weren't shadows to give objects on the ground solid form. I lagged behind Adrian, tripping over trees that appeared to be small sticks. I thought this was hilarious. It resembled certain memories from childhood.

After a while, I gave up following Adrian and made my way to the Neches without knowing where he went. The moon shimmered on the water. Clouds

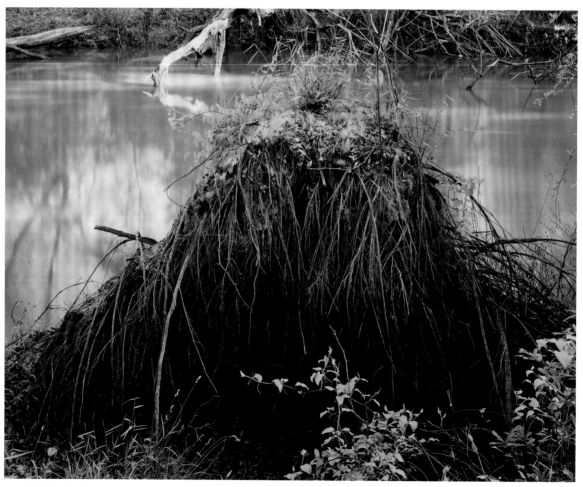

Rootball of a fallen tree below the beaver island

locked together like a jigsaw puzzle. I hoped that somewhere on the other side a mama beaver was dragging food to the river.

Suddenly, Adrian's powerful flash erupted. "Did you get a beaver?" I asked. Just a test, I was told.

Time passed and the moon slipped through cracks in the clouds. A silky breeze rustled the leaves. I slid against a tree trunk and sat in the dirt. Another Adrian flash. There was a mad jumble of jungle, a crisscross of crazy woods, and then the forest disappeared into cavelike blackness.

I could feel every cell in my body opening up to the Neches. I rose up onto my knees, lifted my hands toward the moon; I felt like a wild animal conjuring the forces of the universe, and suddenly I sank into the sadness of my childhood. The wild woods behind my Meyerland home had been completely destroyed as if they had never been there at all, and I was terrified the same fate awaited the Neches.

It was late when Adrian and I returned to camp. Hovering motionless in the water, between us and the beaver island, glowed the bright red eyes of a large alligator. Adrian estimated the reptile was nine to ten feet long. "One inch from between the eyes to the tip of the snout for each foot in length," he said, repeating the usual formula.

Adrian thought the alligator angled for a meal. Alligators ate beavers. I had a more fanciful theory. I believed the alligator was providing protection to the beaver family threatened by our presence.

The next morning I proposed that we leave. "The beavers don't want us here. That's why the alligator was looking at us and not at the beaver island," I said.

Ridiculous, Adrian said. I tried to explain my reasoning. "It's rude for us to be so close to their nursery."

But Adrian was on a mission—he wasn't leaving. The discussion ended.

In the afternoon, out of the corner of my eye, I saw a snake's tail slide under my tent. With Adrian's help we uncovered a coiled copperhead. I kicked dirt at the reptile and imagined the terrible bite I might have received if I had lain atop the venomous thing. I told Adrian that the snake assassin was in some way connected to beaver malice, but he rejected my speculations. I joked, yes, but not completely. I couldn't shake the feeling that the animals didn't want us there.

Perhaps my strange ideas worked on Adrian's mind. In any case by the next morning, he still hadn't photographed a beaver. And like the night before, the alligator had hovered between us and the beaver island. This time I didn't have to say anything. Adrian made preparations to move on.

We packed and canoed away from the underground beaver house. Sometime later I came to a tight spot in the river where the only way through was to squeeze the canoe between the riverbank and the rootball of a fallen tree. As I entered the narrow space, pushing against the shore with my paddle, a brown blur dove into the river from directly behind my boat. Startled, I twirled around. The canoe crashed into the tree roots, and I dropped the paddle and nearly toppled over into the river. An hour later the same thing happened again. As I passed between the bank and another rootball, a beaver—was it the same one?—pounced within inches of my boat like someone jumping out from behind a door. Again, I almost plunged headfirst into the water, possibly into the jaws of a hungry alligator.

I waited for Adrian near the location of the second beaver attack. I described what had happened and then asked the obvious question: "Do you know, or have you ever heard of, a beaver jumping into a boat and attacking somebody?"

Of course not, he said, and there was no chance it was the same beaver. He told me I had lost my mind. At first I took his rebuke as an insult, but then I accepted his comment as fact. The water rodents had gotten under my skin. But I wasn't alone in thinking that beavers had supernatural abilities.

The local Caddo Indians of two centuries before called these river beavers the Little People and considered them cousins. Northern Plains Indians believed the beaver was the sacred center of the land because of their ability to create rich habitats by damming streams in shallow valleys. Eighteenth-century nature writers claimed that beaver lodges had two stories with windows. They had separate rooms inside for drying fur coats and storing provisions and space for forty beavers to slumber through the winter in soft weed beds. Five hundred years earlier in the Middle East, dried beaver testicles were used as analgesics for headaches and menstrual cramps. Artists illustrated beavers nipping off their own testicles to avoid death or running away while cupping their private parts with a free claw. All these people also had lost their minds about beavers.

River stump, downstream from the beaver lagoon

On the Neches, beavers usually don't build dams, and their lodges aren't in the center of ponds. They live in the banks, usually under tree roots. They are nothing but giant water rats, but very strange ones. Landowners hate them because they chew on valuable hardwoods and stop up drainage pipes and ditches.

We moved camp to a narrow peninsula. Deep into the night, a beaver swam back and forth, slapping its tail like a machine gun. I put on my special beaver hat, which had two headlamps lashed above the visor, and grabbed two more flashlights, one for each hand. I rushed to the river and caught the rude rodent in midslap. He flipped me the tail and dove underwater.

Neches River from the top of a narrow peninsula

When I was wide awake at three in the morning, the bizarreness of the trip made me think the beavers were actually working against me. In all my years of photographing Texas rivers I had never encountered anything like these water rodents. It was no wonder I was jumpy.

In the afternoon, a red-headed woodpecker emerged from a dead tree and chattered near our camp. Adrian positioned his camera to focus on the bird. More red-headed woodpeckers joined in a chorus of pleasant woodpecker talk. In that perfect moment of tree and red-plumed bird against a blue sky, the sun shining bright and warm, Adrian whispered, "I got a keeper photograph."

I heard a grunt and saw a swirl fading in the river. Had a beaver been watching me pay homage to the beautiful woodpeckers and decided I was more friend than foe? I chose not to discuss this with Adrian.

That cold night the beavers didn't harass us, and the next night was quiet too. The rodent wars seemed over, though I have yet to return to Chinquapin Ridge to learn if the truce still holds.

Red-headed woodpecker. Photo by © Adrian Van Dellen

Beaver-chewed branch on the shore

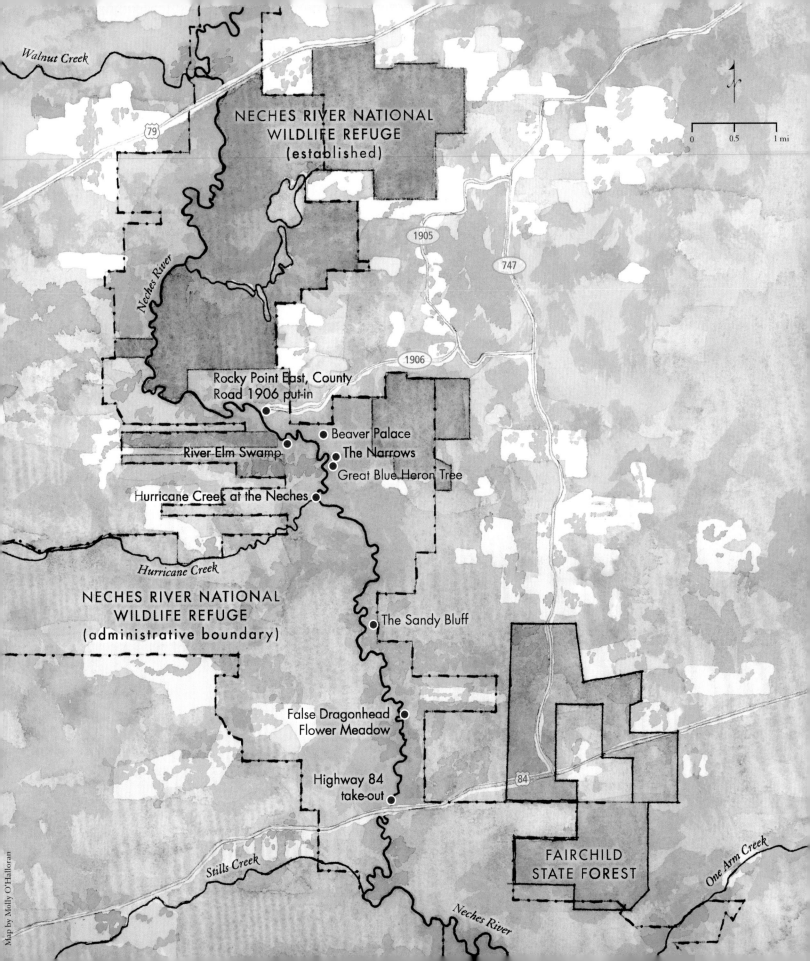

NECHES RIVER NATIONAL
WILLIFE REFUGE
(established)

Walnut Creek

79

1905

747

1906

Neches River

Rocky Point East, County
Road 1906 put-in

Beaver Palace

River Elm Swamp

The Narrows

Great Blue Heron Tree

Hurricane Creek at the Neches

NECHES RIVER NATIONAL
WILDLIFE REFUGE
(administrative boundary)

Hurricane Creek

The Sandy Bluff

False Dragonhead
Flower Meadow

Highway 84
take-out

84

FAIRCHILD
STATE FOREST

Stills Creek

Neches River

One Arm Creek

Map by Molly O'Halloran

Going to the Hurricane, Wildlife Refuge

November

Mid-November, and the forest was shedding. Oak and gum leaves filled the air. Everything Adrian and I set down while unpacking our canoes collected a leaf or two in the few moments it took us to grab more gear. Our campsite along a sloping bank was a quarter mile past a derelict cabin where two hunters waved at us without enthusiasm and two miles from Hurricane Creek, our ultimate destination.

It was all Adrian and I could talk about since our first trip through the new wildlife refuge in June. "We're going to the Hurricane," we sang like gospel singers during preparatory phone calls. The Supreme Court of the United States had ruled against Dallas's plans to build Fastrill Reservoir on the upper Neches, instead ruling that almost thirty-nine river miles be set aside for the Neches River National Wildlife Refuge. In the heart of the refuge was Hurricane Creek, a tributary of the Neches that drained a large area to the west.

On the June trip, I had found a sheet of water flowing over clay-stepped waterfalls into Hurricane Creek.

After photographing the waterfalls I took my camera to the Neches, but the music of rushing water underneath the tall trees of Hurricane Creek pulled me back. I encountered an otter family below the falls—two pups and their mother. The bright-eyed babies, chirping like curious children, crowded

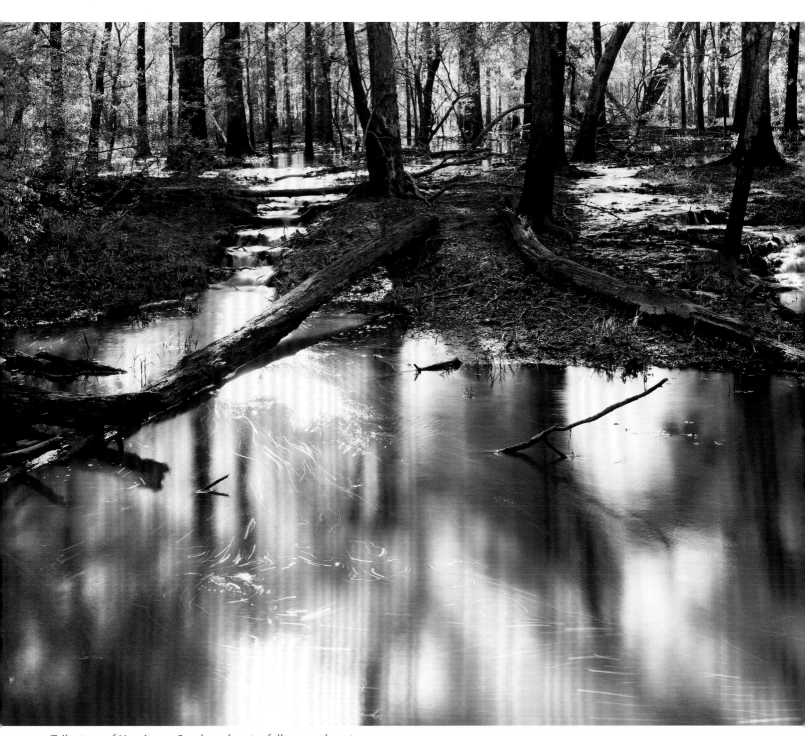

Tributary of Hurricane Creek and waterfalls over clay steps

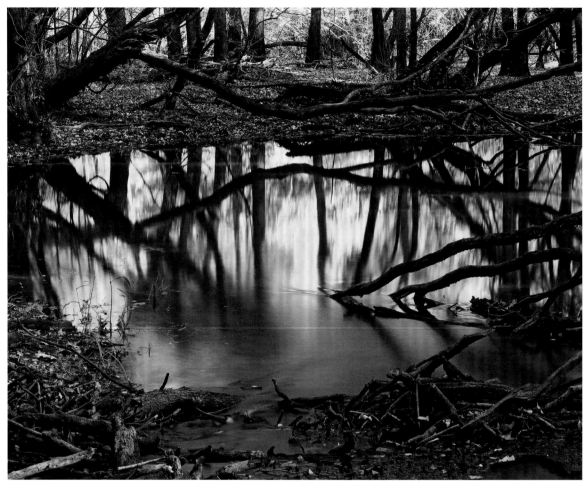

Clear pool, tributary of Hurricane Creek

around her shoulders to get a look at me. Mother chittered a warning and pushed her babies downstream. I followed them to another tributary that slipped so pure and clear over the bottomlands, I could hardly believe my eyes when I stepped to the edge of a glowing pool.

A prothonotary warbler flashed through the deep green, a yellow fireball singing in high fidelity. The heavy canopy, tree limbs layered on top of each other, created an acoustic chamber. The waterfalls and warblers filled the forest with pure, untainted music.

At our Hurricane Creek campsite, everywhere around us were Neches creatures, including Adrian, one of the more interesting animals out here. He scurried around in a new set of river clothes: old torn pants, no shirt, old

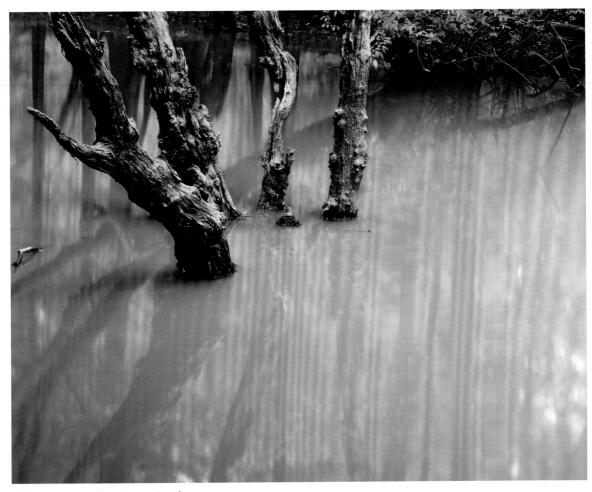
Warty stumps, Hurricane Creek

moccasins, a cap on backward, a toothpick sticking out of his mouth. He checked on his camera pointed across the river, where we had heard deer snorting; nothing there. Next, he fiddled with his sound-recording equipment, which he couldn't get to work. Then he rearranged items outside his tent into a tidy pyramid.

Exhausted from watching his endless energy, I crawled inside the tent and took a nap. That sultry night, Adrian and I walked the woods along Hurricane Creek. We found thousands of green specks dotting the forest floor. When I reached for one, it disappeared. I stood, bewildered at the disappearance, and adjusted my headlamp. There they were again, the green eyes of grass spiders scooting away. I walked without a care, emeralds everywhere.

Farther along Hurricane Creek, big golden eyes shone in the dark and big ears waved wildly. A baby deer lay in woody debris not ten feet ahead. Mother deer hide their newborns while they forage. We turned for camp, not wanting to disturb the fawn. A barred owl hooted, and a panicked mouse jumped against Adrian's leg, shivering in fear.

The next day we found hundreds of mushrooms, every color and size: orange and red, white and yellow, big and small. Along the base of a willow oak, orange-brown wood mushrooms were layered like a heap of pancakes. Red-topped mushrooms spread across the bottomlands like a field of poppies. The most unusual mushrooms, a pair of yellow-green orbs in the crook of a fallen tree, had erect tops like nipples.

But it was the tent caterpillars that seemed the most interesting. Bungee jumping from the willow oak above my tent, they swung in the breeze on long silk threads, then slowly lowered themselves. Other tent caterpillars dispensed with the silk entirely. They crashed to the ground as if in a hurry and vanished.

To solve the mystery of the disappearing caterpillars, I plucked a colorful one off my hat. It featured segmented lines of yellow, blue, and red. I placed the you-can't-hide-from-me caterpillar on the ground and moved my stool as he ambled toward the base of the willow oak. He stopped. I poked him. He moved a few inches and then refused to budge. Adrian called, asking for help in identifying a bird.

Then a Cooper's hawk landed in our camp. After those distractions, I returned and found that my caterpillar was nowhere to be seen. I turned over sticks, rustled through old leaves, and kicked at the dirt. It was maddening. I pondered insects that were everywhere, and nowhere.

When we packed to go to the next campsite, I found cocoons attached to the undersides of my gear and tent. Adrian had several on the neck of his paddle. We removed them as best we could and placed them in promising crooks and crannies. Before leaving, I walked down to where Hurricane Creek met the Neches. A stout thicket of river elm trunks weaved across the confluence like the gates of a fort. Hurricane Creek seemed at that moment like a protected paradise.

Six months later in November we returned to Hurricane Creek like pilgrims preparing to enter a shrine. We wanted to cleanse ourselves first, so we camped a few miles from the creek to empty our minds of civilization.

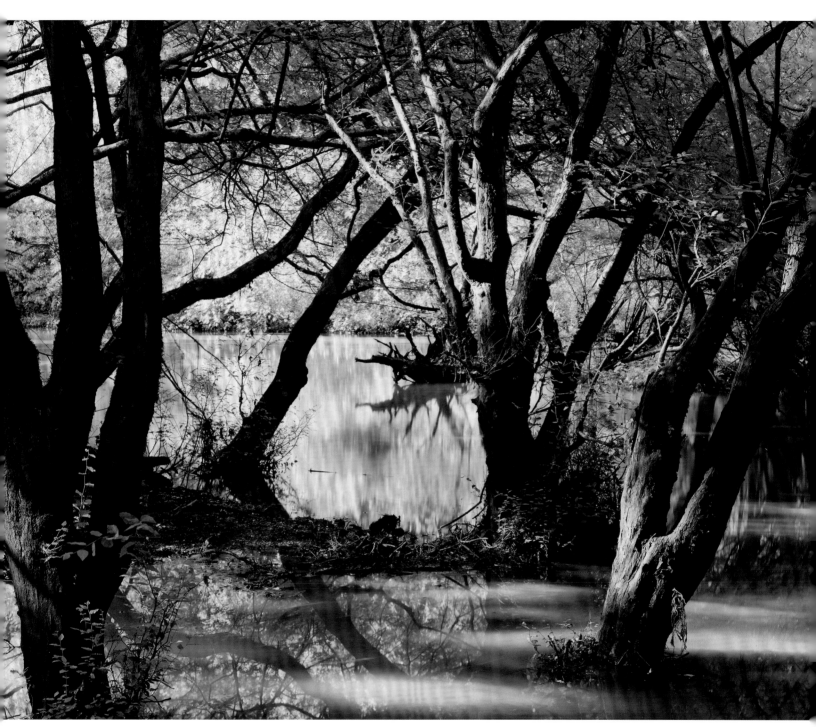

Mouth of Hurricane Creek protected by river elms

Close reconnoitering revealed fascinating details, and camping with Adrian always involved such a search. A pair of sweetgums, the lower trunks eaten away by beavers, leaned precariously on slivers of live wood. A dead pine riddled with holes and buzzing with red and black wasps stood stripped of limbs. Underneath, white droppings from a roosting owl covered the forest floor like splattered paint. Nearby, a recently fallen loblolly pine stretched horizontally for 135 feet a foot off the ground, the trunk held up by limbs plunged into the soil. Near our campsite lay missile-shaped acorns from the willow oaks, spiky seed balls of the sweetgums, and, closer to Hurricane Creek, husk-covered overcup acorns.

It was the season of plenty and also the season of death. Distant rifle shots soon were followed by snorting deer that rushed our camp from both sides of the river. Some deer swam to our side, some to the other. They knew hunters were around, but they didn't seem to know where.

A coyote pack echoed through the woods that night. With deep howls and high-pitched yelps, the adults barked as if they were instructing their children—"Listen up, young 'uns, we're goin' huntin' tonight for wounded deer"—and the young coyotes screamed their excitement.

And the wildlife show continued. Later, I awoke to the shoveling sounds of rooting pigs. I hadn't seen a group of feral pigs since the first night of the first canoe trip with Adrian. I pulled the tent zipper, but before I could exit, a boar growled like a lion. I hadn't known they make that noise. He was clearly saying I should stay in the tent. Five minutes passed and the boar spoke again, not exactly a growl this time, more of a friendly huff, as if to say, "Human, you are free to move about now." The boar trotted off to join his harem. I zipped up the tent and settled down on my sleeping pad, though I was too wound up to go back to sleep.

Feral hogs are something to think about, especially when you are out by yourself. These descendants of escaped domestic stock now resemble their parent species, the European wild boar. Sows with piglets or any adult pig cornered in a tight place may attack you, and if you die or become incapacitated in the woods and can't get help, they may scavenge you.

Half of the five million feral hogs in the United States live in Texas. No matter what's tried, shooting them from helicopters or trapping them all year, the wild pig population continues to explode. Thad Sitton, in his book *Backwoodsmen*, said stockmen hunted the Neches valley black bear to extinc-

tion partly to stop predation on their woods hogs. Perhaps reintroducing the black bear would help control the wild pig population. Almost anything is worth a try.

I rarely see wild pigs during the day, but I note signs of them everywhere—bathtub-sized wallows filled with murky water, shorelines rooted into grassless mud, sandy banks cratered with three-foot holes, and occasionally a rubbing tree caked with dried dirt.

The Spaniards bear some of the blame. They brought over pigs in the 1600s, and more arrived with the early settlers. The bigger mistake, though, occurred in the 1930s. Texas landowners imported Russian wild boars to breed up the local feral hog populations and spice up the hunting experience. Unfortunately, Eurasian swine were some of the hardiest, meanest pigs in the world, and also very prolific. By six months of age a hybrid Russian-domestic sow might have produced ten piglets. By the end of her ten-year life span she could have a hundred surviving offspring, a thousand grandpigs, and just as many great-grandboars.

Rain fell softly by dawn of the first morning. Red gum leaves shone like forest rubies. I slid through a wet forest wearing my bright orange please-don't-shoot-me hat. I discovered a dried-up swamp of immense river elms. One elm was an extraordinary specimen, thirty feet across with seventeen trunks and forming a dense canopy beneath which the ground was bare and the walking pleasant. I decided to hurry back to camp and bring Adrian.

At the enchanted grove—the ground thick with leaves, the curving branches spiraling upward and sideways—things seemed just as strange and beautiful to Adrian. Then we saw something we didn't like: beyond the river elm grove along an old channel of the Neches, an ugly clear-cut shattered the forest. We stood for a while in the subtle light under a mature canopy gazing into the brightness of a missing woodland. A crow cawed like he was singing a lonely eulogy for the destroyed bottoms. Sadly, we turned for camp.

Perhaps because of the clear-cut, the next morning we made the snap decision to leave early for Hurricane Creek. Adrian wanted to get there before the weekend hunters arrived. We slipped into the Neches, canoeing past fallen trees and through narrow openings as usual. I noticed that someone had been using a small chainsaw to make cuts perfectly suited for canoes like ours—but who?

At Hurricane Creek we got out on the bank and I called over my shoulder, "Come on, Adrian, catch up." He hung behind—to let me catch the first bullet —or so he said. The woods glowed from diffused sunlight, and we could see clearly through the forest. Nobody was there.

We were both disturbed by the hunting in the wildlife refuge, though Adrian more so. Most Texas wildlife refuges allow controlled hunts to prevent overpopulation, and it would take time to get hunting in a new refuge under that control. My first experiences with true wildness came during duck hunts with my father. Rising at 4:00 a.m. and being in a duck blind before sunrise had become by high school the best part of my life. The organization Ducks Unlimited has done wonders for ducks. It wasn't sport hunters that caused species decline but habitat loss due to development. Adrian needed hunters and anglers to help protect what was left of the upper Neches bottoms. They were some of his most important allies.

As we walked along Hurricane Creek, dark trunks rose from a three-inch carpet of overcup oak leaves. Brown on top, beige underneath, and up to ten inches long, some oak leaves curled up and angled down, while others lay flat and straight. No animal had been here, no deer or wild hogs, just us, and we left a path across the leafy forest floor like a wake in water.

When we reached the yellow-crowned night heron rookery of last June, Adrian found fluorescent tape and fresh blue paint on trees. "I think we're seeing property markings in preparation for refuge land purchases," he said. I remarked that we were witnessing the real beginning of the refuge and that it must have been the survey crew that cut the gaps in river logjams. But Adrian wasn't listening. His head had gone rigid, his eyes unblinking. He gazed up at an old heron nest like a seeker who had found the divine. "I would sacrifice my life to save this place."

The next morning, fog rose at daybreak white as cotton, and the sun lumbered gently over the water near the entrance of Hurricane Creek.

After the photograph, I waited in camp for Adrian to get up. He showed no sign of rising. "Are you awake in there?"

Adrian said he was and then he popped out of his tent fully dressed, which surprised me. I had forgotten that he slept in his clothes. Last night during dinner, when we normally talk about the need to preserve the Neches, Adrian had said very little, which wasn't like him at all.

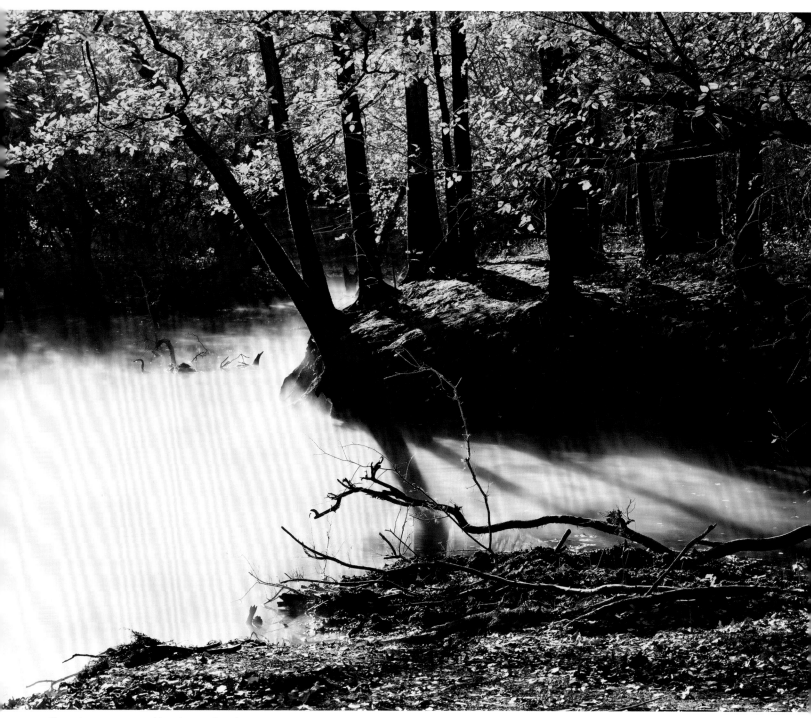

Fog at entrance to Hurricane Creek

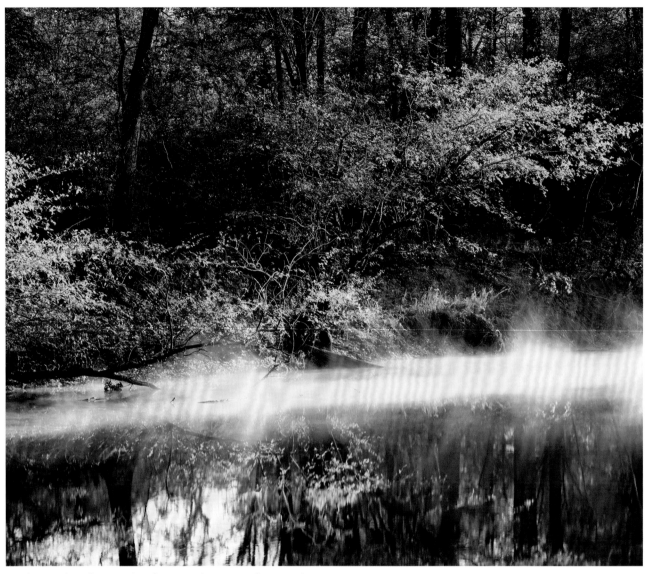

Neches and early-morning fog, Hurricane Creek campsite

"Let's go find the source of the bottomland waters," he said, which was exactly what I wanted to do. For six months I had been wondering about the source of the clear water that formed the beautiful pool I had photographed.

We followed the tributary that emptied into Hurricane Creek until we reached a grassy meadow. Since I was sure the holy grail of life for Hurricane Creek was water from afar, perhaps a major spring, I crossed over the fence and waded into water that quickly rose over my boots.

Adrian stopped me. Pulling out a map, he explained that a vast wetland spread for ten miles to the west. The water moved so slowly across this area that the silt settled out and East Texas muddy water became Colorado clear. "We've got to save this entire drainage to protect Hurricane Creek," he said, jabbing at the map.

We went back to camp, talking all the while. Hurricane Creek was the heart of the refuge, he said. It was so important that we should focus our photographic efforts right there. I changed into dry boots while watching channel catfish arching over the Neches like miniature dolphins. On the far bank, a tiny stream meandered down from the hills and into a sculpted cove with a flat place where I could set up the camera.

As if I was answering a knock, as if the sculpted cove was calling to me, I already knew what kind of photograph I would take. A fraction of the whole—shapes within shapes—a close-up of a constantly changing Neches that I would never grow tired of.

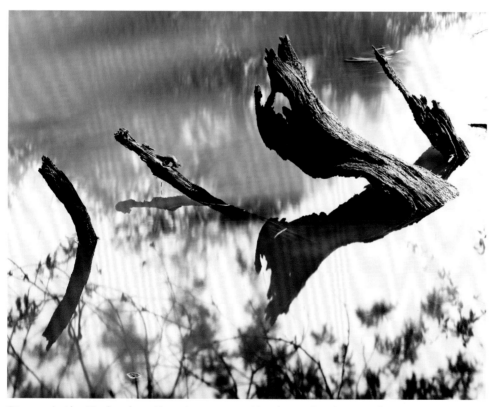

Stumps in the Neches by a tiny stream, near Hurricane Creek campsite

I wanted to stay another day and explore the edges of the swamp, but Adrian insisted we leave in the morning. Hunters were on the way or already present. There was a pine plantation with deer stands and deer feeders only a few hundred yards away.

As if to make the point, a gunshot went off nearby. We packed in a hurry and paddled away into the wildness of the refuge. Beaver sign was everywhere. Beavers were big animals and ate everything, or at least chewed on everything, rodent fashion: yaupons, ironwood, sweetgums, massive oaks and pines. In some places every tree we came to had been gnawed on. There were fresh claw marks along the bank and smoothed areas underneath exposed roots where they liked to hide. I expected to see a beaver at any moment.

I heard a muffled snort and grabbed a branch to hold my boat still. A large otter stood on a stump in the middle of the river. Back-lit by the sun, his whiskers glowed like the filaments of a lightbulb. The otter arched his torso and ruffled the fur around his shoulders, and when he shook his head, sun-fired water drops flew through the air.

I wanted to call for Adrian, but the otter silenced me with a piercing glare. In the shadows behind him, a smaller and darker otter, probably a female, wrestled with a very big catfish. She was biting the head, but the catfish was so oversized it kept slipping away, and she had to dive underwater to retrieve it.

The male came closer, clambered onto a fallen tree, and squared his shoulders. He snorted golden mist, which hung in the air like fireworks. I felt naked and insignificant under otter control. The male's luminous eyes turned to look back at his female. A second later there was only a small circle where he had slid into the river like a graceful diver.

Neches river otters need sixteen to eighteen miles of stream per breeding pair, biologists say, which means that there are just two pairs the entire length of the wildlife refuge. River otters once lived all over Texas, as far north as the Panhandle and as far south as the Rio Grande valley. By the middle of the twentieth century, after decades of fur trapping and habitat destruction, they had nearly vanished from the state. From a remnant population in the wildest parts of the Neches River, the Texas river otter is making a comeback. While Adrian didn't photograph this otter, he later went out by himself to create some of the first Neches River otter photographs ever recorded.

In rhyme with light and night, I developed a daily routine at our new sandy bluff campsite. Twelve hours in the tent, from dark to dawn, twelve hours

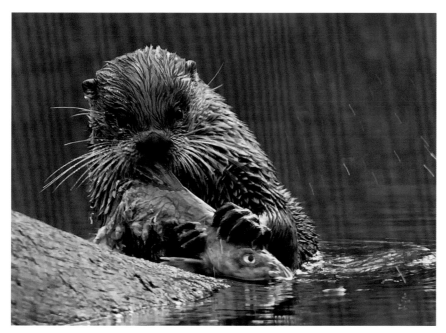
Neches River otter munching a catfish. Photo by © Adrian Van Dellen

in the woods, from dawn to darkness. The mornings were cold, the evenings more so, and there were crows all the time.

I discovered an old channel of the Neches right below the sandy bluff, and I went there morning and afternoon to make photographs. Some places have a special power hard to explain.

One day at that place, a male wood duck swept in and landed below in the pool against the sandy bluff. The beauty of the moment encircled me, rich as a robe of jewels. I stared at the graceful scene below until sadness broke the spell. Our twelve days in the wildlife refuge were over.

That evening, a wash of mauves and pinks streaked through the sky. Stars began to sparkle, and the oaks and pines dissolved into the blackness of a moonless night. I fell asleep and woke up breathing hard—agitated over a dream about the waters that lay beyond the fence at Hurricane Creek. Fear and anger gripped me. In my dream, men hiding behind familiar excuses— the law, a contract, private property rights—sat in a windowless room and signed the execution papers. They stole the gushing tributary and killed the bottomland cathedral of Hurricane Creek. The herons and otters, prothonotary warblers, and all the effervescent life abolished with the simple scrawl of a pen.

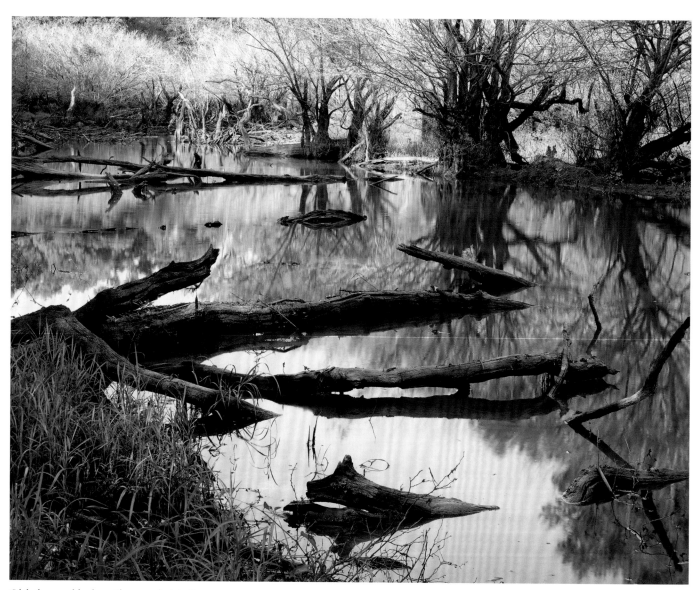

Old channel below the sandy bluff

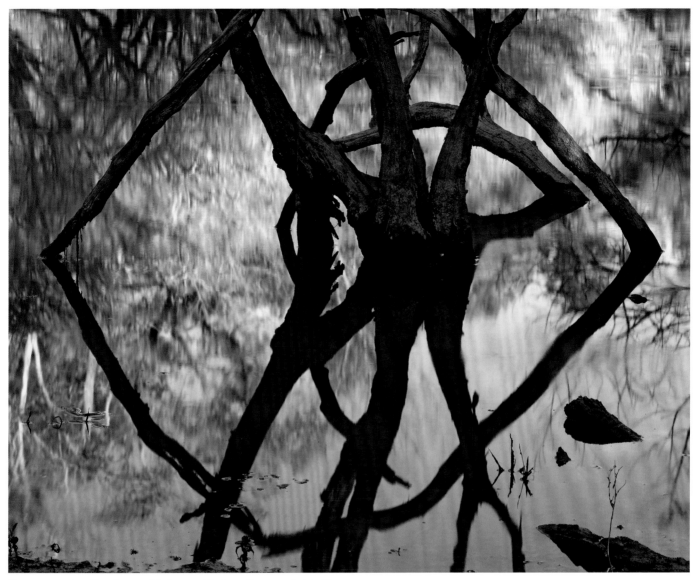

Stumps and reflections, old channel below the sandy bluff

"We've got to show people what the river is like," Adrian said when I told him of my dream. Once they learned about the Neches for themselves, they would want to protect it.

I wasn't sure about this, but I admired Adrian's unshakable belief in the value of keeping the Neches wild.

The old-growth forest awed us during the last few miles to our take-out at the bridge over Highway 84. Sharp-edged light sliced across the woods, velvet shadows punctured the land, and leaves stacked behind fallen logs reflected the sun like polished pebbles. I thought Adrian and I should just keep going and stay out here forever.

The Beaver Palace, Wildlife Refuge

January

Adrian wasn't keen on my idea of canoeing in January—"too cold and I don't have enough body fat." In truth, Adrian had no body fat. He weighed the same as when he wrestled in high school more than fifty years before. I explained

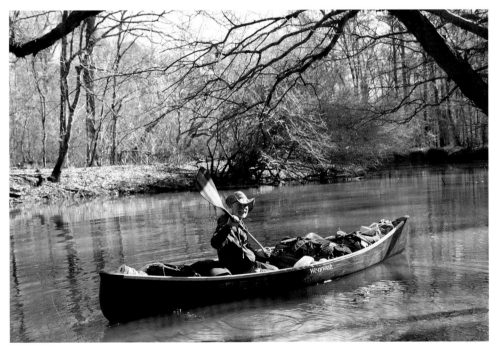

Leaving Rocky Point East. Photo by © Adrian Van Dellen

that I was on a quest to canoe the Neches in every month of the year. If I could get January done, only February and July would remain. Adrian consented, as long as we returned to the refuge. I settled into my boat at Rocky Point East and waved my paddle in the air, a departure ceremony that Adrian liked to photograph.

I turned downstream and everything changed. I floated on the sky. A tree passed underneath me. I was on a road, but my feet didn't move. I weaved around the peninsula where we had once camped under the colony of red-headed woodpeckers. Past the fallen pine tree that hovered a foot off the ground on limbs impaled into the earth, I parked on the sloping bank and grabbed the camera.

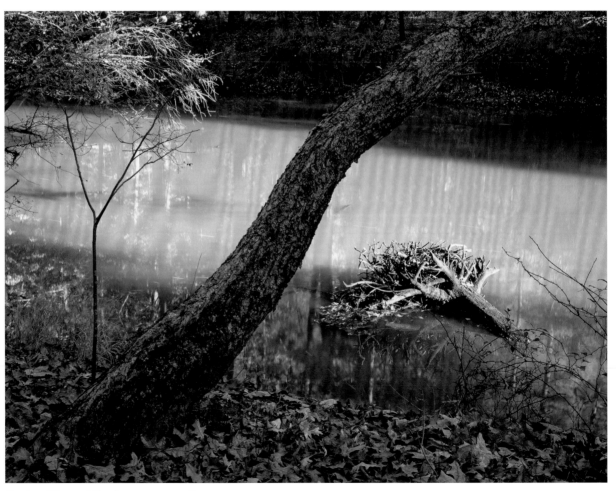

Neches River at the beaver campsite

I walked upstream over mounds of soft, sandy ground. Where wild pigs had rooted the earth, I found my delight: velvet shadows and winter light, an arching tree and leaves, and down the middle a bold yellow brushstroke—the winter sun shining on the river Neches.

A crow cawed, more deep-throated than usual. I thought of Peter Matthiessen's *The Snow Leopard* and a haiku his traveling partner George Schaller wrote as they hiked into Nepal:

> *On cloud trails I go,*
> *alone with chattering porters,*
> *there is a crow*

While our canoe trips weren't as strenuous as crossing a Himalayan plateau to reach a monastery on Crystal Mountain, Matthiessen's search for a legendary lama and Schaller's quest for the rarest cat in the world seemed akin to our journey. Somewhere on this ten-mile stretch of the upper Neches lurked Adrian's elusive beaver, while I sought blue shadows and naked trees.

A cat squirrel flashed over my head, and I ducked instinctively. *Kaae-szshe, kaae-szshe, kit, kit, kit*, the rodent scolded from a tree. I gathered my camera and returned to camp.

I found Adrian preparing his beaver blind. He had recently discovered a beaver lodge, a palace, he called it. I asked if I could tag along. The answer was no; he didn't want the animal to know we were there.

Now it was near dark, and we heard a beaver coming our way, the tail slapping getting closer and closer. "Good to know he's still here," Adrian said. The slapping stopped. "What do you think he's doing now?" I passed my hand over the Neches like a shaman who could see into shadows. "He's watching us."

Suddenly, a pair of barred owls caterwauled from a tree in the center of our camp. A moment later, a coyote howled. His lonesome cry hushed the woods, but soon more coyotes yipped and yowled, their wailing and screeching echoing around us as if they had us surrounded. Then the whole river went silent. Everything seemed to know we were there.

While Adrian waited patiently for the beaver's arrival, I slipped into my tent and fell asleep with all my clothes on. Around one in the morning, the beaver resumed slapping and Adrian called out for the flashlight. I rushed

to the river. The rodent of Adrian's dreams, *Magnificus castor*, aka "The Godfather," arched his back and slammed his tail. Water shot up into the air like silver sparkles. It was an extraordinary display of rodent rage and would have made an award-winning photograph if Adrian's camera hadn't malfunctioned.

Another failure, but he would try again the next night. His resolute equanimity in the face of defeat was a characteristic I deeply admired, but I wondered if we would see a repeat performance.

The next morning, mist spiraled up from the river as I stepped onto the shore of the Neches. Naturally, since I had no camera, a fat beaver now patted a mound of leaves and mud. He turned toward me, sat on his tail, and fixed me with a steely glare. He must have weighed fifty pounds, perhaps more. He folded his clawed beaver hands over his chest, took a step toward me, and grunted like a wild pig. I didn't move—surely I could outrun a beaver attack. He snorted, turned his back on me as if I was nothing to worry about, and waddled into the river.

I brought Adrian to the location, where he whistled at the large paw prints. He told me the leaves mixed with mud was a castor mound, used to entice females and chase away other males. Down on my hands and knees I sniffed, hoping to catch a whiff of beaver ambrosia. The castor mound smelled as it appeared, like rotting leaves and stinky mud. Maybe the beaver hadn't gotten around to anointing it with castoreum, a chemical secretion from castor sacs located near the base of the tail.

The next day I was alone in camp taking notes about winter light, long shadows, and rich colors: the maximum moment of three-dimensionality that I liked to capture in my photographs. I walked to the river, not so much to find a photograph but to feel the urgency of good light that would propel me out of camp.

The sky spread into pale blue, the Neches glowed like polished green stone. I carried my camera to Alligator Lake. There were no basking reptiles at the old Neches oxbow, but whirligigs, a type of water beetle, skimmed the lake surface like shiny drops of mercury.

The light of the universe fell around me like immortality. I moved the camera a few feet, huddled under the dark cloth, and peered at sticks and shadows. I sensed I was close to a good image. I made small camera adjustments,

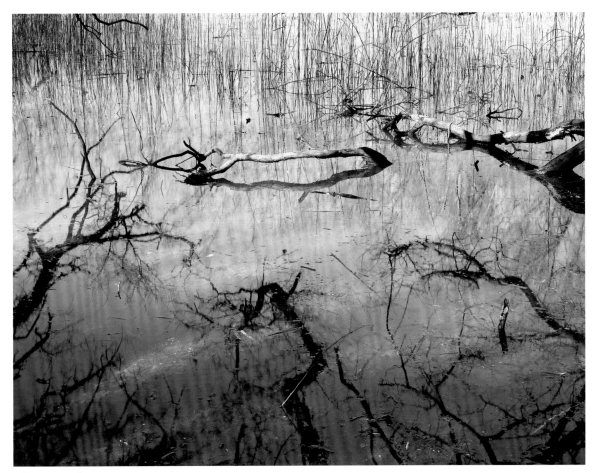

Alligator Lake

trying to feel my way to something grand, until I became utterly exhausted and frustrated. Sometimes going under the cloth worked out that way.

I sat against a tree in full sunshine. I heard footsteps approaching at a steady pace over dry leaves—*crunch, crunch, crunch.* I rose up on a knee and peered around the tree hoping it was a deer and not a hunter. From the edge of my vision, a black-winged creature darted through the forest five feet off the ground. Long tail, short wings, long neck, and a small head; my heart thumped furiously. Had I really seen something? It seemed like a dark thought, an omen of disaster.

Then I remembered my mother was dying. She had been in hospice care for eight months. I made a phone call to Austin and talked to a nurse, who

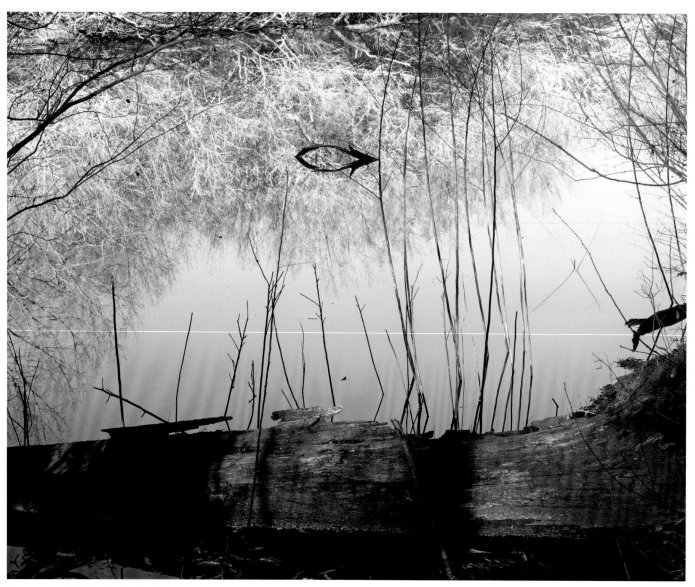

Deeper part of Alligator Lake

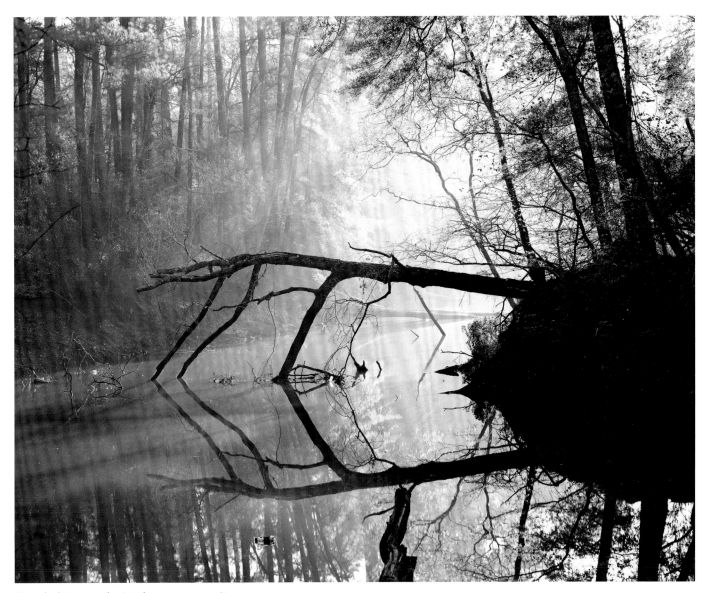

Toppled tree and mist, beaver campsite

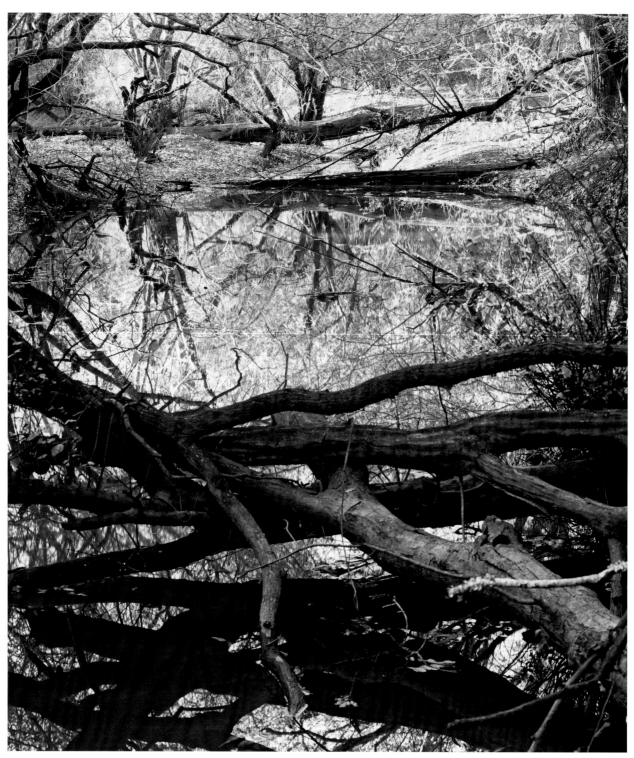

Glossy light, electric blues, red-headed woodpecker peninsula

said my mother's condition remained unchanged. Before Alzheimer's completely erased my mother's mind, she had been a vibrant woman who greeted me when I visited her at the nursing home with a demand: "Are you taking photographs?"

On our third day at the beaver campsite I canoed upstream with my camera. In the cold air, under brilliant winter light, I thought of my mother and hoped she was all right.

Crows perched in the trees above our campsite that afternoon. Normally loud and obnoxious, they made a soft, pleasant whirring sound. It seemed like a social visit. Adrian put an arm over my shoulder, offering a special dispensation. I could accompany him to the beaver lodge.

It seemed to be an elaborate bank den. Hidden from sight by an oak that jutted across the river, a symmetrical dome of limbs stretched fifteen feet across. A cape of green moss graced the front, and to the left, a flood channel allowed rushing water to safely flow behind the lodge. Underneath the

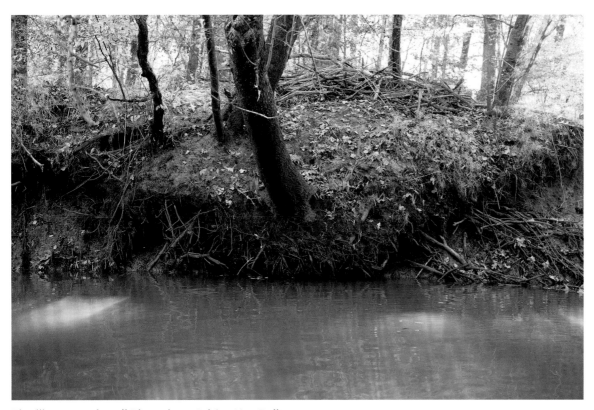

The "beaver palace." Photo by © Adrian Van Dellen

roots of the oak, two beaver slides ended in bank holes that gave access to the house on top of the hill. This was the palace of the giant beaver I had seen, the Godfather who ruled this section of the Neches.

Adrian shined a flashlight onto a mud-floored room where fresh-cut branches poked inside. "That's where he goes for midnight snacks," he said, "and over here"—he shined his flashlight on a room carpeted in fresh-cut grass—"is his bed."

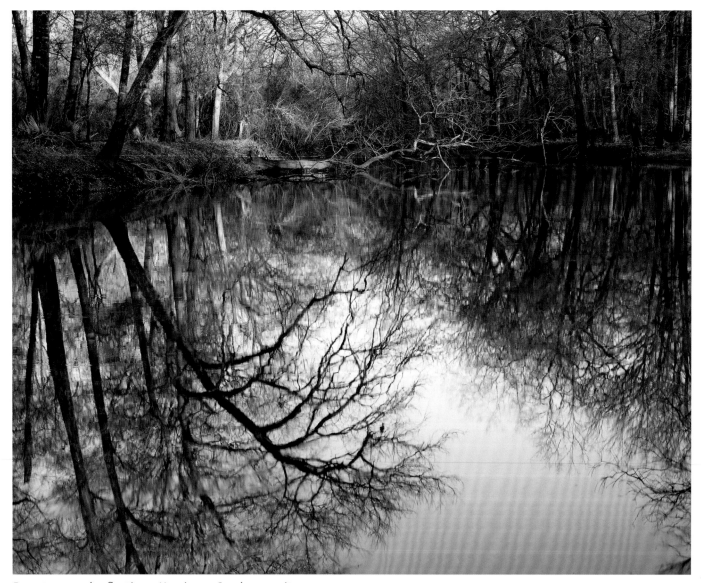

Bare trees and reflections, Hurricane Creek campsite

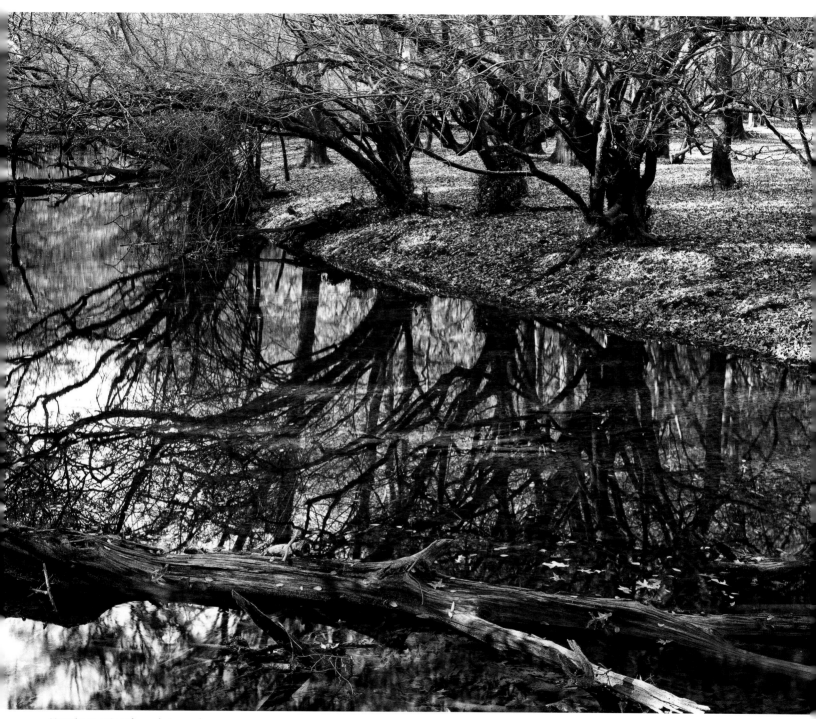

Hurricane Creek and river elms

From down below we heard a splash. A beaver snorted and dove underwater. Probably we had been under observation. Adrian admitted he didn't know how to photograph this beaver. Looking across the river, his beaver blind now appeared all too obvious.

We gave up and moved on. Bare trees reflected on unmoving water when I arrived at our favorite Hurricane Creek campsite. I squeezed through the small opening in the dense brush at the edge of the river and entered the magnificent cathedral of an old-growth bottomland forest. I marched over thick leaves, with acorns shifting underneath me like marbles. At times it almost felt like skating. I passed the yellow-crowned night heron nests, scraggly and disintegrating in January, and turned toward the soft gurgle of the creek.

A dozen wood ducks lifted away: a stream of time, seconds marching by, I felt defenseless to their squealing cries. A warm breath blew on my skin as wind roared over Hurricane Creek. The quiet reflections that I had just photographed fractured like broken glass. Shaking and shimmering, leaves rose and settled down quickly, as if they were too satisfied with winter's sleep to fly away.

"We're so lucky to be here," Adrian said when he arrived, the evening sky spreading into purple dust. I had thought the same.

Acorns of the willow oak, slim and pointy, plopped into the water saying *dewp*; overcup acorns, round and light, said *plat*. I stirred a dinner of spicy lentils, chicken, and rice. "It smells good," Adrian said. I offered him a spoon. "Tastes good too." We were in a paradise, and this is what it sounded like: *dewp, plat, dewp, dewp, plat.*

We stayed two more days under thickening clouds at Hurricane Creek. I tried to call Austin several times but couldn't get a signal. We packed and left the Neches River. When I returned to Triple Creek Music RV Park around 10:00 p.m., I received an urgent telephone call that my mother was near death. I rushed back to Austin and found her in a coma, the last stage of Alzheimer's. I held her hand, told her that I was here, that I had been out taking photographs. Twenty minutes later, she took her last breath. "She waited for you," the nurse said. "They do that; they wait for their loved ones before they let go."

Mr. Ayeeoou, Wildlife Refuge

April

Adrian and I shoved off from Rocky Point East into a rising April flood. Sediment-rich water, a bonanza of nutrients for the trees and ultimately all the creatures that called the Neches home, flooded the bottomlands. We made record time to our usual campsite at Hurricane Creek, but I found it underwater. We pitched our tents on higher ground across the river.

But not much higher. Every depression at our campsite oozed dampness. Deeper holes filled with water. A few inches more and we wouldn't have a campsite. I pushed a stick into the mud to mark the rising river. Asked what we would do if the river flooded the camp after dark, Adrian cheerfully responded, "Sleep in the canoes."

I didn't like that answer. We were by ourselves with no way of getting off the river except to canoe six miles to the bridge over Highway 84. I returned to my stool and watched water rushing into a growing pond behind us. In the trees, birds chattered. In the pond, frogs chortled. It occurred to me that frogs could swim and birds could fly, but Adrian and I had only our canoes. I tied mine to a tree with some care. Adrian, however, seemed unconcerned, predicting that the river would crest soon and start falling by morning.

The sun set on a smooth palette of water. A bright moon rose over the forest. Frogs and toads roared to life, high-pitched peepers and low-pitched croakers. Adrian made sound recordings by the flood pond in the silver-gray

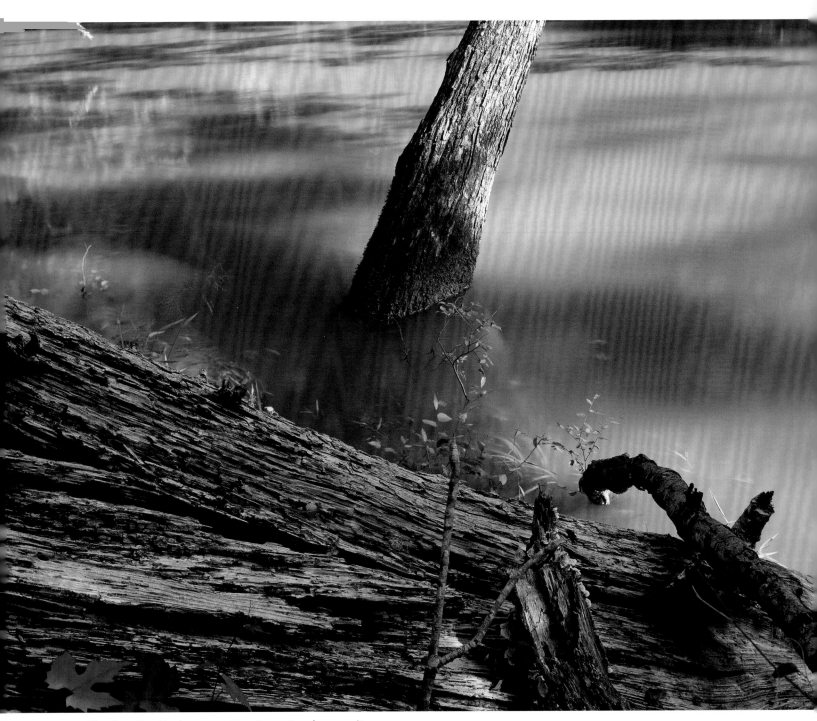

The flooding Neches, near Hurricane Creek campsite

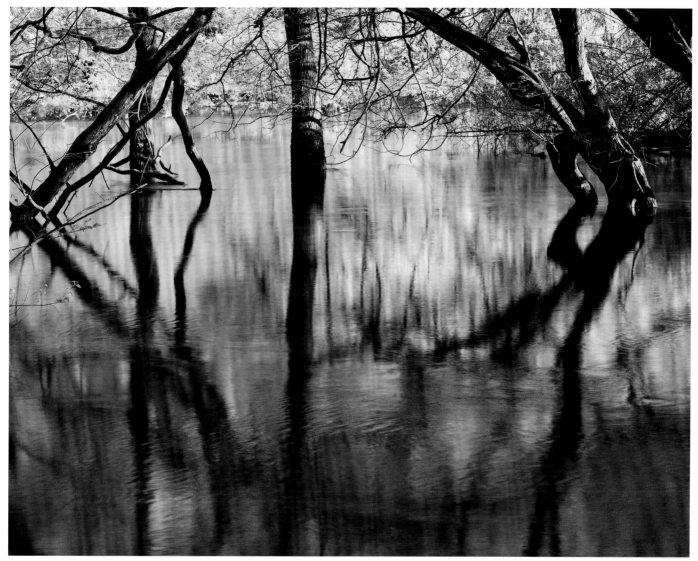

The flooding Neches by our campsite

moonlight. I stuck yet another stick in the mud, intending to rise in the night and check the water level on both sticks.

The next morning I carried my camera over ground stained blue-black from seeping water. At the end of our island fog filled the air and pollen tassels spread downriver like golden adornments.

All was in motion. River waves lapped at my tripod as if the Neches might leap over the bank at any moment and liquefy what little land was left. My

photograph of a solitary ghost tree burst into sunshine. Blue and white colors popped in the sky. It was too much change to comprehend. I felt full of holes, no more stable than the disintegrating earth. Floods will do that, as will going under the black cloth. I moved the camera and tripod to a safer spot and checked on my sticks.

I heard Adrian talking to himself. "We've got to change, or the earth will throw us out. James Lovelock—Gaia, that was his idea—everything's in flux—

Blue-black stain from oozing water, Hurricane Creek campsite

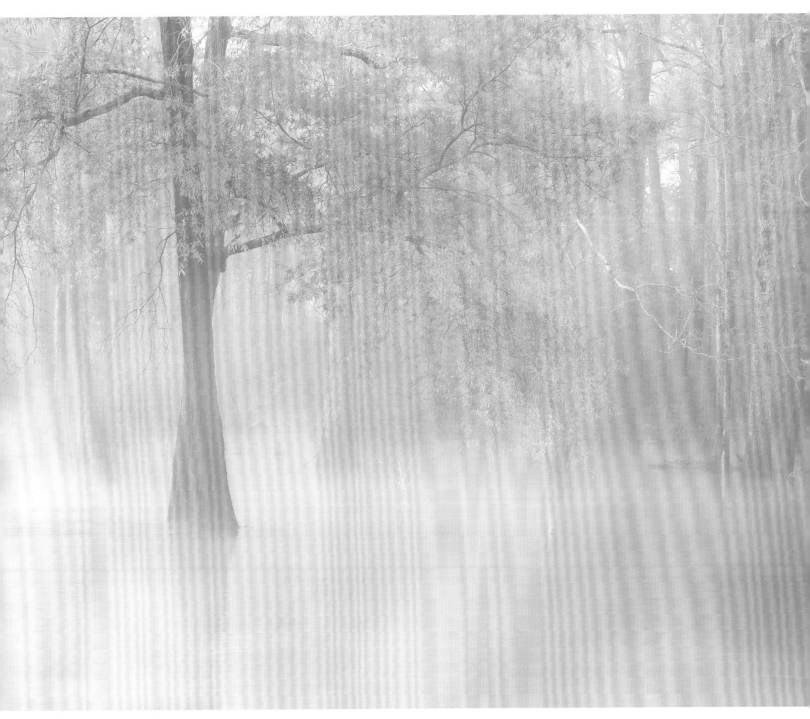

Ghost tree in fog, Hurricane Creek campsite

atoms are switching places with each other—we're just beginning to learn about our universe." He paused. "And we're going to destroy ourselves if we don't change!"

"Adrian, is that you—"

He jumped from his camp stool and punched the air. "Thomas Berry, *The Dream of the Earth* and *The Sacred Universe*, that's what we need, that's what we have to have to save ourselves." He flopped down onto his stool, his eyes ablaze.

Pools of water surrounded our campsite like a spreading virus, and the Neches had risen three inches overnight. However, Adrian's prediction had come true. The third stick I had pushed into the mud around midnight now was dry. The Neches was falling.

I moved my stool close to Adrian's. He opened a Ziploc bag and coaxed a precise amount of his special peanut oatmeal into a cooking pot. I poured water until told to stop. He lit the stove, and I leaned in close and inhaled the aroma of simmering peanuts. Adrian's oatmeal comfort soon spread inside my body like a warm blanket.

We loaded the canoes and crossed the Neches into the flooded bottomlands of Hurricane Creek. Normally twenty feet wide, Hurricane Creek ran a mile across. Nothing was familiar, nothing seemed right, and after a while I couldn't see land or Adrian. At one place I encountered a rush of current so fierce I couldn't go forward. Uncertain of which way to go or even my location, I canoed past a stump studded with woodpecker holes. Like big eyes circled by sawdust eyelashes, they were visions of decay.

I stopped paddling and floated away, letting the current take me wherever. Bumping into trees, floating along, I began to wonder. If I tied my canoe to the stump, stayed through the night and through the next day, could I learn to see through the wall of time and learn the truth? Possibly I would; possibly I'd just spend a long night shivering in the woods.

Lost in the bottomlands, not sure where to go, I mused that the tall healthy trees began to look haggard and torn, prematurely old. Only a twitch of time would pass before they fell and decayed. I drifted with the flow, arrived at the Neches without trying, and saw my tent. Adrian seemed happy to see me. He leaned back on his stool. Red streaks of a setting sun colored the sky with the river beneath shimmering orange. Adrian slipped off his hat and commented on the beautiful evening.

I pointed at the blood trickling down his forehead. He touched the wound and looked at his bloody fingers as if they were strangers. Something had happened to him under the night heron rookery—perhaps a falling limb when six heron pairs took off, perhaps an accidental strike with the paddle that affected his memory.

The next morning, we left the island and floated to the sandy bluff, the highest point overlooking the Neches for miles around. Adrian handed me his spare cooking stove. He didn't want to pass up a good chance to get photos of great blue herons. He'd be back in three days.

Adrian often went off like that. I was used to it. In the first moments of aloneness, I moved the camp kitchen a few feet, then moved it again before

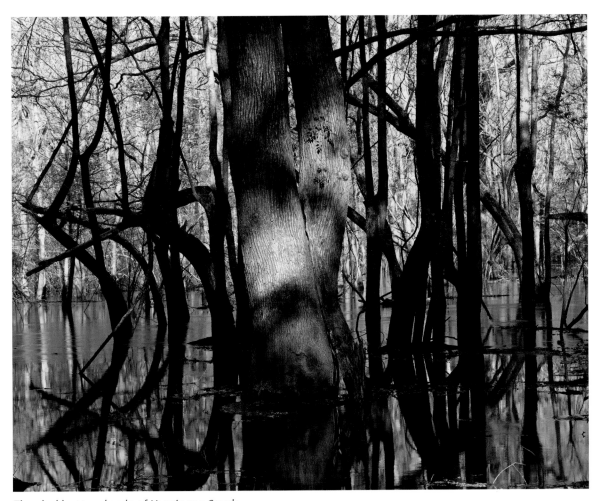

Flooded bottomlands of Hurricane Creek

falling into a deep sleep. I awoke at 5:00 a.m. to hear not a frog or a cricket, not owls or coyotes, only a voice calling through the warm still air, a beseeching falsetto of a delicate and hopeful nature.

Hey-you, *hey-you*, it called. I had no idea what it was.

I walked to the edge of my island. A flood channel cut off the sandy bluff campsite from the mainland. *Hey-you* stopped calling. I decided it was a male creature of some sort, perhaps a frog. I trudged back to my tent. He resumed calling *hey-you* in a sugary voice so heartfelt I imagined a kind and graceful creature in a tree beyond my vision. I named him Mr. *Ayeeoou*.

Up the river I canoed. Past the flood channel, I got out and I climbed to the top of the sandy bluff. Lumpy clouds to the north thundered like drums, and wind scattered the water. From the south a violent storm approached. Mr. *Ayeeoou* was quiet. I rushed for the boat, paddled back to camp, and sheltered inside the tent as rain and wind slashed the forest.

Hours passed—reading and writing, soup and sleep—and when I awoke, Mr. *Ayeeoou* again crooned a honeyed song like a pleading chant. *Come find me. I want you.*

Against all the advice I could give myself—it was 2:00 a.m. after all—I went looking for Mr. *Ayeeoou* once again, with the same result as before. I returned to my tent, settled inside, and *he* sang again, closer than ever. This time I went looking without a flashlight, edging closer to the voice. The flooding Neches moved before me. A faint moon shimmied in the clouds. I slid down a tree trunk and sat on a root.

"Mr. *Ayeeoou*, are you there?" I whispered. I wanted to make contact with the beautiful voice. A train, a few cars crossing the bridge at Highway 84, a distant shriek breaking the silence, but nothing from *him*. It was obvious the creature could see me. It couldn't be a frog; must be a night bird. I waited, grew sleepy, and went back to the tent.

At 8:00 a.m. I carried my camera case across the shallowest part of the flood channel and up the steep hill to the top of the sandy bluff. On the right, river elms bent and ebbed in the old channel, and straight ahead a stout north wind rippled the surface of the new channel. Behind me, the last dogwood blossoms dropped on the ground like white surrender flags.

Then I heard Mr. *Ayeeoou's* voice, weak and distant, from somewhere near my tent. I walked back to camp and searched the trees. A large bird with no neck glided silently away on long brown wings. Mr. *Ayeeoou* was an owl!

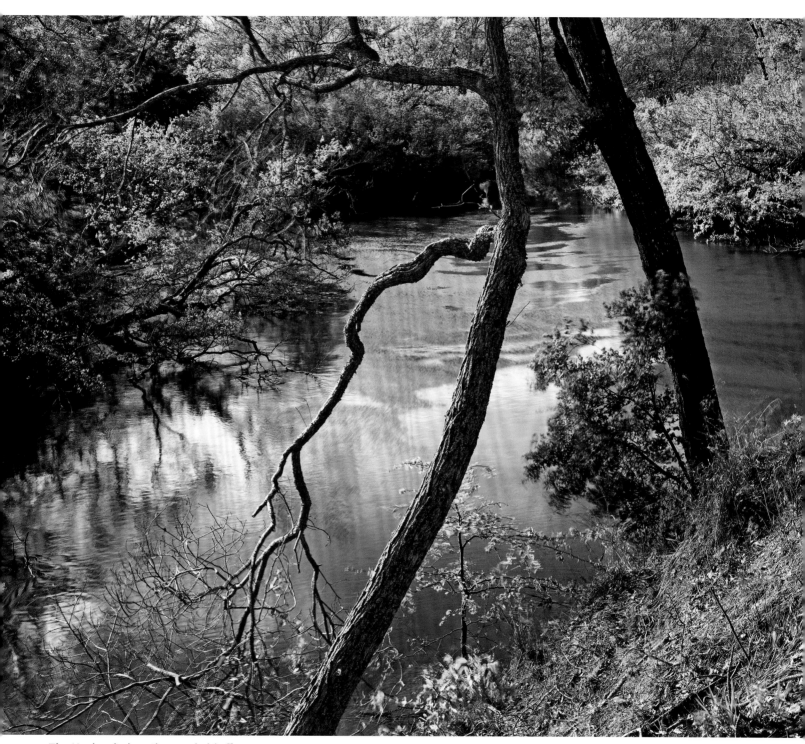

The Neches below the sandy bluff

There is only one Neches owl that calls at night and during the day, but it seemed unlikely it could be a barred owl, because I had never heard a barred owl sing *hey-you*. Perhaps it was an owl of another kind that had been blown off course during the storm and he was calling for companionship.

That night the owl talk was the strangest of all. Mr. *Ayeeoou* belted out calls in quick succession: *eeoou, seeoou,* and the loudest, *oohheeup.* Sometimes, as if he was running out of breath, he wouldn't finish the calls, and late in the night

Floodwaters creeping up a mossy bank, sandy bluff campsite

I heard the familiar call of these Neches woods, the barred owl's *Who cooks for you? Who cooks for you-all?* Was I listening to two barred owls?

The owls talked over each other for hours, as if they were too excited to wait for the other to finish. Deep into the night, I heard something scrounging for food in my kitchen. I peeked outside and saw that a raccoon had the food container with my precious allotment of oatmeal. I chased the masked bandit to the edge of the island, where he tried to take my food up a tree. But he needed both hands so he dropped the container.

I had experienced enough owl song and camping by myself. Where the hell was Adrian anyway? He should have been back yesterday. Even though not showing up at the appointed hour was typical of him, I decided to search upstream the next morning. In my fat-bottomed canoe, fighting the current, I breathed rhythmically with each paddle stroke. My progress was slow, but I found Adrian working behind camouflage netting stretched between two trees. He didn't see me until I was practically standing next to him.

"Charles, you're here," he said, stopping in midstride. "You canoed all the way to see me, make sure I was okay?"

I was happy to see him alive and well and in pursuit of herons.

"I could hear them clacking their beaks at night," Adrian told me of the mating birds. He thought Mr. *Ayeeoou* was a nightjar, rather uncommon around here, and he would like to record the calls. But when we returned to the sandy bluff campsite, Mr. *Ayeeoou* was gone. Adrian never heard the bird sing.

After the river trip, I listened to bird calls in my trailer at Triple Creek RV Music Park. When I heard the identical song, I jumped to my feet. Mr. *Ayeeoou* wasn't a nightjar—or even a mister—but a female barred owl calling for a mate.

According to the online *Texas Breeding Bird Atlas*, barred owls, the most vocal of all the American owls, are capable of "weird shrieks, screams, cries, trillings, grumbles, and squeaks," though none of these descriptions captures the alluring loveliness of her mating song.

The Big Flood, Wildlife Refuge

May

On a May day, with the whole damn river bottom underwater and more rain to come, Adrian worried about his new game camera. Floodwaters had cut the road to Rocky Point East. We had no choice but to load the canoes, drive as close to Rocky Point East as possible, and portage our canoes and gear the rest of the way.

After sloshing our way to the put-in, we floated downstream to where Adrian had his game camera strapped to a willow oak in front of the beaver palace. "Crud, we're too late," he said, showing me the dried mud covering the casing of his game camera. Adrian fiddled with the camera and discovered that there were images, but he didn't want to learn that they were destroyed. He handed me the camera. "Would you take a look?" he asked.

Five years of trying to photograph a Neches beaver and the first time he puts up an expensive game camera, it's all for naught. Or was it? I scrolled through all the images. They were in good shape. I acted as though I saw good things, but Adrian didn't quite trust me. "Please don't be joking."

The beaver appeared in infrared carrying leaves from the bottom of the river, building materials for his growing lodge. The great blue heron stood on the edge of the beaver house in fine afternoon light, as if the bird had posed itself.

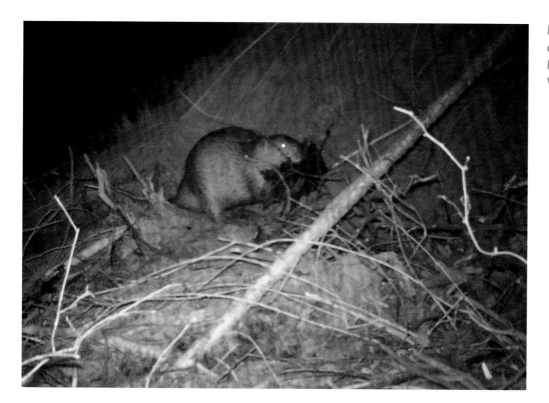

Infrared photograph of beaver at night. Photo by © Adrian Van Dellen

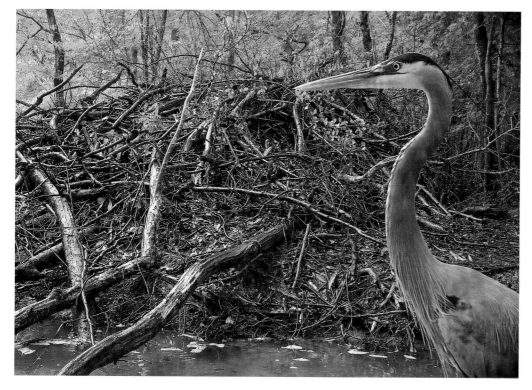

Great blue heron at the "beaver palace"

But it was the last image that was the most amazing. He had photographed a large beaver, probably the Godfather, as he fled his palace during an epic flood. Shortly after that image, the camera stopped working as the river rose even higher.

Now we had to decide where to go. There was no dry land that I could see, but Adrian had a plan. I followed him some distance up Hurricane Creek until we stopped on a tall hill at the administrative boundary of the refuge. So

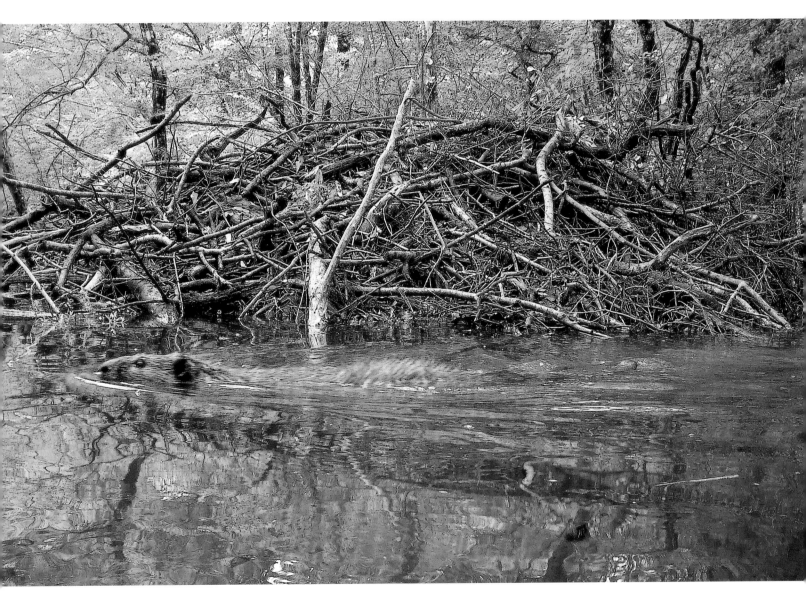

"The Godfather" and his flooded palace

far, Congress has appropriated only enough funds to purchase from willing sellers a quarter of the twenty-five thousand acres designated for the Neches River refuge. The majority of the refuge lies in a technical limbo called the administrative boundary. Adrian informed me that I would be safe from floods there and that he would soon leave the safe campsite to canoe back upstream to the steep-banked Narrows. He wanted to photograph great blue herons nesting in a pine tree.

Once I was alone, a black vulture landed on a tree a hundred feet below my tent. She preened her feathers in a shadowy crook, then jumped down branches to the roof of a deer stand. When I moved an inch, she craned her neck low and stared me down. When I stood, she flew off to a distant limb.

She didn't stay gone for long. The vulture bobbed her head from side to side to get a fix on me. I stayed still as a statue. Both black and turkey vultures see very well, but only the turkey vultures also hunt by smell, literally detecting tiny particles of rotting flesh floating in the air. After a moment this black vulture female hopped across the deer stand, claws clattering on the metal roof. Picking up speed, she extended her snake-neck, leaped to another deer stand ten feet away, and gripped the windowsill with her beak. With a flap of her wings, she pulled her claws up onto the windowsill and slipped into the darkness.

She had a nest inside: two pale blue-green eggs sitting on the floor. With three feet of water surrounding the deer stand and good ventilation from the open window slots, she had chosen a safe nest site. But unlike the great blues and their nests, she probably never would get a chance to return to this one. Once the vulture began regurgitating putrefied flesh for her babies and the stink sank in, the owner probably would burn it down next fall.

With hardly any dry land on which to set up my tripod, there wasn't much to do. The black vulture was my only companion. She arrived several times a day and left by hopping out of the window on the opposite side.

On the fifth day at the pine plantation by myself I canoed to the vulture nest and climbed the metal stairs. I stood on my toes to look through the narrow window. Luminous like matching sapphires in the dim light, the two eggs had been moved since I first saw them. Now they touched one another as if their mother had placed them that way so they could talk the secret language of bird eggs.

Pine needles and floodwaters

I wondered if she had done that because of me, because of what I represented—murder and mayhem. Were the sibling eggs comforting each other? Although we were in a wildlife refuge, shooting and hunting continued all year.

A violent storm approached that afternoon, and I texted Adrian: *Get ready tornadoes are close.* His reply from the Narrows: *All is well! Four nests are occupied in two pine trees. Bull gator is bellowing to his girlfriends!!—Hope you are staying dry, better than me.*

A dark brooding cloud filled the sky. Lightning bolted overhead. A throaty roar raked the trees. My tent creaked and cowered, and for a moment I thought it might collapse. Pine needles plastered my clothes. I crouched by the tent remembering a story of John Muir lashing himself to a tall tree in the mountains of California during a gusty gale. He sang to the ripping glory of Mother Nature as if rocking violently were great fun.

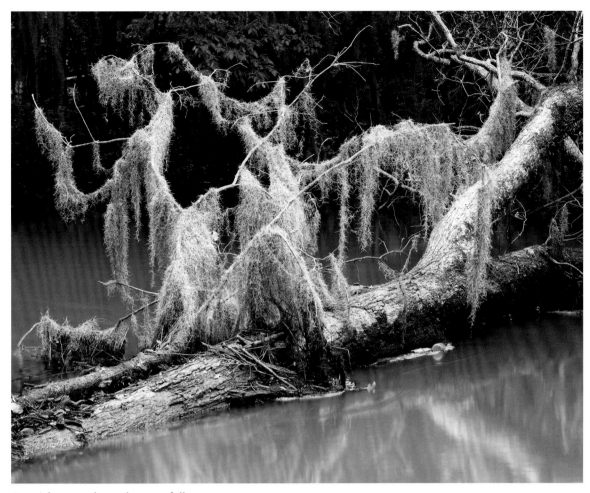

Spanish moss draped over a fallen tree

Twisting from above, a gust of wind like a dragon's tail whipped the air. Trees twirled, limbs shook, and leaves spun out of the forest. I squatted low, close to the ground, and promised myself I wouldn't panic, wouldn't leave this spot. I'd let the storm thrash me.

The dragon came closer, swished her tail, and stole my hat. It sailed onto a blackberry bush. The angry clouds separated. A calm patch of white clouds spread across overhead, and I ran for the hat. Mistake! The dragon returned to buffet me with wind and cold rain. I ran for the tent and jumped inside.

I cursed myself for panicking, though I had to admit it was nice to be inside a comfortable tent that didn't leak. After a while, a break in the storm allowed

me to come out again. I walked a logging road where I found a gruesome sight: dozens upon dozens of crayfish bodies, their claws torn off and tossed aside, their meaty tails missing. It looked like the crustaceans had tried to flee the flood but were caught in the open and devoured by raccoons. I hoped something like that wasn't about to happen to Adrian.

The fury steadily declined. A cardinal began to sing and Adrian paddled up out of the flooded bottomlands of Hurricane Creek. "You won't believe what I've been through," he said, stepping ashore. He casually combed wet hairs on the top of his head, as if nearly being drowned had been a mere inconvenience. I vowed then and there to protect Adrian as best I could. He had the courage of John Muir tying himself to the great tree.

We moved downstream to a new campsite we had never stayed at before, a soggy place of Spanish moss. In the flooded bottomlands I heard smacking sounds. Common carp gulped at black humus where tiny midges were laying eggs. Originally from Asia but farmed in Europe for two thousand years, these invasive carp uproot water plants like their invasive cousins on land, the feral pigs.

I drew close enough to the carp that I could pet their yellow-lipped, shiny heads. I stayed perfectly still. A wood duck squealed. Although I was clearly visible, a female with three drakes in tow swam within twenty feet of my canoe. No male and female ducks could look more different. The red-eyed drakes flaunted jaunty crests of iridescent green atop their heads. With speckled breasts and purple, blue, brown, and black feathers edged in white covering their backs, they seemed ridiculously overdressed. The female displayed speckled plain brown with one striking feature: large white eye-rings that tapered to the back of her head like Cleopatra's eyeliner.

Jousting without their beaks ever making contact, the drakes were goofballs that chased each other while the female slipped away. Then the boys rose up on their webbed feet all at once and raced across the water. Minutes later, I heard the female's agitated squeals. The males weren't total clowns after all. They had found their love interest.

Two mornings later the air smelled so sweet from blooming bushes and the temperature seemed so pleasant I felt tempted to lounge the entire day, but the urge to find a photograph brought me to a field of lavender false dragonhead flowers where bees sucked at nectar and swallowtail butterflies

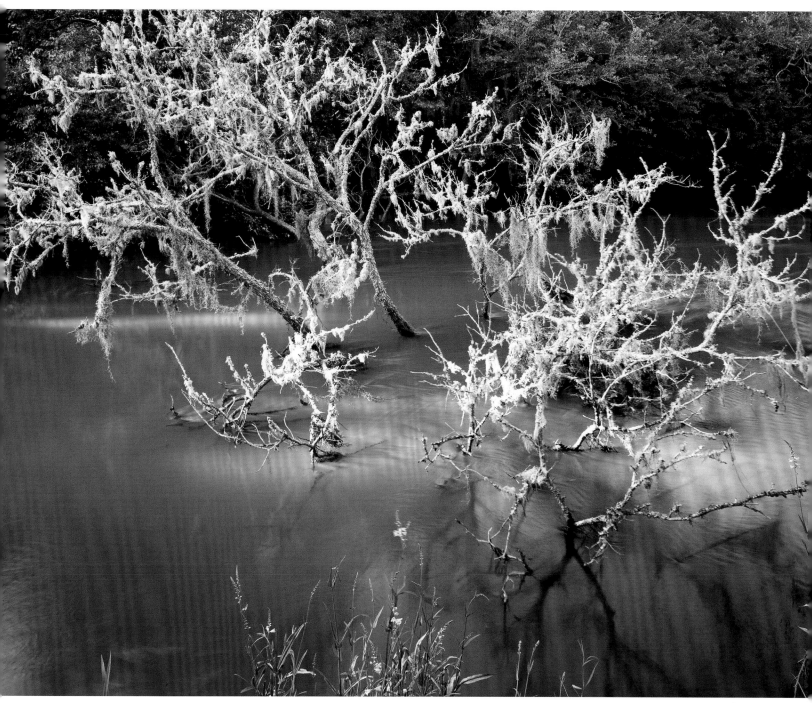

Sunken tree, Spanish moss, and lichens

fluttered. I stayed until the last rays of afternoon light struck a tree bobbing in the water. Covered in moss and lichen, the strange tree seemed so beautiful I decided to find Adrian and then have an early supper together.

We sat on our stools under a river elm with false dragonhead flowers all around, a yellow-billed cuckoo "knocking" above. Adrian finished his meal of sardines and crackers and set up his camera. I handed him an orange and kept one for myself. He pressed the timer on his camera and rushed back to his stool. *Now*, I said, and the oranges flew. The shutter clicked, and we laughed at images of our contorted faces deep in concentration, as if orange tossing were so very important.

More contented than I could recall on any river trip, I wanted to return next year or the year after. It didn't matter when; the important thing was only the thought that it might happen one day. Bring the family and friends, sit among the false dragonhead flowers, and listen to the yellow-billed cuckoo sing its strange song. Under the river elms, we would stay for days, embraced by a wild river, the greatest gift I could think to give anyone.

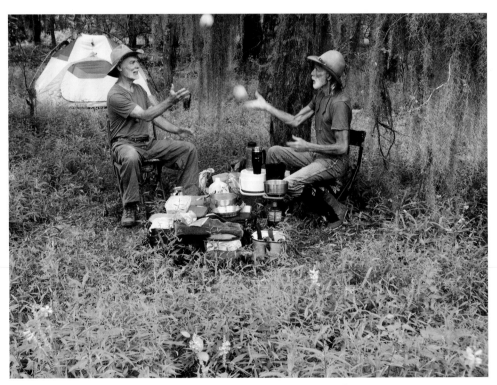

False dragonhead flower meadow. Photo by © Adrian Van Dellen

Adrian's Baptism, Wildlife Refuge

February

Adrian and I stepped outside into crisp shadows at Rocky Point East. The bottomlands, now empty of leaves, enabled me to see deeper into the woods than ever before. A crow-sized pileated woodpecker flew through the forest. Phoebes and flycatchers chased moths over the river.

The Neches still ran high from winter rains. I set off ahead of Adrian and was making good time until I struck an unseen log in the river. My canoe rode up out of the water on the log and hung there dangerously. The boat spun broadside across the current and began to tip over. I jabbed the paddle onto something hard and pushed off the log and into fast current, lucky to have escaped trouble so easily. In the standard river swamping first you stick on something, then you turn crossways to the current, then your upstream gunwale goes under, then you swim with the fishes.

A little farther downriver I climbed ashore to investigate the remnants of the beaver palace. Disaster had descended on beaverland. The water oak that had camouflaged the Godfather's lodge had been washed away, and the green moss that surrounded his house was gone too. He had made a desperate attempt to save the lodge from the floods by building higher and wider, but his palace had collapsed into the river.

When Adrian arrived, I called for him to come to shore. He cupped an ear, his mouth moved, but the roar of the flooding Neches stole his words. I yelled that the beaver house had been abandoned.

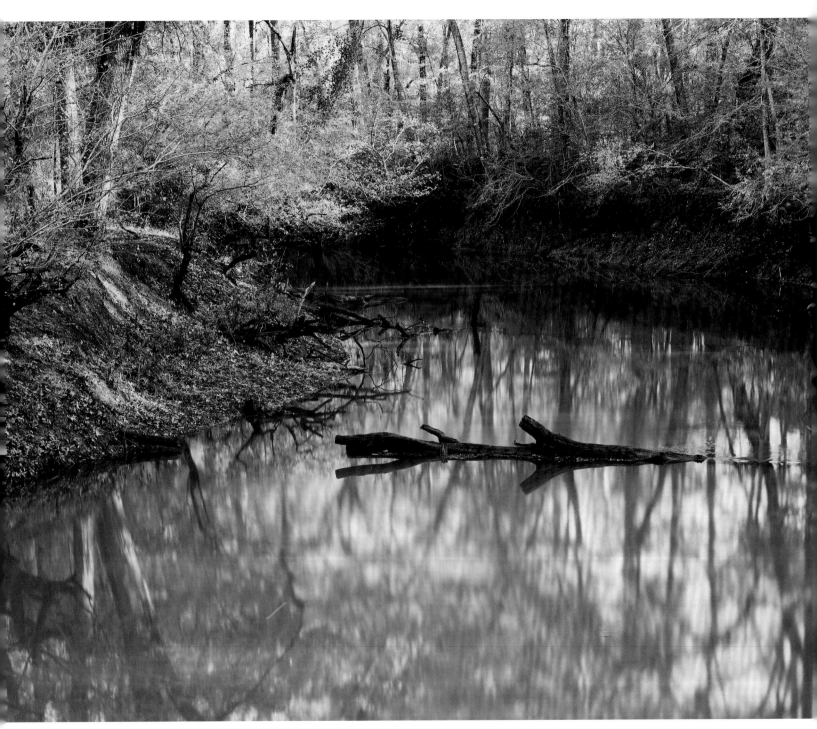

Neches River, upstream from the beaver campsite

Surprised at how fast he was traveling, I waved for him to come back. He nodded as if he had understood, but then his canoe suddenly stopped, turned broadside into the current, and made a violent cracking noise. Suddenly Adrian pitched forward into the bitterly cold water and disappeared.

I couldn't believe it. I had never seen him dump. I gawked at the empty canoe as a coughing and splashing Adrian emerged in a thicket of limbs. He grabbed his canoe and swam it and his paddle to shore. Within minutes Adrian's eyes became glassy. I worried he might be suffering from shock and hypothermia. He indeed had little protective body fat. I gave him an extra pair of waterproof boots and helped find him dry clothes. Although he wasn't back to normal, we soon resumed our trip to Hurricane Creek.

He claimed to be happy to have fallen in. "I feel so alive," he said. But his pupils were enlarged like cat's eyes at night. He continued to shake and admitted he could hardly hold his paddle.

I stayed near his boat. At odd moments his eyes fluttered and his chin fell to his chest as if he had briefly lost consciousness, but we made it to Hurricane Creek.

What happened to Adrian made me think of death, something always closer than you think in winter on icy cold water. Hypothermia strikes fast. But so be it. If I had to die, the Neches seemed a very good place to do it. As for Adrian, when he dies he has instructed me to order an autopsy and send him the results c/o Peter at the Pearly Gates. He wants to learn whether the twenty-four supplements he takes daily did him any good.

But I don't think about dying when I'm on the Neches. I live in the bird song and the bug chatter and the strange splashes in the river. I struggle to understand the meaning of sounds I hear and the vibes I sense as if I might learn a secret from signs and portents, a secret that changes my life forever.

The next morning, as the sun rose and fog boiled from the river, Adrian remained in his tent, no doubt still recovering from his Neches baptism. I fumbled with the camera, chilled by the mist, managing to get one exposure before the scene melted away in harsh sunlight.

Adrian stepped from his tent at midmorning. "Do I smell oatmeal?" Apparently he had returned to normal.

He said he felt fine, ate in a hurry, and left for the Narrows two miles upstream, where he had spotted four nests and eight herons in a tall pine tree. In the silence left behind, a pair of downy woodpeckers chased one another

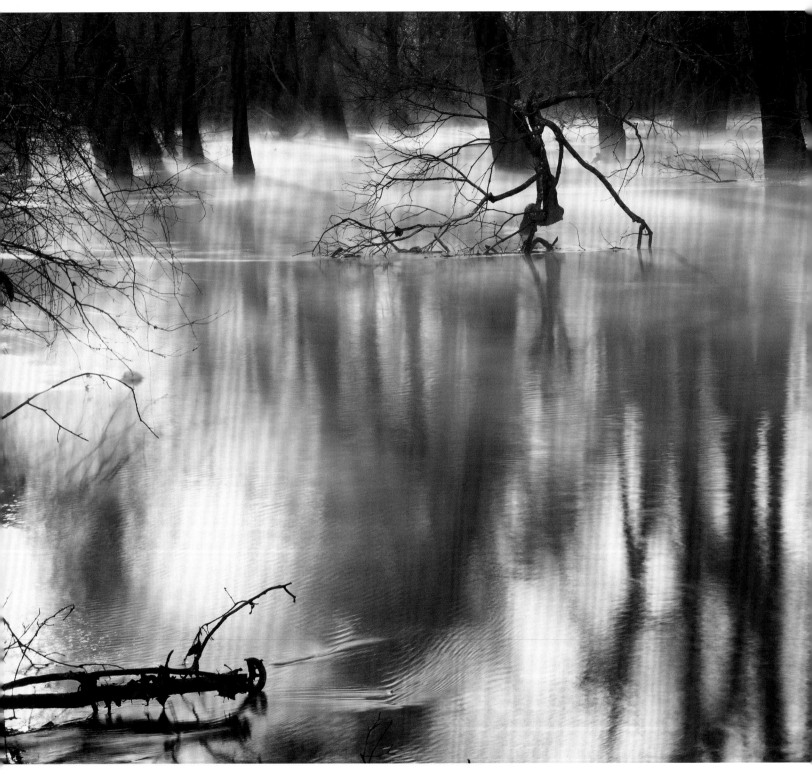

Fog and mist, Hurricane Creek campsite, February

up and down a sweetgum as if they were blind to my presence. They touched beaks, took flight, came together, and tumbled toward the water as if in a fight. Breaking apart, they flew in a circle and returned to the same sweetgum. Clucking softly from opposite sides of the tree, they scurried around the trunk, with hooked tails pressed tight against the bark. Faster and faster they chased each other as if playing a game of catch-me-if-you-can. I couldn't tell the male from the female, since woodpeckers are sexually indistinguishable. Finally, they squawked loudly, leaped into the air, locked together again, and fell toward the ground with wings outstretched. Only then did I realize the smallest woodpeckers of the Neches bottomlands were mad with desire. Spring mating season had begun. The downies parted and flew off in different directions.

Overnight it seemed the pageant of spring had sprouted furry wings of vibrant green. New leaves flashed brilliant silver in the breeze. Pollen tassels speckled the bare ground where no color existed before. I scanned the woods to find the source of a delicious aroma from some flowering bush or tree. High in the sky, four great blue herons appeared from the direction of the Narrows. They circled behind an immature bald eagle like a squadron of long-necked fighter jets. Rotating above and behind the bird, they pushed the eagle out of their territory.

My canoe already packed, I moved downstream to the sandy bluff campsite. Adrian arrived in the afternoon from the Narrows, thoroughly pleased with his great blue heron photography. He attached his game camera, the same one rescued during the May flood, to a tree overlooking a new and active beaver lodge at the base of the sandy bluff. He asked me to look in on his camera while he was gone.

"Found a new heron colony," he explained and left again.

Heated by the sun, I hiked over a hill toward the flowery scent I had noted at Hurricane Creek. In a small patch of wildness on the edge of a pine plantation, the white flowers of a Mexican plum glistened. The scent overwhelmed me like something forbidden. Butterflies and honeybees crowded every flower. I shook a branch. They lifted into the air. I put my nose to a flower. Wings of color and buzzing bees, they took back the sweetness. I shook the branch again. They hardly moved.

Down a different hill, through different woods, I followed a green trail, treading over leaves from last year to an ironwood tree. Marching down the

trunk, hundreds of leafcutter ants carried green pollen tassels and bits of leaves. Like a ribbon crossing the ground, the leafcutters proceeded to their mound, and I followed along behind them.

Except for humans, leafcutter ants have the most complex societies on the planet. Feeding leaves, berries, and pollen tassels to a fungus garden deep inside their mound, the ants cultivate the fungus, which is their only food. So polite and concerned for the well-being of their tribe, they leave their earthen hive to die outside rather than sicken the healthy.

I knelt in close. My carbon dioxide breath caused chaos. Soldier ants with mandible pincers half the size of their body stormed outside to meet the

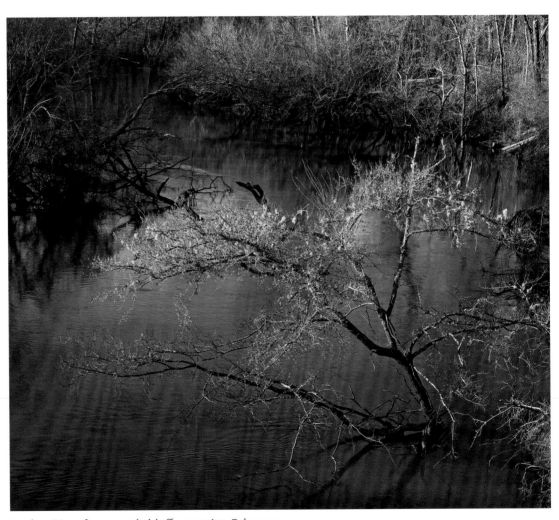

Neches River from sandy bluff campsite, February

threat. I retreated across the sandy bluff, the soft murmur of the Neches calling to me from below. The first snake of the season slithered by my boot. I moved an inch, and the chicken snake glared and bolted down the hill. Red-shouldered hawks mated in a tree. A tiger swallowtail, always one of the first butterflies on the Neches, brushed past, probably on its way to the Mexican plum.

The sun set, a ball of liquid yellow. Magenta settled on the river like a lullaby. Red hornets crawled over the rim of my unused water boots and climbed inside to sleep the night.

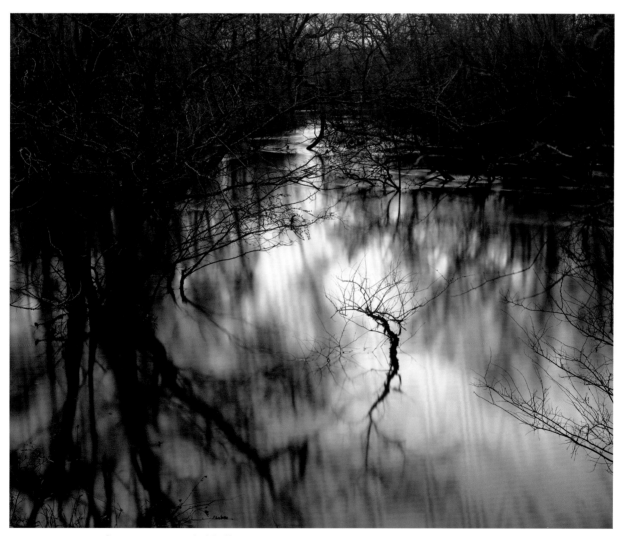

Magenta water after sunset, sandy bluff campsite

The next morning, woodpeckers drummed, kingfishers chattered, and cormorants whooshed overhead. I reached for a boot, slipped a foot inside, and felt something move. I had forgotten about the red hornets. Fortunately for me, they were too cold to sting. I dumped them on the tarp in the morning sun and crossed over to the clear-water stream, where I liked to filter my drinking water from deep holes. When I returned, Adrian was crawling over the beaver lodge.

"I got some good beaver action, but the scene is too messy," he said as he broke sticks and tossed them aside. "And you won't believe this. There's a baby beaver in there. I got sound recordings." I told him that walking on the roof of a beaver house wasn't polite and reminded him of previous problems caused by disturbing beavers.

He laughed and went on repositioning the camera. "Oh, the beavers are going to get us, ha-ha."

We launched our boats for home on the morning of the eleventh day. It hardly seemed possible that we had been gone that long. Adrian predicted we could travel the four miles to Highway 84 in two and half hours. For the first mile or so we successfully maneuvered around every obstacle, but eventually we found ourselves stranded in shallow water.

Unsure of which way to go in the watery maze above the highway, we heard splashing from downstream. A wading herd of feral pigs approached. They stopped, stared at us like they couldn't believe it, then kept going. We wandered over the bottomlands for five and a half hours before reaching Highway 84, only to find my truck vandalized—two tires slashed with a knife. Beaver luck.

I called the sheriff. He spat on the ground and said, "Let me ask you. Where did you get the idea that it was okay to leave your truck here for ten days?" He spat again. "I wouldn't leave anything here for ten minutes."

By the time the tow truck arrived it was almost dark. Then the unthinkable happened. I was filling out paperwork at a hotel in Jacksonville when Adrian joined me in the lobby. We were missing a canoe, he said.

We had failed to properly secure the Prospector canoe Adrian had lent to me. When the trailer arm broke, my boat fell off. We searched along the thirty-mile road between our hotel and Highway 84 and spent the next day looking in pawn shops and backyards, but we never found my boat. Some local boy now had a fine Wenonah Prospector. Damn those beavers.

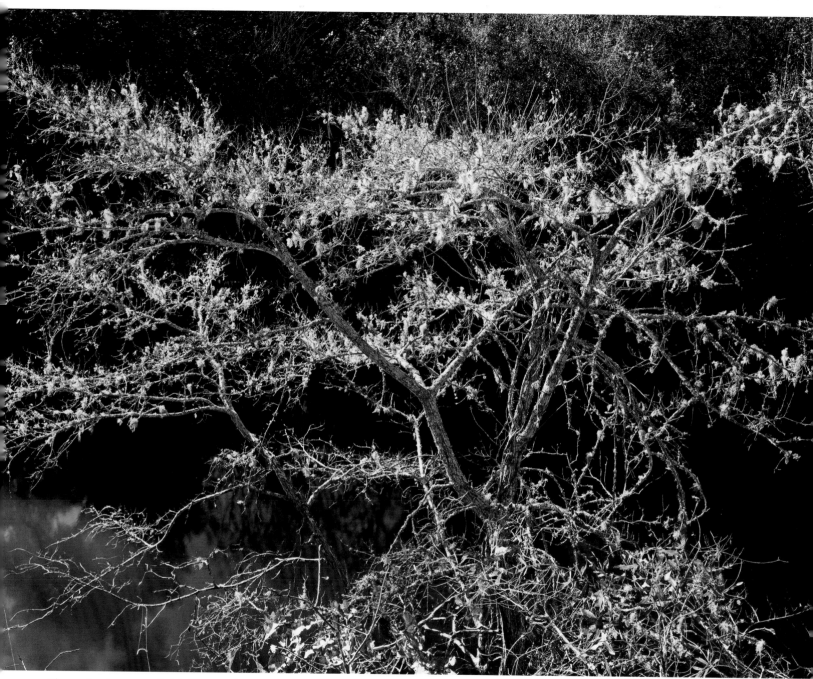

Flowering tree, sandy bluff campsite

Easell's Camp

July

Shirtless and slimy as fish in the July heat, Adrian and I sat on our camp stools, unable to move or speak. We had sawed and hauled timber for an hour to clear the road to the Neches. Our usual road to Rocky Point East had completely washed away from repeated floods. Fortunately, Adrian had secured a key to a wedge of private property that we called the hunters' camp.

Behind us sat an abandoned shack sagging with rot, a decrepit travel trailer, and a mound of discarded carpet covered by gray river silt. It was a place we had always despised and carefully avoided, an irony not lost on us. We had reached the river on a road that should be closed, a road that split the fragile shell of wilderness around the wildlife refuge.

I poured drinking water over my head and considered the strangeness of the scene around me. There had been three major floods over the last eight months; the biggest one had reached twenty-one feet on the gauge near the town of Neches, though other floods had crested at eighteen and sixteen. The bottoms had been stripped of vegetation and grooved with thin furrows, as if the Neches had been a wild beast let loose from a cage. Flotsam extended ten feet above the river channel, and fallen trees crowded the Neches like corpses.

Everywhere I looked I saw a rawness of destruction. Wildness had come from the river and hid there now, pent up and ready to sweep over the banks again. And yet, among the carnage and the threat, a new paradise emerged. A blue, spade-shaped flower I had never seen before grew on a vine along the ground. Down at the river, where the Neches had churned a deep hole

against the bank, fish splashed in incredible numbers. In the sky, dragonflies—I couldn't count them all—darted after mosquitoes and midges in a feeding frenzy.

Cicadas whirred, Adrian grumbled; perhaps to mortify the flesh, he had left both his sleeping pad and sleeping bag at home. He had a tent, but only because he had failed to completely empty his vehicle after his last solo river trip. I watched him fold the camouflage netting of his photo blind into a bed and then place a towel nearby for a blanket. We had hoped to start canoeing this day, but the heat and heavy work of clearing the road had sapped us of energy.

I planned to say goodbye on this trip. With this midsummer voyage, my goal of canoeing and photographing the Neches every month of the year would be complete. I didn't think this was the last of our trips, however. I had a new canoe, another Wenonah borrowed from Adrian, two feet shorter but just as wide in the middle as the big green Wenonah we lost in February. As for Adrian, he had embarked on a new passion as a game camera operator. Game cameras trip automatically by sensing movement, and at night they use infrared light to photograph warm-blooded mammals. Adrian already had one camera strapped to a river elm near the Narrows, and on this trip he planned to install a new state-of-the-art game camera that sent images to his cell phone in real time.

I slipped my loaded canoe into the river and waved a paddle at Adrian. "I'm coming, wait for me," he hollered. We set off together, but as usual Adrian began to lag, looking around at things. My short canoe proved perfect for maneuvering over and around obstacles. Occasionally, I had to step out of my boat to straddle a fallen tree that my canoe couldn't quite fit under. With one foot pushing the bow deeper into the water so it could slide underneath, I used the other foot to guide the canoe safely through. Debris and harmless spiders fell into my canoe. I ignored that except for a fishing spider the size of a small tarantula that I tossed out with my paddle. Fishing spiders are fearsome predators. With large fangs and neurotoxic venom, they dive underwater to kill minnows, and they can bite canoeists.

The banks looked pummeled by the floods. Insects, heat, and the relentless, muddy flow were breaking the uprooted trees into bits of organic material that thickened into mats dense enough for seedlings to sprout and diamondback water snakes to hide in.

Bullfrog at the Narrows

I reached the Narrows, and the first bullfrog I had ever seen on the Neches jumped into my boat. I managed one photograph of the handsome eighteen-inch-long amphibian with my new digital camera before five kayaks appeared—on the remote upper Neches a sight that was at least as much of a shock as the bullfrog.

The kayakers included Dr. Neil Ford, a mussel biologist from the University of Texas at Tyler. He explained that he and a group of his graduate students were searching for rare Neches mussels. They joined me, and we paddled upstream to find Adrian repositioning his game camera.

"Sandbank pocketbook," Neil said, picking up a common Neches mussel species. Meanwhile, I gathered a large Bleufer mussel the size of a small pair of shoes. In the late nineteenth and early twentieth century, people harvested Neches mussels to make buttons. The shells' iridescent interior was hard and durable, but eventually the mussel supply collapsed and so did the button factories. The greater threat to these important river purifiers are dams and pollution. Most mussels need a constant flow of fresh, clean water. When

mussels die, so does the river, like the canary in the coal mine. The Neches has the most diverse mussel population in Texas, but fifteen species are listed as threatened.

I left the scientist and his students and arrived alone at the familiar Hurricane Creek campsite. I waded into the water eager for a cooling swim, but a slimy creature of some sort bumped my leg and I went no farther. Bobbing up and down in the current, I felt the crazy heat sucked away. I moved forward to shore covered with the skin of the Neches—black bits of leaves and bark. Then I noticed a strikingly beautiful banded water snake, orange bands against a black body, swimming the shoreline. It seemed completely unaware of my canoe or me. I guessed that no humans had been here for months, just how I liked it.

The campground itself seemed little changed except for a large red oak that had toppled over near my tent site. I sawed branches to get through, got my camp together, and stepped into the cathedral of oaks along Hurricane Creek. The light of day slid off the treetops. Underneath, the canopy grew so thick and luxuriant in the heart of summer that it blocked the sun like a shield. Only tiny slivers of direct sunlight penetrated to the forest floor.

I walked to the edge of the hardwoods—to the end of grace, the end of holiness, the end of everything that was wonderful and beautiful in the Hurricane bottomlands. The light glared where the old-growth forest ended. I squinted at the tree farm and tried to imagine what this place once looked like.

What should be here instead of a loblolly tree farm? Perhaps a mixed forest of hickories and upland oaks and . . . and, I didn't know what else. I had nothing to compare. Most trips to the edge of the bottoms along the Neches end like this. The higher ground above the floodplain grew in spindly pine trees crowded together like cattle at a feedlot.

I had left poetry and stepped into a murdered forest. Is that hyperbolic, to say murdered forest? If the great old trees that once lived here could speak our language, or we could understand tree language, I think murder would be the word they would use. For everything that had once been here by natural rights, by hard-won competition, had been slaughtered by a timber company. Not a single old tree had been spared to show us what should be here.

We, all of us, needed to say every day, all the time, that the earth is our only home and we would be wise to take care of it. From those beginning words,

grace could flourish along the bottomlands of Hurricane Creek, and then . . . yes, like Calvinist Adrian, I believed grace could happen everywhere.

Weak sun glanced off the river; riffles murmured from the Narrows. Where Hurricane Creek entered the Neches, I dried my hands of sweat as best I could and made the first good photograph of the trip.

Walking around the next morning, I found the flood-cleared ground along the river open and easy except for patches of greenbrier, which the floods couldn't uproot. I flushed wood ducks, spooked turtles, and disturbed a heron fishing along the bank of a river chaotic with fallen trees.

I found crayfish castles rimmed by creamy light on a clay bank eroded by the floods. Along the edge of the forest above the mud chimneys were thumbprints of a crime: piles of discarded crayfish pincers and shell-laced droppings left by the otters that had eaten the little lobsters, a beautiful sign of a healthy river.

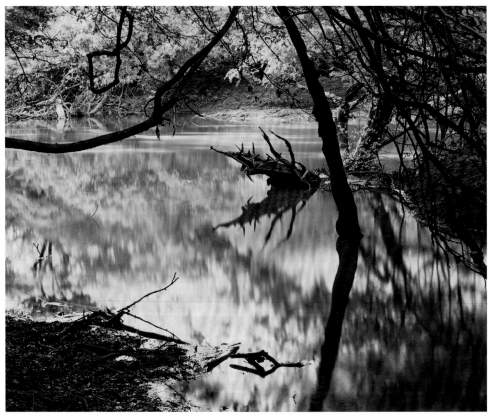

Island in the Neches, Hurricane Creek campsite

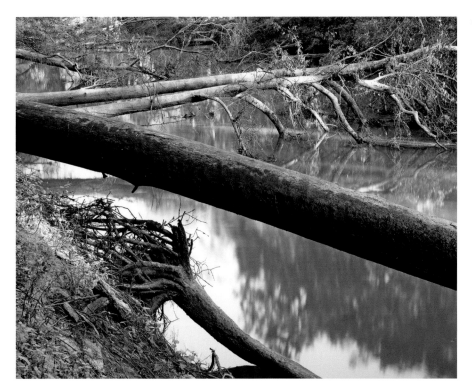

Chaotic mass of fallen trees across the Neches, Hurricane Creek campsite

Crayfish chimneys, Hurricane Creek campsite

It was unusually quiet. Scourged by the floods, the scarce bottomland vegetation didn't provide enough food or cover for the usual mice and rabbits. I hadn't heard a single hawk and only a few owls, though a black-legged ant crawled over the barren clay clutching a baby katydid, and across the river, the rare Neches River rose mallow, white flowers with crimson interiors, grew on a leggy bush. A hibiscus plant listed under the Endangered Species Act, the rose mallow clearly liked a good flood. The high water had created exactly what the rose mallows needed: deep sand and no competition from other plants.

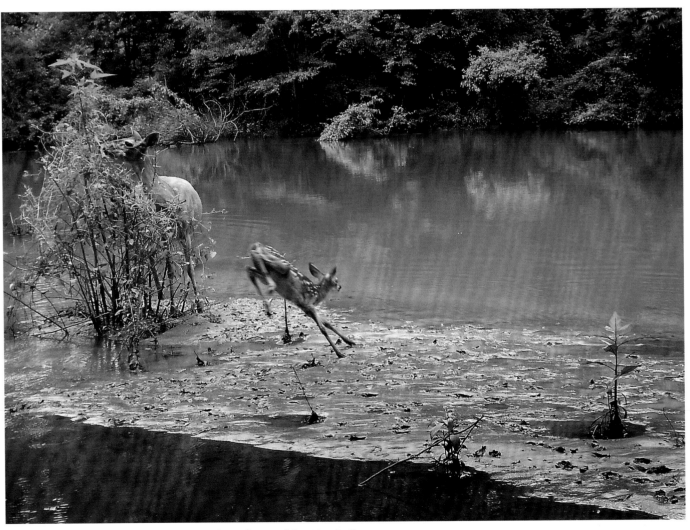

Fawn playing while mother browses. Photo by © Adrian Van Dellen

Back at camp, damselflies were breeding and birthing in the dead branches of the toppled red oak. Unlike dragonflies that actively hunt, the smaller damselflies wait for food to come to them. My tent was their commissary; it had plenty of mosquitoes inside for them to feast on. I encouraged some to enter.

I went over to see Adrian. He excitedly flipped through game camera photographs. "I got some good shots here," he said, handing me his camera. In one, a fawn pranced on the wet sand while its mother browsed.

In another, a coyote vigorously dug a hole then moved a few feet and dug another hole: perhaps the predator was chasing a mole. Then he walked up to the camera and stared straight into the lens.

Crows came and went without revealing their intentions.

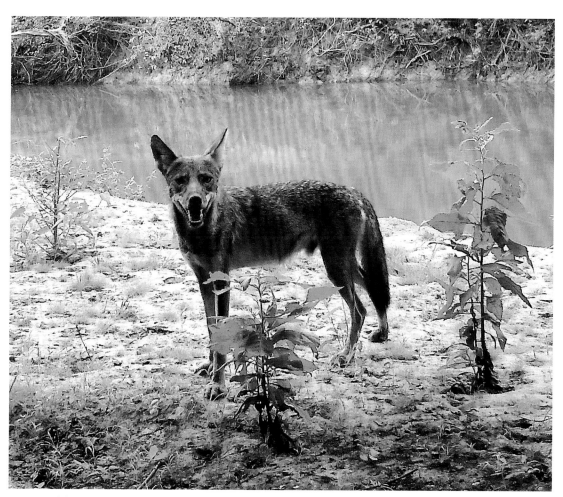

Bold coyote. Photo by © Adrian Van Dellen

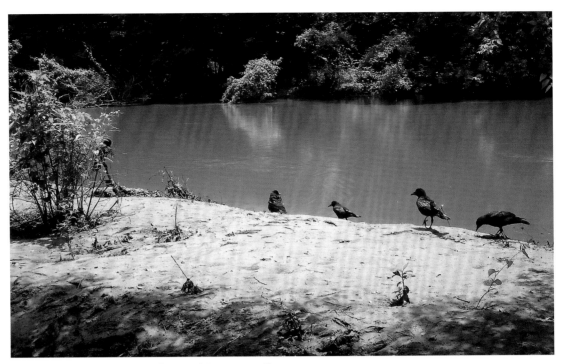

Crows on a sandbar. Photo by © Adrian Van Dellen

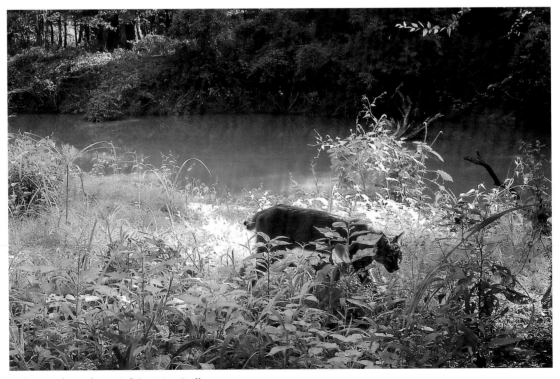

Bobcat. Photo by © Adrian Van Dellen

Then a bobcat, a creature we had never seen before on the Neches, crossed quickly in front of the game camera.

I would have loved more interaction with these creatures, something like what Barry Lopez described while visiting the Galapagos Islands, where "mockingbirds snatch at your hair and worry your shoelaces—you are to them but some odd amalgamation of nesting materials," but that was not to be on the Neches. At least not now. The birds and animals in the refuge feared people and their firearms. In all the years Adrian and I had canoed the Neches, he had never seen a coyote or a bobcat, much less photographed one. One day, we hoped, a Neches River National Wildlife Refuge ranger would be stationed nearby to stop the year-round shooting, and daylight might begin to reveal the Garden of Eden.

The heat, the wet, intense heat—I could feel it coming like an approaching train. I felt like I was being baked in an oven. The birds went silent, and so did the flies. Adrian refused to go swimming with me. "I'm cleaner than the river," he said. "I don't want the silt to clog my pores."

I went to Hurricane Creek and knelt in the water under the deep green of the overcup oak forest, but by the time I returned to camp the heat seemed intolerable. It had to be endured. I lay on a tarp, watching my sweat pool around me while carpenter ants feasted on a dragonfly, its yellow wings spreading like a fan.

After a while, when the light came in low, I sawed my way downstream through fallen trees and stopped in the deep shade of a river elm, the woody arms of the tree twisting above a glowing river, my sweat dripping.

On the last morning at our favorite Hurricane Creek campsite, chickadees rustled in the dried leaves of the toppled red oak as sunlight spilled gold on the forest floor. I slipped an index finger underneath the baby damselflies and released my mosquito-eating friends outside the tent.

For the next leg of our trip, we would need to travel five miles to reach our new take-out: Easell's deer camp. Pat Easell had taken pity on us, Adrian said, since we had lost an expensive canoe and my truck had been vandalized. It wasn't a long distance, but sections of the Neches could often be difficult. I took the lead through the maze of downed timber; Adrian kept up with me as we rounded a water-beaten tree, but he didn't follow me around the next bend. Adrian chose the outside channel, which had always been clear but now was closed by debris after the floods.

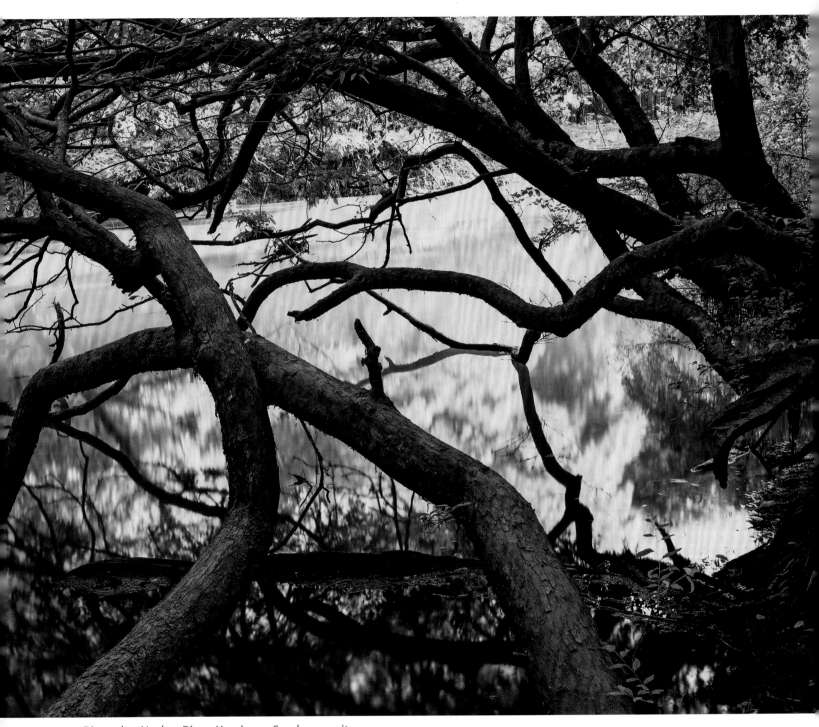

River elm, Neches River, Hurricane Creek campsite

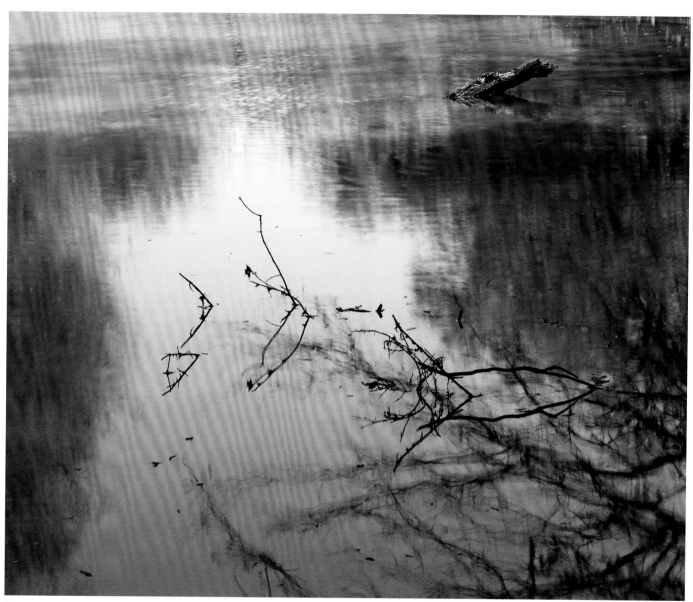

River scene near our camp at Hurricane Creek

I heard him swear and then he laughed. "I've got a good-sized bass in my canoe," he said. He maneuvered upstream and arrived at my side. He had been pushing his paddle into the bank to stop the boat when the bass jumped inside.

The floods had enriched the fish life of the Neches to numbers we had never seen before: herds of grazing carp and surface schools of spotted gar dressed in handsome green and big black spots. Needlenose gars too, so thin they appear translucent and slightly blue, and those were just the fish we could easily see. Bass, bluegills, and catfish lurked below the surface. When the Neches floods the bottomlands in spring, river fish spread far and wide and go into a breeding frenzy.

Adrian stopped at a grouping of old heron nests in a tall loblolly pine. I continued to the sandy bluff campsite where the hill stream we liked to filter water from emptied gravel into the Neches, creating the best swimming hole in the refuge. I stayed for an hour, kneeling in the river, rubbing water over my body, then drying off and writing in my journal. I tried to tell the river how much I loved it. *Sweat and piercing heat, tangled trees of misery: if you can't handle the river to paradise, you don't belong here.*

I had a goal—get to the next campsite before darkness. Through openings and passageways, the sun a burning torture, the water a soothing balm, I slid and crunched under fallen trees. Feeling wild like the animals—in a world of trees born from the soil—nobody to please, no mirror looking back at me—only the river, my paddle, a canoe.

The camp was up ahead. A new place to explore, photographs to be made, seconds of time caught on film forever mine, but when I arrived at the Easell camp, I was boiling hot. Confused and nauseous, my heart pounding, I stumbled ashore. By the greatest of good fortune, I found a bubbling spring at my feet. Water from deep underground pulsed through sand and filled a tiny pool the size of a football. I stuck my head into the cold water until it hurt.

Adrian arrived after sunset. Soothed by the faint wind of a thunderstorm, I helped shuttle his gear up the hill. Bull-headed clouds flashed lightning from the east. Adrian dropped his load, then walked past his canoe and into the river. Fireflies blinked like stars. I couldn't stop staring. The Neches shimmered white in the middle with purples and blues around the edges. It was as if the sun were pulling on a multicolored blanket before settling inside the water for the night.

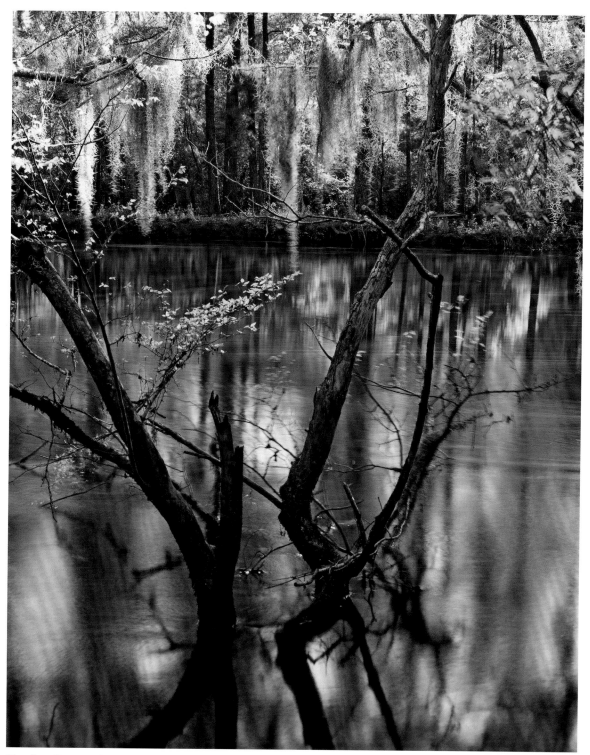

The flooding Neches near the proposed site for Rockland Dam

Adrian took another step forward, as if preparing to take a swim. Thunderstorms rattled. His shirtless torso and bald head glowed with the faint colors of a rainbow. One hundred eighty-two nights of sleeping on the Neches, through heat and drought, floods and freezing cold: *the freedom of the Neches was our freedom too.*

The next day, at 3:00 p.m., my brain felt on fire again. I waited for a change that would signal a rush of air. The minutes ticked by, the leaves hung slack, the temperature approached 102 degrees, with the heat index a murderous 115. Heat exhaustion built on itself; overheating on one day made you more vulnerable the next. Was this the beginnings of heatstroke? I felt like my body temperature had reached the dangerous 104. I had no idea how Adrian was faring, having set off hours ago to install the new game camera. I walked to the spring, dipped a coffee cup just low enough for a thin stream to fill the vessel, and drank. The cold water was so delicious I drank more and more until I felt giddy.

With a gallon from the spring I went back to camp thinking of Paul Horgan's description: *Gods and heroes were born out of springs. . . . They had natural mystery which suggested supernatural qualities; for how could it be that when water fell as rain, or as snow, and ran away, or dried up, there should be other water which came and came, secretly and sweetly, out of the ground and never failed?*

I showered by the cold cupful, water washing through me like an awakening. I remembered an early trip with Adrian during a flood. He wanted to show me the proposed site for Rockland Dam. If constructed, the Rockland reservoir would be bigger than Sam Rayburn Lake on the Angelina River. Rockland, Adrian said, would destroy most of the wildness left on the Neches.

"If Dallas builds this reservoir," Adrian said with rising anger, "it's all over for the Neches. Nobody knows the . . . the . . . damn it." He stomped off into his kitchen and kicked a bucket under his leaky roof. "The Neches needs to be declared 'Wild and Scenic.' That'll stop them from building another dam."

If the best part of life is the poetry of living things—children and otters, beavers and flowers, a tiny ant crawling on the ground—then the Neches must rank near the top. That the wild Neches has lasted so long in Texas, a state that sometimes seems allergic toward the protection of its natural heritage, is a miracle of sorts.

May the Neches always run free.

EPILOGUE

After I finished this book, Adrian wanted to record the mating ritual of great blue herons. He bought climbing gear and made plans to scale a tall pine tree in the Neches River National Wildlife Refuge. I thought he was crazy for even thinking about climbing a hundred-foot pine tree, but he did. He installed two game cameras near the top and sent me these self-portraits as proof. One of the cameras had the capability to send photographs to his cell phone, but the mating season came and went, and he never received a single image.

He investigated and discovered broken eggshells at the bottom of the tree and, later, piles of sawdust—a bad sign. The pine tree had been struck by lightning, and pine beetles had moved in where the bark had been split. The heron chicks—if there were any—had likely been killed. The game cameras were probably fried, but Adrian held out hope that images had been recorded before they failed.

Never one to stand still, Adrian is now looking to move the experiment to a new tree. Meanwhile, as the new chair of the Texas Black Bear Alliance, he is leading the effort to reintroduce Louisiana black bears to the Neches riverwoods where they once flourished. Black bears will improve the habitat for all the Neches creatures and bring balance to the fauna and flora of East Texas.

Determined conservationists like the Temple Foundation, whose founding family once owned more than a million acres along the Neches River, is helping to protect the river. For example, the Temple family recently donated a conservation easement for Boggy Slough, a nineteen-thousand-acre parcel that includes eighteen miles along the Neches. The last effort to win a federal Wild and Scenic designation for the Neches River ended with Sen. Kay Bailey Hutchison's retirement. If she had been successful, no more dams could be built to tame this wild river, and, paired with the reintroduction of the black bear, an outstanding Neches River ecosystem could have been created anew.

Adrian used an eight-foot-long slingshot to fire a lead string up and over a fork in the tree. Photo by © Adrian Van Dellen

Next he installed climbing ropes and an ascender, a type of tree-climbing cam. Photo by © Adrian Van Dellen

My hope is that this book will inspire another attempt at winning Wild and Scenic protection for the Neches River.

Texas has a poor record of protecting the rivers that flow across the state. Only a few miles of the Rio Grande are protected, whereas tiny neighbor Arkansas has nine rivers designated Wild and Scenic. Will Texas politicians protect the free-flowing Neches from the water hungry cities of Dallas, Houston, Beaumont, and industrial users like oil and gas frackers? Don't hold your breath. In the end, it is up to the people of Texas.

Call and write your representatives in Austin and Washington, DC. Demand protection for the last wild river in Texas, and, when the next reservoir is proposed for the Neches, help us mount a vigorous opposition.

Thad Sitton, a Texas historian, gives me hope when he writes, "In a way the people of Texas have already protected the Neches. Many impediments now lie in the way of Rockland Dam, the long-proposed dam on the middle Neches that would create a giant lake and destroy the wild river as we know it today—not just by inundation but by drastically changing the river for many miles downstream of the dam. Since Tomcat Red's day, people have been trying to preserve the Neches, and the results are the national wildlife refuge, the state wildlife management areas, the national forest wilderness areas, and the wonderful 80-mile public wilderness corridor of the Big Thicket National Preserve. Such lands have many friends who would fight like bears to preserve the river."

For myself, I've kept my feet on the ground. I've started a new project photographing a tributary of the Neches, Rush Creek, with the encouragement of the retired leader of the Big Thicket Association, Maxine Johnston. Eighty-eight-year-old Maxine wants Rush Creek to be included in the Big Thicket National Preserve. I've been photographing the deep, sandy canyon and surrounding beech-magnolia forest to help bring her dream into reality.

"Hurry up," she tells me—"I don't have much time before I kick the bucket." I'm doing my best, Maxine. There's lots of visual poetry in Rush. I want to get it all.

And then Hurricane Harvey arrived, bringing the heaviest rainfall ever recorded in the United States during a tropical storm. As thirty inches of rain fell on Rush Creek, a magnificent energy scoured the canyon. Dead trees were tossed onto the canyon floor as if a great artist had used Hurricane Harvey to playfully decorate Rush Creek.

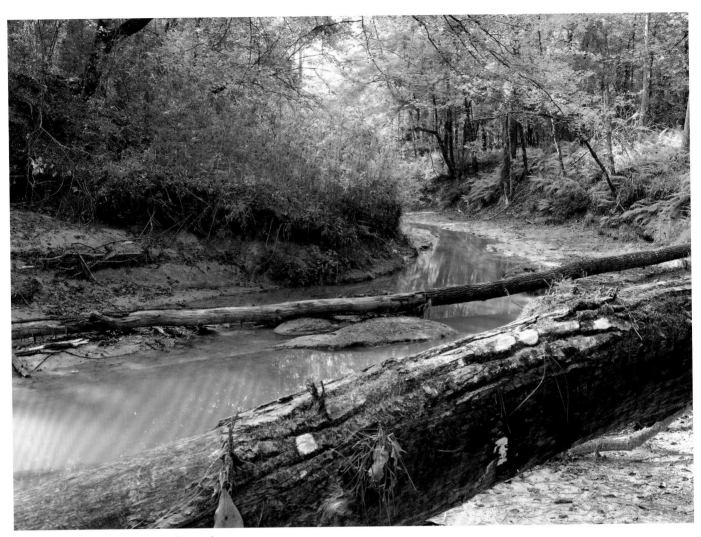

Flood-tossed trees, lower Rush Creek

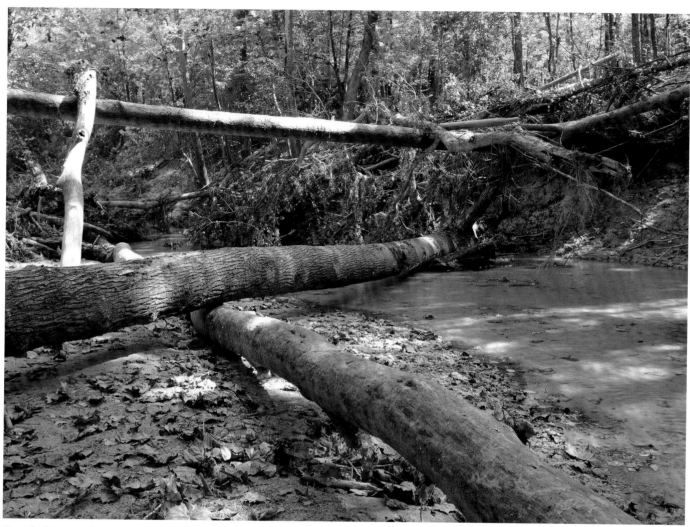

Toppled trees after Hurricane Harvey, lower Rush Creek

Farther south and much closer to the Gulf of Mexico, sixty-four and a half inches of rain fell in Nederland, breaking Hawaii's record of fifty-two inches, recorded in 1950, and exceeding Nederland's annual rainfall in just five days. I talked to friends, Dale and Cynthia Parish, a month after Hurricane Harvey had ravaged southeast Texas and flooded their house in Orange County. Dale stayed upstairs as the floodwaters swamped the first floor, while Cynthia, a science teacher at Lamar University, evacuated with the help of a group of boat owners from Lufkin who volunteered their aid.

Dale worked in the IT department and later as a database administrator at ExxonMobil until his retirement. "Climate change means bigger storms and bigger droughts," he said, adding that much of the flooding was the result of human activity. Construction for State Highway 12, the Kansas City Southern Railroad, the Sabine River Authority irrigation canal, Interstate Highway 10, and the Southern Pacific Railroad all conspired to restrict the natural drainage. "There was so much rain and so few openings; the water had no place to go," Dale said, "so it backed up into my house."

Where humans have messed with nature in Orange County, houses were flooded and destroyed. But Harvey's enormous energy made Rush Creek even more beautiful.

Before handing the manuscript and photos for this book off to Texas A&M University Press, I drove to Adrian's house knowing that he had complaints about my manuscript. I pulled into Adrian's driveway, and after pleasant greetings he ushered me into the living room. I was confident that the manuscript was truthful and considerate of his feelings, but I was wrong.

"Number one," Adrian said, "I object to your characterization that I was an unprepared guide that didn't bring enough food for my client."

I pulled out a notebook and began taking notes.

"You see," he said. "I brought the river food I was used to eating, and doubled the quantity."

I reminded Adrian that my belly bloated and I moaned in pain within minutes of eating one of his sandwiches. They tasted like compressed sawdust with some kind of goo in the middle.

Although we liked to poke fun at each other, Adrian and I shared a closeness to grace that neither of us had experienced until we came to the mighty Neches. I learned that we are born of the earth. Our blood is like the sea.

Minerals make our bones, and our intelligence is derived from the complexities of the universe. I was so grateful to Adrian that I had learned what he had to teach. I had to make the manuscript right.

"How many issues do you want me to fix?" I asked.

"Twenty-four," he replied.

"Would you mind repeating complaints two and three?"

"Sure, but first I have something to show you."

Adrian had recovered both game cameras from the tall pine tree. One was blackened and ruined from the lightning strike, but the other captured a stunning image of a courting great blue heron arching its neck in the dead of night—a priceless photograph from the last wild river in Texas.

Courting great blue heron on the nest. Photo by © Adrian Van Dellen

FURTHER READING

Abernethy, Francis Edward, and Adrian F. Van Dellen. *Let the River Run Free: Saving the Neches*. Nacogdoches: Stephen F. Austin State University Press, 2013.

Abernethy, Francis Edward, ed. *Tales From the Big Thicket*. Austin: University of Texas Press, 1966.

Bray, William. "Distribution and Adaptation of the Vegetation of Texas." *Bulletin of the University of Texas No. 82, Scientific Series No. 10* (1906).

Donovan, Gina, Stephen D. Lange, and Adrian F. van Dellen. *Neches River User Guide*. College Station: Texas A&M University Press, 2009.

Donovan, Richard M. *Paddling the Wild Neches*. College Station: Texas A&M University Press, 2006.

Doughty, Robin W. *Wildlife and Man in Texas*. College Station: Texas A&M University Press, 1983.

Fritz, Edward C. *Realms of Beauty: A Guide to the Wilderness Areas of East Texas*. Austin: University of Texas Press, 1986.

Graves, John. *Goodbye to a River*. New York: Curtis Publishing Company, 1959.

Gunter, Pete. *The Big Thicket: An Ecological Reevaluation*. Denton: University of North Texas Press, 1993.

Harris, Larry D. *Bottomland Hardwoods: Valuable, Vanishing, Vulnerable*. University of Florida, Institute of Food and Agricultural Sciences, Cooperative Extension Service, 1984.

Huser, Verne. *Rivers of Texas*. College Station: Texas A&M University Press, 2000.

Lay, Daniel W. "Bottomland Hardwoods in East Texas: A Historical Overview." In *Bottomland Hardwoods in Texas*, edited by Craig A McMahan and Roy G. Frye, pp. 8–19. Austin: Texas Parks and Wildlife Department, 1986.

———. "Forks of the River." *Texas Parks and Wildlife* 41 (1983): 24–29.

Loughmiller, Campbell, and Lynn Loughmiller. *Big Thicket Legacy*. Austin: University of Texas Press, 1977.

Neal, Jim, and Jeff Haskins. "Bottomland Hardwoods: Ecology, Management, and Preservation." In *Wilderness and Natural Areas in the Eastern United States*, edited by David L. Kulhavy and Richard N. Conner. Nacogdoches: School of Forestry, Stephen F. Austin University, n.d.

Olmstead, Frederick Law. *The Cotton Kingdom*. New York: Alfred A. Knopf, 1953 [1861].

Parvin, Bob. "Bottomland Hardwoods: Every Acre Counts." *Texas Parks and Wildlife* 44 (1986): 24–37.

Seale, William. *Texas Riverman: The Life and Times of Captain Andrew Smyth*. Austin: University of Texas Press, 1966.

Sitton, Thad. *Backwoodsmen: Stockmen and Hunters along a Big Thicket River Valley*. Norman: University of Oklahoma Press, 1995.

———. "The Enduring Neches." *Texas Parks and Wildlife* 53 (1995): 14–20.

Sitton, Thad, and James H. Conrad. *Nameless Towns: Texas Sawmill Communities, 1880–1942*. Austin: University of Texas Press, 1998.

Swanton, John R. "Source Material on the History and Ethnology of the Caddo Indians." *Smithsonian Institution Bureau of Ethnology Bulletin 132* (1942).

Taylor, Rick. *The Feral Hog in Texas*. Austin: Texas Parks and Wildlife Department, 1991.

Truett, Joe, and Daniel W. Lay. *Land of Bears and Honey: A Natural History of East Texas*. Austin: University of Texas Press, 1984.

Walker, Laurence C. *The Southern Forest: A Chronicle*. University of Texas Press, 1991.

Watson, Geraldine Ellis. *Reflections on the Neches: A Naturalist's Odyssey along the Big Thicket's Snow River*. Denton: University of North Texas Press, 2003.

Wharton. Charles H. *The Ecology of Bottomland Hardwood Swamps of the Southeast: A Community Profile*. Washington, DC: Fish and Wildlife Service, US Department of the Interior, 1982.

Wright, Solomon A. *My Rambles as East Texas Cowboy, Hunter, Fisherman, Tie-cutter*. Austin: Texas Folklore Society, 1942.

INDEX

National Park Service, 3
Nature Conservancy, 72
Native Americans. *See* Neches River:
 Native American settlement along
natural levees, 14
Neal, Jim, 6
Neches River, 1–3; Anglo American
 settlement along, 30–31; bad first
 impressions of, 8–12, 37–38; biological
 refuge function of, 24–26, 45–46;
 bottomland ecosystem of, 3, 7–8, 14–
 26; bottoms as traditional free range,
 2, 3, 32–33; bottomland ecosystem of,
 3, 7–8, 14–26, 107–108; conservation
 of, 3–7, 20–21, 198–204; droughts,
 89, 96–97, 106; floods, 12–24, 26–27,
 155–160, 184–185, 196; hermits, 33–34;
 hydrology of, 14–17; oral history of,
 2–3, 27; logging of hardwood bottoms
 along, 4–7, 31–32; Native American
 settlement along, 29–30; place names
 along, 34; settlement-era fecundity of,
 22–24; stock raising practices along, 3;
 subsistence lifestyles of, 3, 32–33
Neches River National Wildlife Refuge, 4,
 5, *27*, *28*, 125–205
Neches River User Guide, 3, 38
Nederland, 204
New River, 18

Old River, 12
Olmsted, Frederick Law, 8
oral history, 2–3
otter, river, 43, 45, 108, 109, 128, 138, 142,
 188
overflow bottoms. *See* Neches River:
 bottomland ecosystem of
overflow channels, 14
owls, barred, 24, 31, 87, 103, 114, 145, 164,
 165
oxbow lakes, 14

paddlefish, 52
Parish, Dale and Cynthia, 204

Parvin, Bob, 19
Patton's Landing, 30
Pine Island, 12, 14
photography, 1, 29, 34, 45, 53, 60, 145–
 147, 157–158, 162
plum, Mexican 179, 181
point bars, 18
protozoans, 52
pumas, 4, 23–24

Ramer family, 13
reservoirs, bad effects of, 20, 126
"river rats." *See* Neches River: hermits
Rockland Dam, *15*, *25*, 197–198, 201. *See*
 Reservoirs, bad effects of
Rocky Point East, 144, *144*, 155, 166, 175,
 184
rocky shoals, 53, 57–59
Rose mallow, Neches River, 190
Ross, Nancy and Emily, 96

Sabine Lake, 3
Sabine National Forest, 37
Sandy Bluff, 139, 162
San Pedro Creek, 95–103
Santa Fe Railroad, 31
Schaller, George, 145
scour channels, 14
Seale, William, *3*
Sheffield's Ferry, 13
Shinrin-yoku, 108
Shooks Bluff, 30, 31
snake, banded water, 108
snake, copperhead, 119
snake, diamond-back water, 59–61, 185
snake, yellow-bellied racer, 46
Southern Pine Lumber Company
 (Temple-Eastex, Temple-Inland), 7,
 31–32
spider, fishing, 185
spider, wolf, 98–99
steamboats, 8, 30–31
Steinhagen, Lake, 38, 48, 87
Stirtle Eddy, 34

The Blanco River
Wes Ferguson and Jacob Croft Botter

Bob Spain's Canoeing Guide and Favorite Texas Paddling Trails
Bob Spain

Caddo: Visions of a Southern Cypress Lake
Thad Sitton and Carolyn Brown

Canoeing and Kayaking Houston Waterways
Natalie H. Wiest

Exploring the Brazos River: From Beginning to End
Jim Kimmel and Jerry Touchstone Kimmel

Flash Floods in Texas
Jonathan Burnett

Freshwater Fishes of Texas: A Field Guide
Chad Thomas and Timothy H. Bonner

Living Waters of Texas
Ken W. Kramer

Neches River User Guide
Gina Donovan

Nueces River: Río Escondido
Margie Crisp
Artwork by William B. Montgomery

Paddling the Guadalupe
Wayne H. McAlister

Paddling the Wild Neches
Richard M. Donovan

River of Contrasts: The Texas Colorado
Margie Crisp

Running the River: Secrets of the Sabine
Wes Ferguson and Jacob Croft Botter

San Marcos: A River's Story
Jim Kimmel and Jerry Touchstone Kimmel

Sharing the Common Pool: Water Rights in the Everyday Lives of Texans
Charles R. Porter

Texas Aquatic Science
Rudolph A. Rosen

Texas Riparian Areas
Thomas B. Hardy and Nicole A. Davis

Texas Rivers and Texas Art
Andrew Sansom and William E. Reaves

Texas Water Atlas
Lawrence E. Estaville and Richard A. Earl

Untold Story of the Lower Colorado River Authority
John Williams

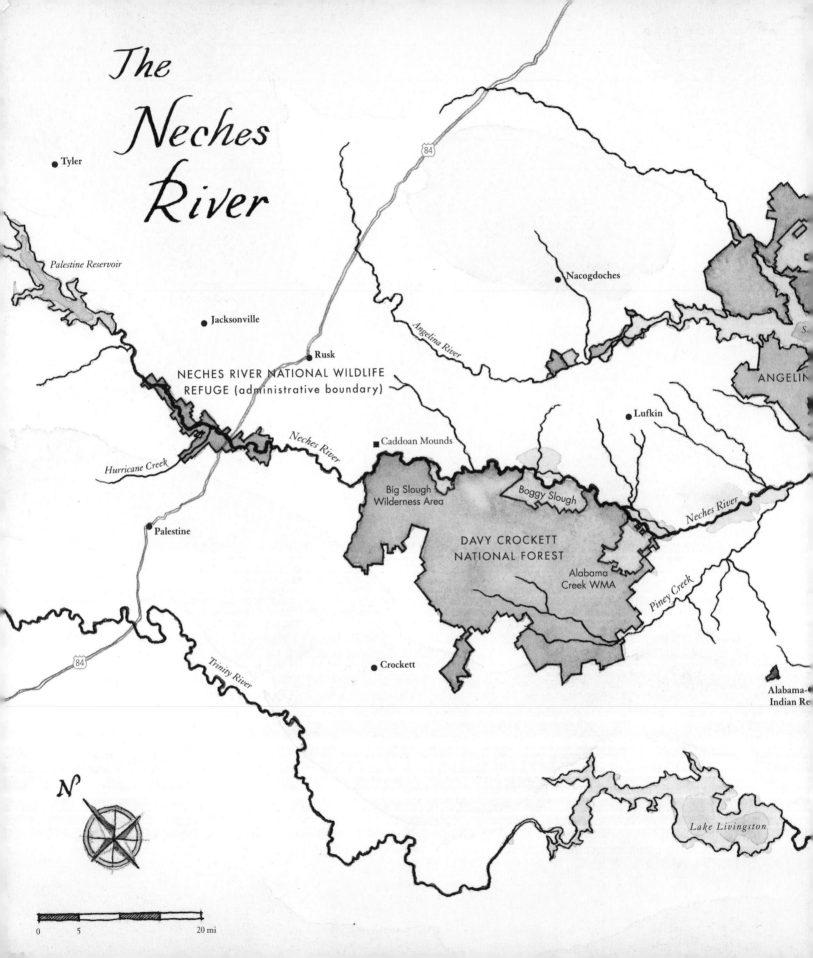

The Neches River

Tyler

Palestine Reservoir

Jacksonville

Rusk

NECHES RIVER NATIONAL WILDLIFE
REFUGE (administrative boundary)

Hurricane Creek

Neches River

Caddoan Mounds

Nacogdoches

Angelina River

Lufkin

Big Slough
Wilderness Area

Boggy Slough

Neches River

Palestine

DAVY CROCKETT
NATIONAL FOREST

Alabama
Creek WMA

Piney Creek

ANGELIN

Trinity River

Crockett

Alabama-
Indian Re

N

Lake Livingston

0 5 20 mi